THE COMPLETE PHOTOGRAPHY COURSE

PEACHES AND CREAM.

KODAK EPD 6036

EPD ▷ 2

▷ 1

6

IWS – NUDE
on 1000mm Pentax

Michael Joseph
46 Clapham Common
North Side
LONDON SW4 0AA

KODAK EPN 6012

THE
Complete
Photography
Course

**Michael Joseph and
Dave Saunders**

VIKING

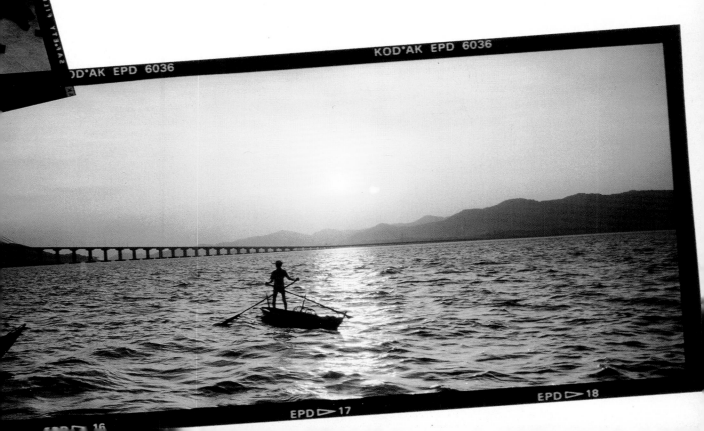

Dedications
Michael Joseph: For my late father and my mother who
nurtured my leanings in the early days. For Julie, my wife,
who prevented me from paddling the Orinoco and suggested
advertising instead. For my three children, Joanna, Justine
and Jay, for being model models.
Dave Saunders: For Fran, Serena and John.

VIKING
Published by the Penguin Group
Penguin Books USA Inc., 375 Hudson Street,
New York, New York 10014, U.S.A.
Penguin Books Ltd, 27 Wrights Lane,
London W8 5TZ, England
Penguin Books Australia Ltd, Ringwood,
Victoria, Australia
Penguin Books Canada Ltd, 10 Alcorn Avenue,
Toronto, Ontario, Canada M4V 3B2
Penguin Books (N.Z.) Ltd, 182-190 Wairau Road,
Auckland 10, New Zealand

Penguin Books Ltd, Registered Offices:
Harmondsworth, Middlesex, England

First American edition
Published in 1994 by Viking Penguin,
a division of Penguin Books USA Inc.

10 9 8 7 6 5 4 3 2 1 1 3 5 7 9 10 8 6 4 2 1 2 3 4 5 6 7 8 9 10

CIP data available on request

Printed and bound in Italy

Acknowledgements

Michael Joseph: I would like to thank all those who have modelled, helped and contributed in so many ways. Thanks to those who may not have been aware they were being photographed and to the patient models, such as Jay, who sat for the portraits on the lighting spread, only minutes before flying to Athens. Margo, Olga and Dorothia, all elegant ladies on the Johannesburg Tatler – my first job. Leo who sold me film. Oliver Scott for the cover shot of the flying bike and Michael Portelly for the underwater mother (Lauren Heston) and baby (Billy Zeqiri) on the cover and other underwater shots on the spread 'Beneath the Waves'. Etienne Bol for capturing the spirit of propeller planes on the spread 'Flying Time'. Brian Moynahan who chose me to accompany him to Vietnam, and made our two months there memorable. Roy Carruthers, Pam and Alison for their guidance in the early reportage days. David Puttnam and Peter Lyster-Todd for their advice on dealing with publishers and ad agencies. Paul and Toni Arden at Saatchi & Saatchi, with whom I have shot many award-winners. Ken Scott for creating the pool ladies scenario. Susan Scott who cast most of my big scenes. Tanya Dring and Victoria Hockley who tied up loose ends. Peter Vincent and Chris Mugford at GGK for a Buchanans Whisky shoot. Gunner Moum and Fin Rogstat for travelling to London from Oslo for twelve consecutive years for the Evergood coffee campaign. All on the Pirelli two-week rally across France, Spain and Andorra, with Margella Lewis whipping us along. Gordon Jackson for being such a co-operative model. Dave Gardiner for modelling for the Polaroid spread. Manfred Vogelsanger and Mickey for stripping off for my calendar. Sian Huston, the gorgeous red-head in numerous fashion shots, and to her daughter Bonny for patiently appearing in others. Assistants over the years who have made many of these shots possible, especially Peer Lingreen and Andrew Lowell. Lookalikes Peter Hugo as Prince Charles, Christiana Hance as Princess Diana, Deanna Keene as Diana Ross and Maloviere as William Shakespeare. Vincent McEvoy and Linford Christie for Ford shoots. Roland Scotoni (Young & Rubicam, Zurich) for the Kodak shoots. Kay Wiederemann and Helen at adworks for providing Max and Benji and the still-video pictures. Graham Fink for being outrageous and an outstanding art director. John Herlinger at Kaiser for the flash sync and camera accessories. Fotospeed for retouching dyes, Selenium and other toners. Kevin O'Connor at O'Connor Dowse for art directing the Malcolm Venville shot of swollen, bendy and coiled art directors. Roger Barker and Mark Grosvenor at Nucleus and all those at Style. Joe Lim and Saadah Shaik Mahmood at Malaysian Airlines. Brian Grieves at Agfa. Angelo and all at Snappy Snaps C41 lab. Charlotte and all the helpful technicians at Metro for their multi-computerized open-all-hours lab. Sue Coleman and Chris Boffey at Nikon. Pat Wallis at Polaroid for film. Derek Gatland at Hasselblad for their shift mechanism. Bernard Petticrew at Minolta for providing the pre-set zoom facility. David Brown and all at KJP for all sorts of Polaroid cameras. Stein Falchenberg at Teamwork for the Roundshot panoramic camera. Simon, Karl, Frazer, Steve, Guy, Roy and Steve at the Flash Centre for their Elinchrom lighting. Colin Carron, the editor, and Maureen at PIC magazine. Paul Gates and others at Kodak for being extremely helpful. May Christea, my neighbour, who posed with her hollyhocks, and Sharon Clarke for her hand colouring. Melvin Cambiette Davies who helped with printing. Mick Jagger of The Rolling Stones for realizing I was an orgiast!

Dave Saunders: I would like to thank the Australian Tourist Commission and Qantas for showing me the greatest island on earth. Twickers World for helping me take the plunge in the Red Sea. The Alternative Shooting Company for calling the shots. Ray's Parasailing, Jamaica, for the uplifting experience. Anders Gaarder, Exodus Expeditions and Hayes & Jarvis for the photo opportunites they've given me in Norway, Thailand and Kenya.

Contents

The Complete Photography Course

Cameras don't take pictures, people do. This book is designed to help you take better pictures – whether snaps of family and friends, photographs for commercial publication or striking images for display. A feast of tips and tricks is laid out in palatable bite-sized segments to help you take your photography further.

At one level, photography, like good driving, is the result of keen observation, judgement and reactions. But it is also a creative process: the subjects you choose to photograph reflect your own character, mood and opportunities. *How* you shoot them depends on your imagination plus the technical know-how you've picked up along the way.

Welcoming the technological revolution in photography, *The Complete Photography Course* opens with a review of the wide range of equipment available, with guidance on how to choose (and use) cameras and accessories to suit your needs. Is a motorized compact camera with zoom lens right for you? How can you avoid 'red-eye' when using flash? How good are 'disposable' cameras? What are the pros and cons of a single-lens reflex (SLR) camera? Why is it worth learning to control exposure? And depth of field? What are the advantages of using different lenses and films? When do wide, medium and large format cameras come into their own? What do you need to know about digital technology?

The second section explores a battery of techniques to help you create impressive photographs across a wide spectrum of subjects: children, sport, portraits, nudes, weddings, animals, still life, natural elements, travel *et al*. Looking through the photographer's eye, this section examines the thinking behind the lens – what to look for and how to achieve effective results. It is packed with functional hints and short-cuts gleaned from years of practical problem solving.

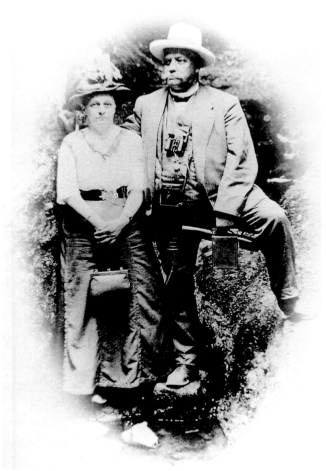

Bedecked with cameras and binoculars, Michael Joseph's great-grandparents set the tone for a life of great photography.

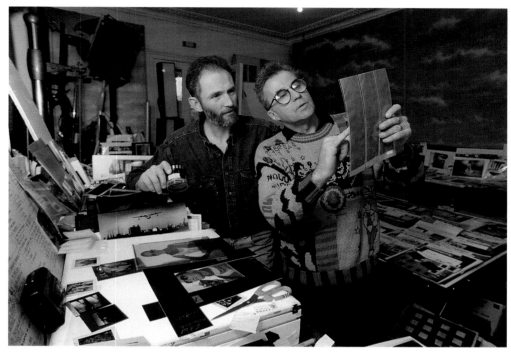

Dave Saunders (left) and Michael Joseph make selections from a lifetime of pictures and experiences. Photograph by Etienne.

The third section spotlights the reality of professional photography – self-promotion, lucrative markets, casting, photographing celebrities, reportage, war, beauty, fashion, elaborate sets and costumes.

The final section illuminates many mysteries of the darkroom, with innovative suggestions for creative approaches.

Each spread contains a brief introduction, a checklist of advice, and a clutch of pertinent photographs with captions and technical information, making this an ideal volume to work through, or dip into. Occasional spreads give a personal account of a specific assignment. We join the Rolling Stones being photographed for an album cover; we follow the frustrations of conducting a day's location shoot; and we revel in the orchestration of a medieval orgy!

Photography is about opportunities … seeing them, then seizing them, or making them happen. Look beyond the obvious, and learn from what you see. Experiment, and learn from your mistakes.

Michael Joseph's myriad experiences have contributed to his 'anything is possible' approach. A childhood in South Africa opened his eyes to both beauty and injustice. When he was six, Michael was given his first camera, a Zeiss Ikon box camera, by his grandmother. By the age of fourteen, he was accepting photographic commissions, which gave him confidence handling people, and taught him to experiment with different approaches. Between the ages of eighteen and twenty-one he supervised the photographic printing

A quick snap of Michael against a zany backdrop is interrupted by an enigmatic figure in the foreground. Photograph by Julie Joseph.

department at the Johannesburg Stock Exchange in the morning, and shot and developed his own pictures in the afternoons and evenings. An opening on the Johannesburg Tatler exposed him to the world of premieres, parties, personalities and politicians. His first assignments included gatecrashing the garden party where British Prime Minister Harold Macmillan was giving his 'Winds of Change' speech, and photographing Field Marshal Montgomery.

When his sister sent him a book of Bill Brandt's nudes, Michael Joseph was struck by his versatile use of a pin-hole camera on the beach, turning toes and fingers into giant pebbles. Then, when Anthony Armstrong-Jones (now Lord Snowdon) married Princess Margaret, photography gained a respectability that dispelled any reservations held by his family.

Using second-hand equipment and outdated film and paper, he compiled a small but impressive portfolio which won him a place at the London College of Printing and Graphic Arts. In many ways he was self-taught and had already outgrown the college. Through his own initiative, he obtained large-scale lighting from a company called Strobe and devised ways of illuminating large sets. With a fellow student he converted a bedroom into a darkroom and washed prints in the bath. Another student asked him to photograph the editor of Town magazine, to accompany his thesis. This chance encounter led to a number of commissions including an assignment to cover the conflict in Vietnam. Helicopter sorties with Time-Life photographer Larry Burrows proved a steep learning curve and taught Michael to keep cool under 'fire'. His pictures subsequently appeared in newspapers and magazines all over the world.

The hard graft of advertising commissions proved not only lucrative but also gave him a huge repertoire of tricks of the trade in pursuit of that evasive 'look'. Agented by David Puttnam, later to be head of Columbia Pictures, Michael quickly became one of the most successful advertising photographers, constantly on the move, solving problems on the run.

Over the years he has always been ready to learn from experiences and to explore new approaches. Many photographers have influenced his ideas in different ways. He found the work of Art Kane stimulating; he responded to the humour and atmosphere of Howard Zieff's pictures; he was excited by

Dave Saunders finds that the facilites in the heart of darkest Kenya are not always very sophisticated for the peripatetic journalist–photographer. Photograph by Fran Saunders.

the zany annual calendar produced by Horn and Griner; he likes Pete Turner's use of vivid colour; he finds Jacques-Henri Lartigue's photography inspiring; and he admires Barry Lategan's vibrant images, Angus McBean's surreal theatricality and Norman Parkinson's joie de vivre.

Today, with well over 3000 commercial assignments under his belt, he has handled almost every photographic situation. Together with journalist–photographer Dave Saunders, he spent a year sifting through millions of images, assembling shots into themes designed to inform and inspire. Dave Saunders has collaborated with Michael on many projects over the years. Dave Saunders has travelled extensively, interviewing photographers around the world about their approach to photography, as well as shooting his own pictures for publication internationally.

Whatever your experiences have been, you can use this book as a source of information and also as a springboard for your imagination. Treat it as an invitation to open your eyes, to think laterally, to bend the rules, to experiment, improvise and customize. View the camera as a tool which can shoot wonderful pictures. But it is the eye – the ability to see a good picture – that will make you a good photographer.

Michael Joseph
Dave Saunders
July 1993

Equipment

Compact Cameras

There are two main types of 35mm camera: the compact and the bulkier single lens reflex or SLR (*see* SINGLE LENS REFLEX). Compacts are small, light and often very sophisticated, doing most of the thinking for you. They have a better quality lens and larger negative than 110 or disc cameras, so give sharper, less grainy pictures. Basic models have one fixed-focus lens, manual wind-on and simple exposure settings for 'cloud', 'hazy sun' and 'bright sun'. Manual focus models can be adjusted by rotating the lens to line up with distance symbols, usually 'head and shoulders', 'small group of people' and 'mountains'.

Top-of-the-range compacts offer many of the advantages of SLRs, including different lenses built into the camera, continuous shooting, programmed exposure control, auto and manual focus and macro facility. Some of the more sophisticated compacts have a red-eye reduction feature and a zoom lens that can be used at any focal length from wide-angle to telephoto. Red-eye occurs when light from the flash is reflected off the back of the retina. The effect is reduced by contracting the iris with a pre-flash.

Some compacts offer the option of printing the time and date on the edge of the print itself. This can be a useful record and can be turned off when not required.

With good composition and an interesting setting, a simple compact camera can take very satisfying pictures. Fill-in flash on the small group of people is balanced by the ceiling lights and lanterns. *Nikon AW, Kodacolor 400, auto-exposure*

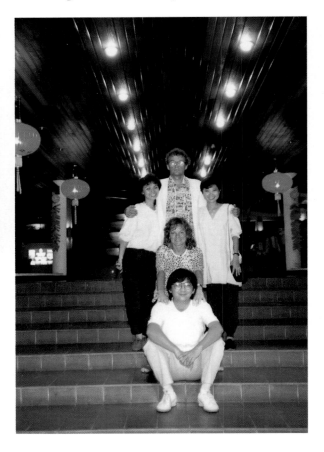

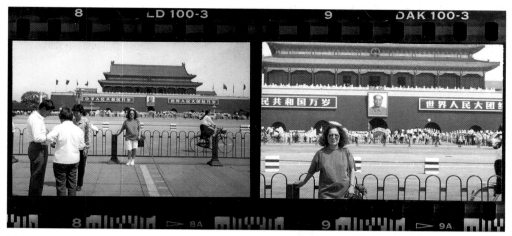

Many compact cameras have simple one-touch zoom lenses, giving them some of the versatility of an SLR zoom lens. The wide shot of the entrance to the Forbidden City in Tiananmen Square, Beijing includes both foreground and background in focus. The telephoto focuses attention on the distant building. Photographs by Ginette Dureau.
Canon Megazoom, 35-105mm zoom at 35mm and 105mm, Kodacolor 100, auto-exposure

When involved in a physical activity such as skiing you want a small, light camera that can be slipped into a pocket and is easy to operate even when wearing ski gloves. The combination of a fast film and wide-angle lens gives a good depth of field (*see* DEPTH OF FIELD).
Nikon AW, Kodacolor 400, auto-exposure

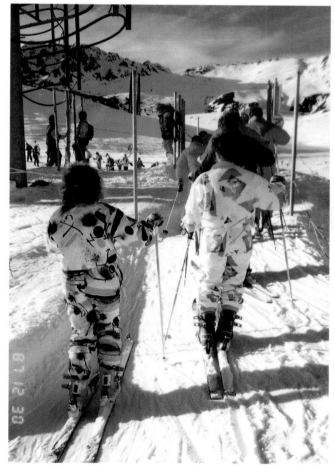

CHECKLIST

When starting photography buy a camera that is easy to use. Move on to more creative techniques after you have mastered the basics.

Choose a camera that has the functions you think you will use and which feels comfortable to hold and operate.

Consider a compact with a lightweight zoom lens to get the buzz of composing shots.

Compacts are used by many professionals as accessible backup cameras.

Equipment

Using a Compact

Compact cameras are designed to be easy to use, with no-fuss automation for point-and-shoot photography. Although certain procedures apply to all cameras, find out about the idiosyncrasies of your model from the instruction manual.

Change film out of direct sunlight as light can seep inside the film canister and fog the film. Avoid confusing used (exposed) film with new film by labelling the roll or winding the exposed film right back into the canister. Double exposures can be extremely embarrassing.

When shooting, adopt a comfortable, stable stance, then squeeze rather than jab the shutter release. Remember that the minimum focusing distance is usually about 1 metre. The autofocus mechanism on many compact cameras focuses on the centre of the frame. Take care as this may be infinity, as even a head-and-shoulders shot of two people with a gap between them could back-focus. To avoid out-of-focus subjects, point the camera directly at one of the people, half depress the button that locks the focus control, then recompose the shot and fully depress the shutter when ready.

Make sure the tongue of the film is pulled out far enough and lines up with a marker near the take-up spool. If you are about to photograph a very important occasion, it is worth reopening the back after advancing the film to frame 1, just to check that the film is winding on properly. After closing the back again fire off three exposures to make sure you have reached the unexposed film.

CHECKLIST

Carry a simple compact camera everywhere, as photo opportunities are unpredictable.

Try shooting quick, unposed snaps; they can be very revealing!

Before loading a new film, check the film counter to make sure a part-used film is not already in the camera.

If planning to re-use a partly used film, put a bend in the end and note which frame to rewind to.

Label the back of the camera with the date when fresh batteries were inserted and keep a tally of how many films have been exposed.

Autofocus compacts take a reading from the centre of the frame. If you don't lock the focus on the main subject before composing the shot, it will probably be out of focus. For maximum depth of field focus a third of the way back. Also, the flash unit will try to give an average exposure for the whole scene. As the intensity of light drops away quickly, the foreground will be overexposed and the background dark.
Nikon AW, Konica 100, auto-exposure

As compact cameras have a direct viewfinder positioned above and to one side of the lens, you will see a slightly different picture from the one that the film sees. This difference is called parallax. When framing very close subjects, allow for parallax error by angling the camera up a little. With such tight framing as this, failure to compensate would have ruined the shot.
Nikon AW, Kodak Tri-X (ISO 400), auto-exposure

Shot while skiing, this swooping hang glider was snapped with a no-fuss compact which was quickly whipped out of a pocket to catch the drama.
Nikon AW, Kodacolor 400, auto-exposure

Red-eye is a disquietening effect that many manufacturers have tried to reduce with a pre-flash that makes the iris contract. Another way to avoid red-eye is to bounce the flashlight off the ceiling or wall, or, if the camera has a sync lead socket, to have the flash unit away from the camera on an extension lead.
Nikon L35AF, Polaroid 400, auto-exposure

Disposables and Miniatures

Small, inexpensive disposable plastic cameras made by Kodak, Fuji, Konica and others are very light and generally have absolutely no frills – often not even a flash. They are ideal for holiday snaps as they are quick and easy to use, and it is not too upsetting if they are lost or damaged. The results are surprisingly good if you take pictures under appropriate conditions – sunny or slightly overcast or with flash – and as long as the camera is at least 1 metre from the subject. The film remains in the camera when sent for processing. Although the camera is not returned to you, it is recycled.

Disposable or single-use Panoramic cameras use 35mm film, but a wider angle lens takes in a broader view. The top and bottom of the frame is masked to produce an impressive 10 x 3 inch print instead of the normal 6 x 4 inch print. The picture may be distorted at the edges of the frame.

The Action Tracker camera shoots four images in quick succession, making it suitable for capturing the stages of a laugh or sneeze for example or, in this case, for panning with a moving subject.

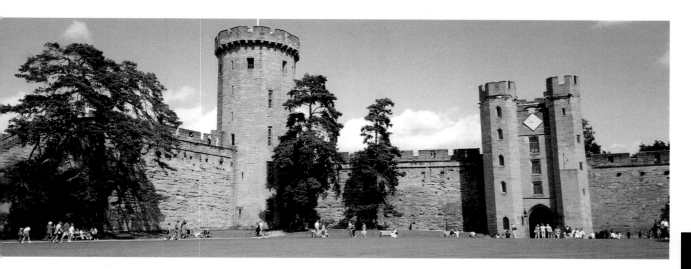

The walls of Warwick Castle, England were shot using a Fujicolor QuickSnap Panorama camera. It is ideal when you want to include a wide subject in one picture without including too much sky and/or foreground. Cheaper panoramic cameras invariably use 35mm negatives cropped top and bottom to produce a long thin image. Here the wide-angle lens has produced converging verticals. These are especially noticeable at the edges – the tower to the right appears to be leaning inwards.

Because the cameras are so simple to operate, quick snaps can be taken with the minimum of fuss. Some cheap disposable cameras, such as the Fujicolor QuickSnap Flash, have built-in flash, which extends their versatility, giving good flash exposures from 1 to 3 metres because the film is quite fast (ISO 400).

CHECKLIST

Treat disposable cameras as fun tools for impromptu snaps (see HAPPY SNAPS).

Consider using these cameras to experiment with shots you wouldn't normally consider taking on a 'serious' camera.

Study the negatives if you think the borders have been cropped and part of the frame has not been printed by the machine's crop.

There is even a waterproof version of a disposable camera, the Fujicolor Marine, which has a big wind-on lever to make it easier to operate underwater. The Action Tracker camera has four lenses and a rotating shutter that snaps four consecutive images. The Fujicolor QuickSnap Panorama produces 10 x 3 inch prints. The Sinomax uses 120mm film with a considerably larger negative area.

Single-Lens Reflex

Unlike a compact camera, a single-lens reflex or SLR enables you to look through the viewfinder and see exactly what will be exposed on the film, thanks to a prism and mirror that direct the light to your eye. During an exposure the hinged mirror flips up and the image in the viewfinder turns black. Before the shutter is released the viewing screen is bright and clear to aid framing and focusing. At the moment the picture is taken, an aperture diaphragm stops down, turning the image dark. Many models have a depth-of-field preview button that stops down the aperture to the set f stop and enables you to see how much of the picture would be in focus (*see* DEPTH OF FIELD).

People are attracted to SLRs because you can change lenses and have the option of controlling exposures. Although some compacts have a zoom lens or two lenses that can be changed at the touch of a button, SLRs accommodate a much greater variety of lenses, from fish-eye (extreme wide-angle) to long telephoto (1000mm or more), as well as enabling you to draw on a larger system of accessories. Unfortunately the major manufacturers produce their own-design bayonet or screw fittings, which are not compatible with those made by their rivals.

A basic manual SLR such as the Zenit 11 leaves you to decide the shutter speed, aperture and focus. To do this you need an understanding of the principles of photography. As the price increases so does the quality of the lens, the range of shutter speeds and the smoothness of the design. Most SLRs have their own through-the-lens (TTL) metering system with light-sensitive cells inside the camera activitating a variety of methods of determining exposure: aperture-priority, shutter-priority and programmed, plus a number of refinements peculiar to specific models (*see* EXPOSURE). Top-of-the-range SLRs place a lot of battery-powered technology at your fingertips.

Manual cameras have less to go wrong. The only battery-operated feature of the Nikon FM2 is the through-the-lens (TTL) metering system. The exposure is determined by looking through the viewfinder and adjusting the aperture or shutter speed until a needle (or LED on many cameras) indicates correct exposure.

An SLR can be fitted with a wide range of lenses. This wide-angle lens has a 2-stop grey grad to leave space for a caption at the top of the picture (*see* GRADS AND POLARIZERS).
Nikon FM2, 28-85mm zoom lens at 28mm, Ilford Delta (ISO 400), 1/250 sec, f22

Within a second you can zoom in to shoot a variation on a scene. Often a tighter composition looks more dramatic.
Nikon FM2, 28-85mm zoom lens at 85mm, Ilford Delta (ISO 400), 1/250 sec, f22

A 500mm mirror lens has a fixed aperture and limited depth of field. The harbour wall is sharp and the boat is starting to appear out of focus. To avoid camera shake with such a long lens, a fast shutter speed and tripod should be used (*see* TELEPHOTOS AND TELECONVERTERS).
Nikon FM2, 500mm, Ilford Delta (ISO 400), 1/2000 sec, f8

CHECKLIST

Buy a camera that feels comfortable to hold and easy to operate. You may find that a camera with built-in motor drive is too heavy.

Decide if you want an SLR with fully automatic exposure or one where you can have some degree of control with a choice of exposure modes.

Do you want built-in flash, a pre-illumination facility to reduce red-eye or a detachable flash unit you can hold away from the camera on a lead?

How important to you is an automatic film advance? Do you need single frame advance or continuous mode?

Decide what special facilities you want, for example autofocus, focus tracking, ability to double-expose, etc.

A camera body with one zoom lens may suit your needs better than a standard lens.

Using an SLR

The joy of using an SLR is the versatility that comes from its huge range of accessories. Choose a camera that does what you want it to, without being too complicated. Microchip technology first brought automation, which made basic picture-taking easy, but took creative control out of the photographer's hands. It then returned the control to the photographer, giving him or her the option of a variety of exposure modes and override systems.

You can make the day-to-day use of your camera easier by following certain routines. When loading film, tear off the end of the cardboard film box with the information about type of film and number of exposures, then insert it into the holder on the back of the camera. Many cameras have a viewing window through which you can read this information on the film canister itself.

If the camera has a manual film advance, you can squeeze in an extra frame or two at the beginning, although you risk losing part of the first shot or, even worse, the film may fail to wind on at all. Check the digital read-out to make sure the film is properly loaded and advancing. It is a good idea to advance the film after each shot so you are always ready for the next.

To avoid camera shake hold the camera firmly and comfortably, then press, not jerk, the shutter release button. When using slow shutter speeds ($1/4$-$1/30$ sec) brace yourself against a tree or post, or lean your elbows on a wall or table. Wrapping the strap around your wrist can help keep the camera steady.

The LCD (liquid crystal display) panel on the top of a Nikon 801 provides information about the metering system, exposure mode, film speed setting, film advance mode, film installation, self-timer, exposure compensation, film speed, shutter speed, aperture/exposure compensation value, frame counter, multiple exposure, film advance and rewind. (a) PH – high speed program, S – single frame shooting; (b) S – shutter-priority auto, CL continuous shooting (low – 2fps); (c) – S – shutter priority auto, CH – continuous shooting (high – 3.3fps); (d) A – aperture-priority auto.

A fast continuous motor drive is essential when photographing sports or any rapid movement. The Nikon F4 has a dial on the motor drive which can be adjusted for speeds up to 5.7 frames per second.
Nikon F4, 28mm, XP2, 1/500 sec, f11

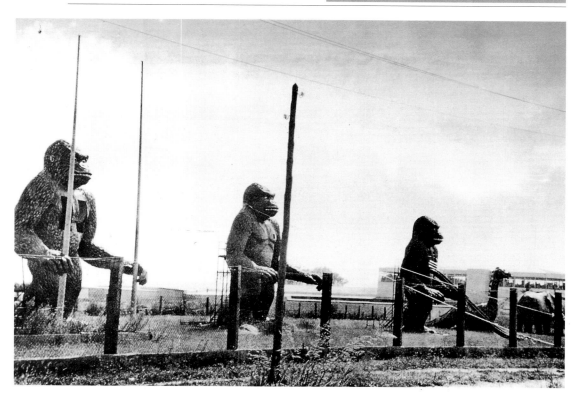

The fast shutter speeds of most SLRs allow shots to be taken of, or from, moving vehicles. These gorilla statues at the roadside in Cadaqués, Spain, were photographed as the car sped by.
Nikon F4, 25-50mm zoom at 35mm, XP2, 1/1000 sec, f8

A long zoom lens on an SLR gives you the freedom to select a small element of a scene and to frame it quickly without disturbing the subject.
Nikon F, 85-250mm zoom at 250mm, Kodak Tri-X (ISO 400), 1/500 sec, f8

CHECKLIST

Master the basic controls first so you can enjoy shooting successful pictures, then experiment with the different modes.

Cover the lens with a hood when not in use, and clean off dust and hairs with a blower brush followed by a lens-cleaning tissue or cloth.

When changing film clean the inside of the camera with a blower brush.

When changing lenses check that the back element of the lens is clean, and that the fitting attaches smoothly.

Try using XP2 film when testing equipment as it can be processed and printed quickly at a high-street colour lab (C41 process).

Exposure

Controlling exposure means regulating the amount of light that reaches the film. In order to expose the film, the aperture must be open for a period of time, which is determined by the shutter speed. The size of the aperture can be varied, as can the length of time it is open. For a given exposure, the slower the shutter speed, the smaller the aperture must be, and vice versa. Each stop increase in the aperture is equivalent to halving the shutter speed. For example, an exposure that calls for a shutter speed of 1/500 sec and an aperture of f4, could equally be 1/250 sec at f5.6, or 1/15 sec at f22. Instead of having to accept an automatic or programmed assessment of the exposure, an understanding of this basic relationship allows you to freeze movement or emphasize it and to use selective focus or increase the depth of field.

In the first shot, on automatic setting, the exposure meter took into account the light background (sun on a rocky cliff), reducing the aperture and rendering the foreground too dark. You could compensate for this by overexposing the shot one or two stops, or by using a fill-in flash. Where there is an even spread of light, as in the shot of the alfresco café overlooking the harbour, an automatic exposure can be used successfully. *Nikon 801, 28-85mm zoom at 60mm (left) and 40mm (above), Ektapress 1600, 1/250 sec, f16*

Shutter speeds between 1/1000 sec and 1/8000 sec froze all movement, whereas a shutter speed of 1/125 sec showed movement in the ball and racket. As the shutter speed was slowed down, the aperture had to be reduced (larger f number) to give the same exposure value.
Far left: Nikon 801, 28-85mm zoom at 85mm, Delta 400, 1/1000 sec, f8
Left: Nikon 801, 28-85mm zoom at 85mm, Delta 400, 1/125 sec, f22

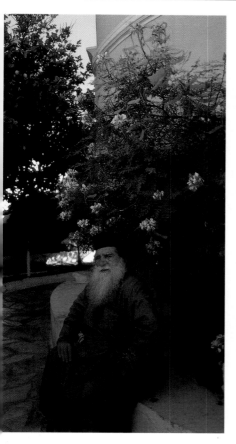

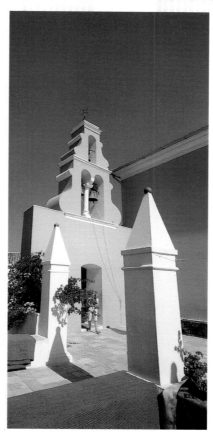

The Greek monk in a Corfu monastery is given greater dignity and fitting solemnity by the saturated colours in the shade, which would be absent from a garish, sunlit scene. Focus must be checked carefully when a wide aperture is used as it gives a limited depth of field. In contrast, the white gateposts and sandy-coloured building in the sunshine produce a bright, vibrant picture in which a small aperture has given a large depth of field.
Far left: Linhof, 65mm, Ektachrome 100 (rated at ISO 150), 1/125 sec, f5.6 Left: Linhof, 65mm, Ektachrome 100 (rated at ISO 150), polarizing filter, 1/60 sec, f16

The first shot shows the result of an automatic exposure. The meter read the bright reflected light and stopped down to produce a dark image.
The second picture is over-exposed by one stop to compensate for this backlighting.
*Top: Nikon FE, Tokina 50-250mm zoom, Kodachrome 64, 200mm, 1/250 sec, f8
Bottom: Nikon FE, Tokina 50-250mm zoom, Kodachrome 64, 250mm, 1/250 sec, f5.6*

Bracketing an exposure means taking shots brighter and darker than the exposure value (EV). In these three frames the first is plus one stop, the second is normal, and the third is minus one stop. By bracketing in tricky lighting situations you increase the chances of success.
*Top: Hasselblad, 500mm, Fujichrome 400, 1/250 sec, f16 (+1 EV)
Centre: Hasselblad, 500mm, Fujichrome 400, 1/250 sec, f22 (normal)
Below: Hasselblad, 500mm, Fujichrome 400, 1/250 sec, f32 (–1 EV).*

CHECKLIST

Override the auto setting and select different aperture/shutter speed combinations.

Try shooting exposures plus one stop, normal, and minus one stop on a test roll, then examine the results.

If there is doubt about the exposure, bracket your shots.

For a dark subject against a light background, or vice versa, take a reading from the subject, lock the exposure (or set the exposure compensation), recompose the frame and shoot the picture.

Practise guessing the exposure value of a scene before looking at the meter reading.

Polaroid Cameras

Producing a photograph within seconds is both exciting and useful. A Polaroid snapshot camera provides an almost instant image that can be used for reference or given as a gift. The camera has a built-in flash that operates even in bright sunlight. The film is more expensive than 35mm print film, but there is no additional development cost and waiting time. A professional Polaroid back is used with many medium and large format cameras in order to assess a scene's lighting, exposure, composition, costumes and props before shooting with a conventional camera. The size of the print is limited to the size of the film, but the largest Polaroid camera produces 20 x 24 inch prints.

The Polaroid Image is a multi-programmable camera with options of time-lapse sequences and up to five exposures on the same piece of Polaroid film. It can also produce a set of either four different or four identical images, suitable for passport photographs. A wide-angle lens can be clipped on the front of the camera.

CHECKLIST

Take Polaroid snaps on your travels to give as presents to people who help you.

Use a Polaroid camera as a visual notebook, for example when looking for suitable locations, potential purchases or to support insurance claims.

Study the print produced using a Polaroid back on a medium or large format camera to check depth of field, composition and movement, and to verify that the shutter is working. Then reshoot on conventional film.

The Studio Express is a useful camera for instant pictures of an image repeated four times or four of different images, on a single $3\frac{1}{4}$ x $4\frac{1}{4}$ inch sheet of colour print film. Called the Model 403 passport picture camera, it is marketed with a range of polyester laminating material for ID cards.

The Cossack outfit was shot on the versatile Polaroid 600SE camera, useful for instant portraits. It has three Mamiya lenses: a 75mm wide-angle, a 127mm normal (used for this shot), and a 150mm portrait lens, each with bayonet mounting and manual aperture settings. It uses either black and white or colour $3^1/4$ x $4^1/4$ inch pack films. Colour Polaroids have warm, rich colours. Being grainless, they can be copied and enlarged.
Polaroid 600SE, 127mm, Polachrome (ISO 40)

Type 665 medium-contrast black and white positive/negative film (ISO 80) provides reusable negatives and is available for Polaroid cameras accepting $3^1/4$ x $4^1/4$ inch pack film.

Polaroid backs can be fitted to several medium and large format cameras, allowing you to take a reassuring test shot of the scene that will give an indication of what the print or transparency film will look like. The colour Polaroid takes one minute to develop; the black and white twenty seconds.
Polaroid 600SE, 127mm, Type 665

Medium Format

Rolls of 120 and 220 film can be used in a variety of cameras with different formats: 6 x 6cm, 6 x 7cm, 6 x 12cm and 6 x 17cm. The Mamiya 6 x 6 and Pentax 6 x 7 look like bulky 35mm SLRs and are held to the eye in the same way. Some roll-film cameras are single-lens reflex, for example Hasselblad; others are twin-lens reflex, including Rollei; and others are rangefinder cameras, such as the Mamiya 6 x 6.

The main advantage of medium format over 35mm is that the image is about four times bigger and therefore does not have to be enlarged so much when printed. This produces higher quality images suitable for magazines, brochures, calendars, greeting cards, posters and advertising work.

Most roll-film cameras are modular in design, with interchangeable lenses, viewing screens and film magazines that can be changed mid-roll. Many accept different formats, including 35mm, 6 x 4.5, 6 x 6 and Polaroid backs.

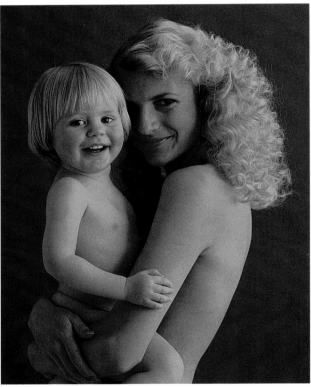

The square format can be cropped vertically (portrait) or horizontally (landscape). If it is being used for an ad or editorial, you can allow for type and a product shot.
Hasselblad, 140-280mm zoom, Ektachrome 200, 1/125 sec, f16

CHECKLIST

When changing film backs, have a blower brush handy to clean out dust, and cotton buds to reach inaccessible crevices inside the camera.

Check that there are no pieces of film backing paper caught inside the back, or hair inside the film gate.

Before a trip or important shoot, expose a film to check lenses, depth of field and shutter, especially at low speeds.

A sheet of newspaper on a wall is an ideal subject for a test shot as newsprint will indicate if the lens is sharp in all four corners.

When you plan to enlarge an image to hang on a wall or turn into a postcard, greeting card or calendar, medium format will give better quality results than 35mm. As the camera looks 'serious', it may help you gain extra co-operation from those you wish to photograph. A larger format is usually too cumbersome on location.
Hasselblad, 60mm, Ektachrome 200, 1/60 sec, f22

A 6 x 4.5 back on a 6 x 6 camera gives sixteen instead of twelve exposures per roll. When shooting portrait or landscape format you have more chances to perfect the shot.
Hasselblad, 60mm, Ektachrome 100, 1/125 sec, f8

Many advertising clients demand images that are at least medium format. This 6 x 6 shot for a German beer company is large enough to retain sufficient quality when enlarged. The image equates the luxury of the 1930s with the product.
Hasselblad, 120mm, starburst filter, Ektachrome 200, 1/125 sec, f11

Wide Cameras

While there has been a rapid growth recently in the manufacture of cheaper panorama cameras (*see* DISPOSABLES AND MINIATURES), the more expensive 35mm and medium format wide cameras have a regular following, especially among landscape enthusiasts. These include the Horizon 202 Panorama, Widelux, Roundshot, Noblex, Linhof 612 and 617 and Fuji 6 x 9 and 617 Panorama/Technorama cameras. The wide view lends a grand, epic quality to a photograph, similar to the effect of a wide screen in the cinema or a giant billboard. With wide-angle lenses, objects close to the lens or the edge of the frame are distorted, which can be exciting or disturbing, according to how it is used. Consider hiring a wide camera to experiment.

The clockwork rotating mechanism in a Widelux camera may result in an uneven exposure. This is especially evident in plain areas such as skies. Have a test roll (C41) processed quickly and reshoot if necessary.
Widelux, 26mm, Kodachrome 64, 1/125 sec, f8

CHECKLIST

Insert fresh batteries to help ensure smooth operation of rotating cameras.

Use a tripod and/or clamp where possible.

Attach a lens shade to mask extraneous light which can be a problem with a wide angle of view.

Experiment with distortion to create striking effects.

The Seitz Roundshot camera is a reflex mirror panorama camera, available in 35mm or 220mm format. The rotating lens is mounted in the centre of the camera. During an exposure the film is rolled on to a cylindrical plate. The Roundshot can be programmed to shoot in 90° increments up to 720° coverage, and is operated via a remote control lead. A 360° shot on the 35mm model uses the equivalent of six 35mm frames, i.e. 6 x 36mm. An aperture of f22 on the fixed focus lens gives a depth of field from 6 ft to infinity. This shot was made at one end of Westminster Bridge in London, using a tripod.
Roundshot, Kodak Ektar 25, 1/15 sec, f16

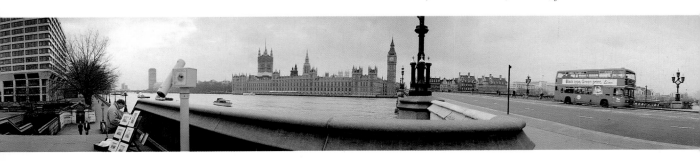

Many subjects, besides landscapes, lend themselves to the panoramic format. The tungsten spotlights in this temple in Malaysia added a warm glow to the daylight. Ideally use a tripod, but this may be frowned on in places of worship. Use a camera that is quick and easy. The Linhof 6 x 12 takes six exposures on 120mm film or twelve exposures on 220mm film. The 65mm lens gives coverage equivalent to a 20mm lens on a 35mm camera.
Linhof 6 x 12, 65mm, Agfa 200, 1/30 sec, f8

Using flash meant that the aperture could be stopped down to emphasize the dramatic sky. A portable Norman flash was masked so it only illuminated the lady. A wide camera gives this shot an epic feel. The lens of the Linhof 6 x 12 has an 8mm lens rise that effectively shifts the lens to help correct converging verticals (*see* SPECIAL EFFECTS LENSES). This tilt means the frame includes two-thirds sky. The camera can be inverted using a tripod thread on the top to include two-thirds foreground and one-third sky.
Linhof 6 x 12, 65mm, Fujichrome 100, 1/125 sec, f16

Large Format

Cameras designed for sheet film are used when top quality images are needed for enlargements, especially in advertising and quality portraits. The film comprises individual sheets rather than a roll. Most common sizes are 5 x 4 inches (12.5 x 10cm), 5 x 7 inches (12.5 x 17.5cm) and 8 x 10 inches (20 x 25 cm). Unlike technologically sophisticated compacts and SLRs, a sheet-film camera is actually quite basic in construction. It has a front panel or 'standard' that holds the lens, shutter and aperture. This is joined by a lightproof bellows to a rear 'standard' that has a ground-glass screen for focusing. By tilting, shifting or swinging the front and rear standards, changes can be made to the field of view, apparent shape of the subject, and planes of sharpness.

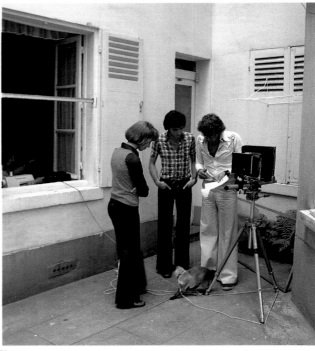

A plate camera is heavy and needs a sturdy tripod to hold it. Besides being expensive to buy and use, large format cameras require a lot of experimentation and precision handling (*see* JEWELLERY). When familiarizing yourself with a large format camera, begin by experimenting with cheap black and white film, even if it is out of date.

By tilting the lens forward it is possible to have the extreme foreground in focus as well as the background. The lens can also be tilted or swung sideways to increase the plane of focus in selected areas.
Sinar 8 x 10, 300mm, 5 sec, f45

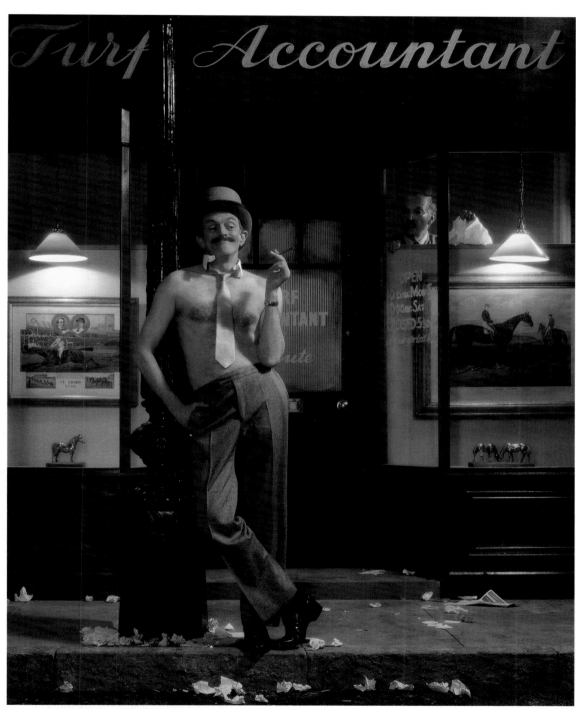

CHECKLIST

The lens can be moved in almost any direction to control focus and correct distortion, for example converging verticals on buildings.

Check in the manual the angles to which the lens can be tilted without causing aberration.

Sheet film is available for 5 x 4 cameras in paper containers called slides. These provide a lightweight way of carrying film on location.

Large sheet film retains small details, such as the discarded betting slips on the ground and the man in the window holding the shirt. There is even considerable detail in the paintings displayed in the windows. The shot was lit by electronic flash, and a long exposure was used to allow the light shades to glow.
Sinar 8 x 10, 360mm, Ektachrome 100, 1 sec, f22

Digital Technology

With the advent of digital technology our perception of cameras and film is being transformed. Digital and still-video cameras are already here, but a few more years' development is needed before conventional film is replaced by digital information. The Kodak Photo CD allows you to have your favourite pictures scanned and transferred to a digital disc can be replayed through a domestic television. The Canon ION still-video camera RC 560 stores up to fifty images on a re-usable 2-inch magnetic disc. Still-video cameras have their uses in conjunction with video recorders and personal computers, but image quality does not yet match that of film.

Still-video images are not ready to compete with the quality of celluloid film. The advantages are that they can be viewed on a television immediately, they are easily filed, and the images can be accessed on a video tape. They are useful when casting character scenes. A particular expression can be 'captured' and printed on a model card.

Here a Canon ION still-video camera provides a spontaneous freeze-frame picture of a group of relatives on the church steps after a confirmation service, but image quality has yet to match that of conventional film. It is just a matter of time before digital pocket cameras are simple, cheap and good enough to make an impact on the mass market.

A computer was used to combine three different-sized transparencies and add subtle detail to this whisky ad. The skyline background (a) was photographed in Toronto, the architect's office (b) was shot on location, on a Saturday when the office was empty, and the foreground pack shot (c) was taken in the studio.
(a) Linhof 6 × 12 with rising front, Fujichrome 400
(b) Hasselblad, 60mm, Fujichrome 100
(c) Sinar 5 × 4, 150mm

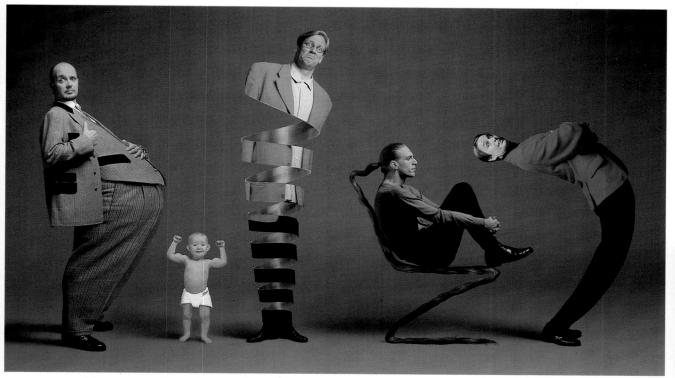

Most photographs are electronically scanned before publication, and the pictures held digitally. In advertising in particular, these images are often manipulated on screen before being printed. Many photo libraries now store and transmit images digitally. To demonstrate the capabilities of the Barco image manipulation system, a London retouching house stretched, bent and coiled four art directors and a baby, using ten separate images photographed by Malcolm Venville.

This eight-part photo composition of a Busby Berkeley style Visa card was 'comped' together. The top shot was set up in the studio with the camera rigged on scaffolding 9 feet from the model.
Sinar 5 x 4, 90mm, Ektachrome 100, 1/60 sec, f22

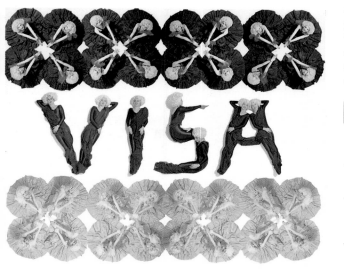

CHECKLIST

Shoot parts of scenes that can be used as backgrounds for product shots, for example clouds and landscapes (see STOCK SHOTS).

Use a fine grain film such as Kodachrome 64 or Fuji Velvia when shooting for 'comping'.

Consider using an inexpensive digital camera, such as the Logitech Fotoman. Images recorded on the camera's disc can be fed into a Mac or PC.

The higher quality Kodak DCS 200 (digital camera system) attaches to the base of an SLR and records images digitally.

A Visa can entertain you in 400 British theatres.

VISA

IT'LL MAKE YOU FEEL AT HOME HERE.

Equipment

Wide, Ultrawide and Fish-eye

You can have a lot of fun with fish-eye lenses (6-9mm on a 35mm camera) when you want to create special effects or weirdly distorted images. Ultrawide lenses (10-20mm) are extremely useful in very tight or overcrowded situations, and also when you want to show the subject in close-up at the same time as including the background in sharp focus. Many professional photographers, especially photojournalists, use a 24mm, 28mm or 35mm as their 'normal' lens. They know that getting in close with a wide-angle lens often produces a more striking picture than a 50mm lens will. Fish-eye lenses produce barrel distortion of all the straight lines, more noticeable closer to the edge of the frame. Tilting the camera produces dramatically converging verticals.

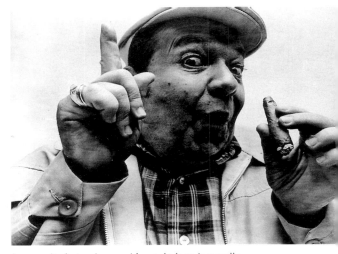

A portrait shot using a wide-angle lens is usually more dramatic than flattering, accentuating the nose or chin. Here, comic actor Stubby Kaye's hands are close to the lens and dominate the picture. The 28mm lens has a coverage of 74°. *Nikon F2, 28mm, Kodak Plus-X (ISO 125), 1/60 sec, f22*

The distortion produced by a fish-eye lens can be quite outrageous. Only a slight change of viewpoint will cause a marked change in composition and the juxtaposition of elements in the picture. The large depth of field keeps foreground and background in focus (*see* DEPTH OF FIELD). With this wide angle of coverage you should be aware of the likelihood of including your own feet in the shot. *Nikon FE, 8mm, Ektachrome 200, 1/8 sec, f8*

CHECKLIST

Unless you have reason to include them, make sure your feet are not in the frame.

For a great sense of involvement move in very close when shooting with wide-angle lenses.

Experiment with various viewpoints, tilting the camera up and down for dramatically different perspectives.

Use a wide-angle lens for candid photography where careful composition is difficult, then crop.

Include foreground, middle and distant objects to give a wide-angle picture a sense of depth.

Remember to cancel a built-in filter after use.

Most cameras have a depth of field preview button that stops down to the aperture set to indicate the range of sharpness.

A 20mm ultrawide lens has an angle of view of 94°. Because converging verticals are exaggerated with a wide-angle lens, domes and spires lean noticeably inwards. Distortion is minimal in subjects situated near the centre of the image.
Nikon 301, 20mm, Fujichrome 100, 1/250 sec, f11

A 16mm lens produces a full-frame picture with a 170° angle of view. The horizon is straight only if positioned across the centre of the image. In the lower half of the frame it will curve up at the edges and in the top half it will curve downwards. This can be used to dramatic effect, but can look gimmicky if overdone.
Olympus OM-2n, 16mm, Kodachrome 64, 1/250 sec, f16

Standard Lenses

On a 35mm camera the 50mm lens is commonly called a standard lens, and many cameras are sold with one. Increasingly, cameras are supplied as body only or with a zoom lens. The standard lens, which covers approximately the same angle of view as the human eye and has no perspective distortion, generally has the best optical quality, with the optimum arrangement of lens elements. It is usually cheaper, because it is mass produced, and faster (has a wider aperture) than longer or shorter lenses. The focal length of a normal or standard lens is approximately equal to the diagonal measurement of the negative. As this is 43mm for a 35mm negative, the standard lens should, in theory, be 43mm. Larger format cameras have longer focal length standard lenses, such as 80mm for 6 x 6 (2¼) format.

Where there is no reason to keep your distance, to change the perspective or to throw the background out of focus, a standard lens is ideal, as with this captive audience.
Nikon FE, 50mm, Kodacolor 200, 1/90 sec, f8

The wide aperture of a fast standard lens enables you to shoot in low light. The resulting selective focus can achieve a striking result (*see* DEPTH OF FIELD).
Nikon, 50mm, Ektachrome 200, 1/30 sec, f2

CHECKLIST

As a standard lens has a similar angle of view as the human eye, it is ideal for those beginning photography.

Remember that images can be cropped to produce more dramatic shots.

Cover shots both vertically and horizontally to make them more versatile (see STOCK SHOTS).

If you are accustomed to the luxury of several focal lengths, try restricting yourself to a standard lens as a useful exercise for training your eye to seek out images within that perspective.

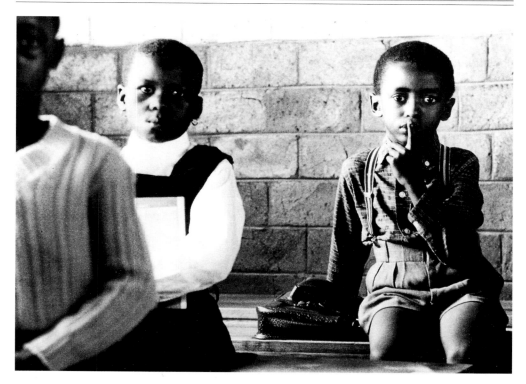

A shot taken with a good quality standard lens can be cropped and enlarged and still give a clear, sharp image. The full frame shows a pupil in a classroom situation, perhaps considering the answer to a question from the teacher. By cropping the image and showing only the boy, the picture tells a different story, with the boy becoming isolated and slightly anxious (*see* CROPPING).
Nikon F2, 50mm, Kodak Tri-X (ISO 400), 1/60 sec, f2

A standard lens is quick to capture most scenes and events, separating the subject from the background more noticeably than a wide-angle lens does.
Nikon FE, 50mm, Kodacolor 400, 1/500 sec, f8, printed on Kodagraph paper

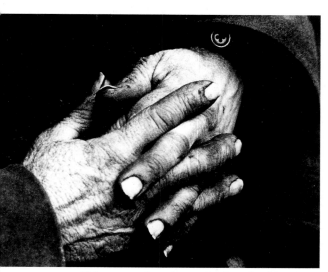

This uncomplicated portrait of a pair of hands with interlaced fingers is an ideal subject for a standard lens. A close-up shot increases the effect of selective focus, concentrating attention on the fingers.

Telephoto and Teleconverters

Telephoto lenses appear to compress linear perspective, often producing a flat, two-dimensional effect. This can be flattering in portrait photography. Telephoto lenses are used to isolate a small proportion of a scene or to get closer to inaccessible subjects in candid, sport and wildlife photography. At a given aperture they have a smaller depth of field than wider lenses, and are often used to help emphasize a subject by throwing its background out of focus. A fast shutter speed or tripod is used to minimize camera shake. As a rule of thumb, use a shutter speed at least as fast as the focal length of the lens. For example, use 1/250 sec or faster with a 150-250mm lens; 1/500 sec or faster with a 300-500mm lens; and 1/2000 sec if it is windy.

Focus is critical with very long lenses. If accurate, a good-quality lens will pick up detail you may not have noticed with the naked eye, such as the television aerial at the side of the right hand tower of the Houses of Parliament in London. Teleconverters, which fit between the lens and camera, are a light and inexpensive way of extending the apparent focal length of existing lenses. A x2 converter doubles the length, but requires an additional two stops exposure. A x3 converter trebles the effective focal length of the lens, with a three stop exposure loss. When a converter is added the quality deteriorates and there is a loss of definition. (The right-hand tower in the second shot is the left tower in the first shot.)
Left: Hasselblad, 500mm, Agfa RS 50 Plus, 1/30 sec, f8
Right: Hasselblad, 500mm, Agfa RS 50 Plus, 1/8 sec, f8

CHECKLIST

Use a fast shutter speed and/or tripod, clamp or beanbag to avoid camera shake. Using the self-timer allows the camera to settle before the shot is taken.

As a mirror lens has a fixed aperture, the exposure can be changed only by altering the shutter speed.

Check the subject is sharp, as focus is more critical with long lenses.

With an autofocus lens aim at a surface with texture to enable the autofocus mechanism to operate.

When using an extreme long-focus lens it may be quicker to survey the scene with small binoculars before framing the shot.

Equipment

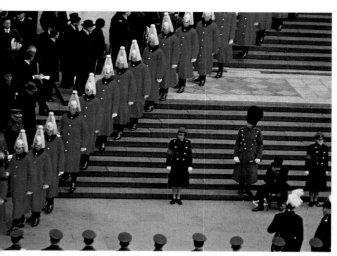

At formal occasions and ceremonies it is often difficult to get close to the subject. At Churchill's funeral, Lord Attlee was photographed from a high vantage point. The extreme long lens has compressed the line of soldiers on the left.
Nikon FE, 600mm, Ektachrome 200, 1/125 sec, f8

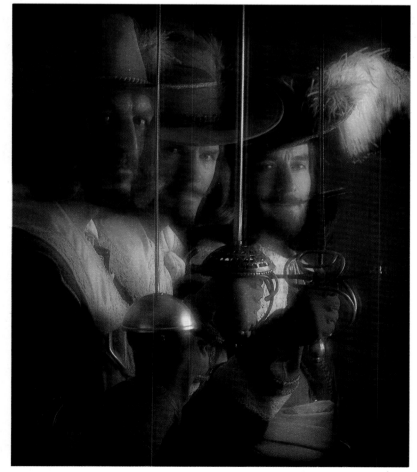

A medium telephoto lens is ideal for portraits as it does not accentuate facial features and can be used without crowding the subject. The long lens and small aperture have thrown the background out of focus.
Nikon FE, 105mm, Kodak Tri-X (ISO 400), 1/125 sec, f2.5

Perspective is compressed with a medium telephoto lens, emphasizing the unity of the Three Musketeers. A sidelight accentuates their noses, making them look more determined.
Hasselblad, 150mm, Ektachrome 200, Diffuser One, 81C filter, 1/60 sec, f32

Zoom Lenses

Zoom lenses have transformed the time-consuming business of changing lenses into a quick and easy action. By zooming in or out, a series of pictures can be composed and shot rapidly and accurately, allowing you to consider several alternative views of a subject in the time it takes to change a lens (*see* ZOOM IN, SEQUENCES *and* WEDDING SEQUENCES). On most lenses the focus remains undisturbed when zooming in and out, so refocusing is not necessary. As a bonus most zoom lenses incorporate a macro facility (*see* MACRO AND CLOSE-UP RINGS). The quality of zoom lenses is now comparable to that of fixed-focus lenses.

A zoom lens makes it easier to look at different options within a single scene. First, a wide shot gives the context. The, by zooming in, small elements of the scene are isolated. For *contre jour* shots, flare can be more of a problem than with a fixed-focus lens because a zoom contains more lens elements.
Left: Nikon 801, 50-300mm zoom at 50mm, Ektapress 1600, 300mm, 1/4000 sec, f5.6
Centre: Nikon 801, 50-300mm zoom at 300mm, Ektapress 1600, 50mm, 1/4000 sec, f5.6
Right: Nikon 801, 50-300mm zoom at 300mm, Ektapress 1600, 300mm, 1/1000 sec, f11

CHECKLIST

Zoom into the main subject to focus, then zoom out to compose the picture.

Experiment with the unusual effects created when zooming during the exposure (see ZOOM IN).

Handle zoom lenses with extra care as they have more elements than a fixed focus lens.

Consider using lens shades and filters, especially grads, to reduce flare (see GRADS AND POLARIZERS).

A versatile pair of zoom lenses might be a 25-50mm and 50-250mm with macro. If you have only one zoom lens, a 28-85mm zoom and x2 converter will cover most situations (see TELEPHOTOS AND TELECONVERTERS).

A zoom gets in close, when there is no time to change lenses.
Nikon FE, Tokina 50-250mm zoom at 250mm, Ektachrome 200, 1/500 sec, f8

A zoom lens made quick framing possible, capturing the range of expressions on the boys' faces, while also making a good composition.
Nikon, 43-86mm zoom at 43mm, Kodak Tri-X (ISO 400), 1/60 sec, f5.6

Action shots are easier with Minolta's Image Lock system. By pressing a button on the lens, the zoom lens determines the size of the object as it approaches. It follows the subject, keeping it in focus and the same size.
Minolta Dynax 7xi, 35-200mm, Polaroid Instant 400 black and white transparency, 1/250 sec, f11

Special Effects Lenses

Specialist equipment allows you to explore photography beyond the usual range. Underwater cameras, for example, open up a whole new environment (*see* BENEATH THE WAVES). UV lenses, corrected for ultraviolet light, are used in scientific photography where ultraviolet is the light source. Medical lenses with built-in ring flash are used to photograph insects and medical subjects. Various lenses improve the image, such as a microscope lens and a perspective correction or shift lens, whilst others distort the image. Front projection involves using a half-silvered mirror in front of a lens to combine two images.

The perspective correction or shift system is used in architectural photography to avoid converging verticals. With the camera horizontal, part of the lens can be shifted up or down. The picture shows Hasselblad 40mm and 100mm lenses with the shift system. A 28mm and 35mm shift lens is made by Nikon for 35mm cameras.

CHECKLIST

Large prints of microscope shots of coloured crystals make exciting murals.

Ask a hire studio for a demonstration of a front projection system using your own transparencies.

Hire a shift lens to assess its usefulness before buying one.

Shoot tests using a shift lens before tackling an assignment.

Photographic magazines often feature new special effects you can adopt or adapt.

Anamorphic attachments 'squeeze' the picture to fit 50 per cent more image into the frame. A bird's-eye attachment contains a spherical mirror facing the lens and produces a circular image with a black spot in the centre.

Several makes of microscope are fitted with a photo-tube or camera port to which an SLR camera body can be attached. By sliding a lever, a prism within the microscope can then be moved to divert the light beam from the eyepieces to the camera. When using colour film, care should be taken to ensure correct colour balance either by using tungsten film or by using a white light source with daylight film.

When the camera is tilted up to photograph tall buildings the vertical lines converge, creating a dramatic but unrealistic effect. This is accentuated with a wide-angle lens. Although photographed from the same position, the converging verticals are corrected in the second shot with the use of a perspective control lens.
Hasselblad, 40mm, Agfachrome 50, 1/15 sec, f22 (above) without shift lens, (left) with shift lens

Front projection enables you to photograph someone against an exotic background without leaving the studio. From the same position as the camera, but at right angles to it, a flash-powered projector projects a transparency on to a half-silvered mirror in front of the camera lens. The image is deflected along the lens axis and on to a highly reflective screen behind the subject.
Hasselblad, 80mm, Ektachrome 100, 1/60 sec, f11

Macro and Close-up Rings

A macro lens enables you to photograph something life size. An eye, for example, will fill the frame of a 35mm negative or transparency. Many zoom lenses have a macro built-in. A telephoto lens with macro can take a full-frame shot of a timid butterfly. Depth of field is very small on the macro setting (*see* DEPTH OF FIELD), and although it can be increased a little by stopping down to a small aperture, focus is still critical. An ordinary lens can be converted into macro by adding a close-up attachment or close-up rings. A bellows unit gives more control over focus. Using a macro lens or close-up attachment, copies can be made of transparencies on a light box or against a window. Place a layer of tracing paper behind the transparency to diffuse the light and give even illumination. To bring a slide show to life, a video camera with macro setting can be used to copy 35mm slides, which will then fill the television screen.

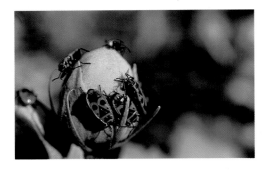

A macro lens can get a closer view of bugs and insects, thereby revealing their intricate decoration. *Nikon FE, Tokina 50-250mm zoom on macro, Kodachrome 64, 1/125 sec, f8.5*

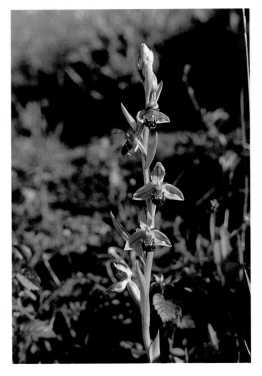

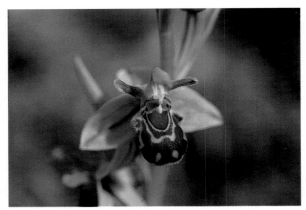

A standard lens was used for the first shot of the bee orchid then three close-up rings were attached behind the lens for the closer shot. *Left: Olympus OM-2n, 50mm, 1/60 sec, f11* *Above: Olympus OM-2n, 50mm with x3 close-up ring, 1/60 sec, f11*

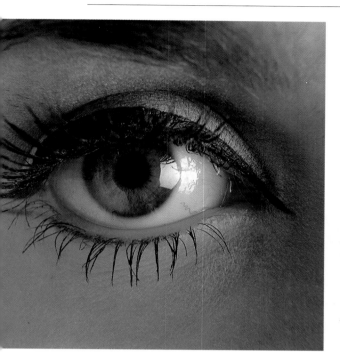

When photographing eyes be aware of the reflections of lights, windows or flash, as here (*see* HANDLING ANIMALS). Where possible, use a light source that looks effective when reflected, such as a ring flash or a shaped mask over the flash. *Hasselblad, close-up extension, close-up ring and close-up 250mm lens, 1/250 sec, f32*

A telephoto lens with macro facility takes you close into the subject without intruding. *Nikon FE2, Tokina 50-250mm zoom on macro, Ektapress 1600, 1/250 sec, f16*

CHECKLIST

Focus is critical with macro; use a small aperture and keep the camera and subject as still as possible. Ideally use a tripod.

Use a magnifier to check flowers or someone's face for imperfections which may not be obvious to the naked eye.

Equipment

Depth of Field

Mastering depth of field is like mastering a tennis serve or golf swing. Immediately you're in a different league. By controlling which parts of a picture are in focus, you can create great depth and drama, as well as direct the viewer's attention to particular subjects. Basically, depth of field is the acceptably sharp area in front of and behind the plane of focus. The smaller the aperture, the greater the range of focus. The larger the aperture (small f stop), the smaller the depth of field and the more selective you can be about which subjects are in focus.

Untidy and distracting backgrounds can be thrown out of focus and individuals can be picked out from a group. Wide-angle lenses give a greater depth of field than telephoto lenses. Many lenses indicate the depth of focus at different apertures. Most single lens reflex cameras have a depth of focus preview button to enable you to assess visually which areas are in focus (*see* TELEPHOTO AND TELECONVERTERS, ZOOM LENSES *and* READING PICTURES).

By using a wide-angle lens and a small aperture, a very large depth of focus can be achieved. The shire horses are in focus from about 1 foot from the lens to 30 feet away (*see* WIDE, ULTRAWIDE AND FISH-EYE LENSES).
Nikon FM, 28mm, Ektachrome 200, 1/60 sec, f22

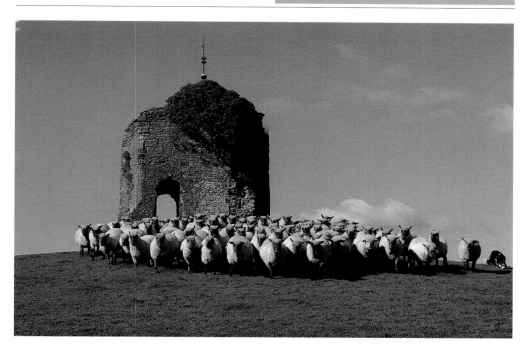

The lens was focused on the sheepdog to ensure that it was pin-sharp, and a small aperture was used to give a substantial depth of field. A fairly fast shutter speed was needed to freeze the movement of the subject and to avoid camera shake.
Nikon, 85-250mm zoom at 150mm, Ektachrome 200, 1/250 sec, f11

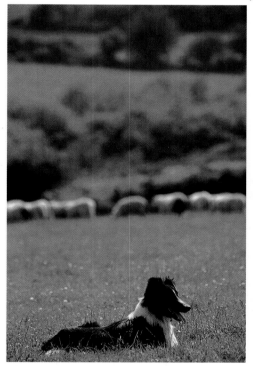

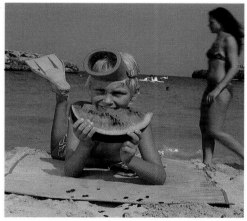

A fairly wide aperture concentrates attention on the boy and watermelon. The lady and the background add to the feeling of place without distracting from the main subject.
Hasselblad, 250mm, Ektachrome 100, 1/125 sec, f8

If a small aperture had been used for this shot, the background would have been in focus and the importance of the dog diminished. The wide open lens throws the sheep out of focus.
Nikon FE, Tokina 50-250mm zoom at 250mm, Kodachrome 64, 1/500 sec, f4

CHECKLIST

To increase the depth of field select a smaller aperture (larger f stop) and slower shutter speed. Note that a compact camera with a wide-angle lens (35mm or 40mm) will have a good depth of field.

Use a tripod or clamp to avoid camera shake with slow shutter speeds.

If precise measurements are required, take a small tape measure.

Film Speed

All films have a speed rating that indicates how fast they react to light, i.e. how quickly an image forms on the emulsion. The speed is measured by two systems devised by the American Standards Association (ASA) and the German Industrial System (DIN). Today, the International Standards Organization (ISO) is used universally. This combines both ASA and DIN numbers. Film rated ASA 200 or 24° DIN is now ISO 200/24°. The higher the number, the faster the film and the more sensitive it is to light. A medium-speed film rated ISO 100 is twice as sensitive to light as a film rated ISO 50, and half as sensitive as one rated at ISO 200. Slow film (ISO 25-50) has a very fine grain structure producing pin-sharp images ideal for enlargements beyond 16 x 20 inches. Generally, as the film speed increases the grain becomes coarser and the tonal range decreases. Most films are now DX coded; the camera 'reads' and sets the film speed.

Where you want to create an impressionist picture showing movement as a blur, a slow shutter speed is necessary. In bright conditions a fast film requires a fast shutter speed, even at minimum aperture, so a slow film must be used.
Nikon, 105mm, Kodachrome 25, 1/8 sec, f22

Fine-grain medium-speed film (ISO 64-100) produces rich, saturated colours, and is ideal for most general uses, except for fast action and low light photography.
Nikon, 25-50mm zoom at 30mm, Kodachrome 64, 1/60 sec, f8

CHECKLIST

Faster films (ISO 400-1600) are more vulnerable to fogging by airport X-ray machines, especially as X-rays have a cumulative effect if a film passes through several machines. Lead-lined X-ray-resistant bags are available, but ineffective if the power is increased in order to view the contents of the bag.

Many films can be 'pushed' or uprated by up to three times to increase the film speed. If pushed three stops, ISO 100 becomes ISO 800 or ISO 1600 becomes ISO 6400 (see COLOUR TRANSPARENCY).

Don't be caught out by non-DX coded films, such as Polaroid reversal film.

The first picture, shot on a very fine-grain film, is sharp and renders colours accurately. The second, on grainier fast film, shows a purple cast. It is contrasty, with less detail in shadow areas.

Above left: Nikon AW, 35mm, Fuji Velvia (ISO 50), auto-exposure
Above right: Nikon 801, 28-85mm zoom at 35mm, Fuji RSP (ISO 1600 rated at ISO 1400), 1/500 sec, f22

Equipment

To help avoid the problem of camera shake when using very long lenses, a fast film will allow you to use a faster shutter speed. These waves were shot on a windy day with a hand-held mirror lens.
Nikon, 500mm, Fujichrome P1600D (rated at ISO 1400), 1/4000 sec, f8

Black and White

Many of photography's great images are in black and white. Besides possessing an appeal of its own, black and white film gives you the chance to experiment and learn basic darkroom processes (*see* PROCESSING BLACK AND WHITE). When shooting in black and white it is important to remember that a scene full of different colours can appear grey if the tones are similar. Bright red, blue and green can turn out the same shade of grey unless suitable filters are used to increase contrast. A red filter will lighten the red areas of the picture and darken other colours, so that lipstick, for example, will register as white. A green filter will lighten green areas. Yellow and orange filters are used to darken blue skies and emphasize white clouds, as well as to diminish blemishes on human skin by lightening the spots.

Medium-speed black and white film gives very sharp detail, here enabling a good range of tones on comic actor Arthur Mullard's face to be recorded, with subtle nuances of light and shadow. *Hasselblad, 120mm, Kodak Plus-X (ISO 125), 1/125 sec, f32*

A fast film with considerable grain gives this costume drama a reportage feel. Gritty black and white images are often used when depicting macho, manly subjects. Fast film enables you to use a fast shutter speed and freeze the action. *Hasselblad, 60mm, Kodak Tri-X (ISO 400), 1/250 sec, f8.5*

CHECKLIST

Ilford XP2 is a black and white film that can be processed in one hour at any colour lab, using the C41 process. It can then be printed in different colours as it is on colour paper, producing a similar effect to toning.

A Cokin filter holder is adaptable and quick to use, enabling you to slot in several filters at a time.

If your camera does not have a built-in meter, remember to allow extra exposure when using colour filters.

Bracket exposures for high contrast scenes.

Use faster, grainier films to produce evocative, creative shots.

As there is no colour to contribute to the composition, the shape and design of a picture become more important in black and white.

Ilford XP2 film can be processed within an hour, using the C41 process.
Hasselblad, 50mm, Ilford XP2 (ISO 400), 1/15 sec, f22

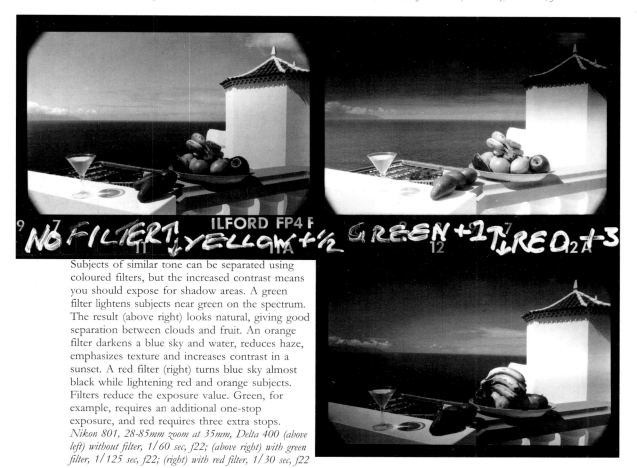

Subjects of similar tone can be separated using coloured filters, but the increased contrast means you should expose for shadow areas. A green filter lightens subjects near green on the spectrum. The result (above right) looks natural, giving good separation between clouds and fruit. An orange filter darkens a blue sky and water, reduces haze, emphasizes texture and increases contrast in a sunset. A red filter (right) turns blue sky almost black while lightening red and orange subjects. Filters reduce the exposure value. Green, for example, requires an additional one-stop exposure, and red requires three extra stops.
Nikon 801, 28-85mm zoom at 35mm, Delta 400 (above left) without filter, 1/60 sec, f22; (above right) with green filter, 1/125 sec, f22; (right) with red filter, 1/30 sec, f22

Colour Print

One big advantage of colour print film is that it has a good exposure tolerance of plus or minus two stops. Over- or underexposed prints are automatically corrected during printing. Colour print film is also called negative film because a negative image forms on the film when it is processed. The picture has to be printed before you see a positive image, unlike transparency or slide film which does not require this additional stage. Most people use colour negative film for snaps of family, friends and holidays. It is also used for high quality portraiture and exhibition prints. Speeds for colour print film range from ISO 25 to ISO 3200. Most print film can be processed within an hour using the Kodak C41 process or similar.

Colour prints are particularly successful when the subject contains well-lit, rich, colours. Strong images can be produced by isolating colourful details or focusing on a complementary combination of colours (*see* DETAILS *and* COLOUR CO-ORDINATION).
Nikon AW, 35mm, Konica 100, auto-exposure

A hint of colour in what is essentially a mono scene can produce a pleasing effect. The subtle brown and fawn tones give the picture depth and character. Even at ISO 400 the grain is minimal.
Nikon 801, 28-85mm zoom at 28mm, Kodacolor 400, 1/250 sec, f8

Colour negative film can be used to create very satisfying monochrome or sepia images. This French cloudscape was printed in black and white, then sepia toned (*see* A NEW LOOK AT OLD PICTURES).
Nikon AW, 35mm, Kodacolor 400, auto-exposure

A fast daylight film produces soft orange/brown colours in tungsten light. The grain is noticeable on enlargements bigger than 6 x 8 inches. The softening effect of fast film on skin can be flattering (*see* TUNGSTEN AND FLUORESCENT LIGHTING).
Nikon 801, 105mm, Ektapress 1600, 1/125 sec, f2.8

CHECKLIST

Kodak Ektar 25 is excellent for very fine detail in cityscapes or crowd scenes.

Kodacolor 400 is a good all-purpose negative film. Ektapress 1600 can be pushed two stops to ISO 6400.

Use a faster film (ISO 400-1600) to shoot glamour/beauty as the grain softens the complexion.

Colour negatives make very good black and white prints.

Colour does not necessarily mean 'loud' (see MONOTONE).

Although direct flash (above left) creates a harsh, flat illumination, it brings out more realistic colours. Without flash (above right) the shot is grainy and atmospheric, lit by the soft, warm glow from the orange lamp.
Nikon AW, 35mm, Ektapress 1600

Equipment

Colour Transparency

Transparency, slide or reversal film produces a positive image that is finer grained and therefore higher quality than print film of the same speed. Transparencies are preferred by most publishers and printers. They are used in audiovisual displays and can be printed by a lab or in a domestic darkroom (*see* COLOUR PROCESSING AND PRINTING). Slide film can be balanced for daylight, tungsten or infra-red (*see* INFRA-RED AND TUNGSTEN FILMS *and* TUNGSTEN AND FLUORESCENT LIGHTING). Slide-film speeds range from ISO 25 to ISO 1600. In general, sharpness and colour saturation decrease with increased speed.

You can increase the effective film speed, contrast and graininess of E6 slide film by uprating or 'pushing' the film, making it more sensitive to light. Uprating film enables you to shoot in low light and/or to stop movement.

Besides bringing out vibrant colours with a sharp, fine grain, slow film captures small detail, as in the road signs here.
Nikon, 25-50mm zoom at 35mm, Kodachrome 25, polarizer, 1/125 sec, f5.6

When you want to emphasize the rich saturation of colours a slow film is ideal. With static subjects you are able use a slow shutter speed when light is poor.
Nikon AW, 35mm, Fuji Velvia (ISO 50), auto-exposure

CHECKLIST

Judging the correct exposure is more critical with tranparency film than with negative film.

Label rolls of film if they are pushed or pulled.

Experiment by pushing film one, two, three or four stops in difficult lighting conditions.

Pushing beyond three stops is not recommended by film manufacturers. When Kodachrome is uprated or downrated two stops the results are not satisfactory.

'Pulling' or downrating a film may be necessary if the film speed is accidentally set too slow, thus overexposing the film. Pulling one stop can be corrected at the processing stage by decreasing the development time. This creates a light blue cast.

A warm salmon 81B filter will help reduce the magenta cast which occurs when a film is pushed two or more stops. A 20 yellow filter will help correct the cast on a film pulled (downrated) two stops.

The graininess of fast film can enhance a shot by giving it atmosphere. Here, the flare over the roof created by shooting into the light adds to the enchantment of the place. If you are not sure of the exposure, most labs will carry out a clip test. They develop the first few frames of your exposed film and assess those before processing the rest.
Linhof 6 x 12, 65mm, Agfa 1000, 1/125 sec, f22

Equipment

By uprating a fast film a lot of shadow detail can be included even in a dimly lit scene. To uprate film by one stop, set the film-speed dial to twice that indicated on the film canister. The film will be underexposed and can be corrected by increasing the development time.
Linhof 6 x 12, 65mm, Agfa 1000 (rated at ISO 2000), 5 sec, f32

A very grainy image with muted tones is created by pushing fast film by two or more stops. In a shot full of atmosphere, the blue evening light contrasts with the warm lamp-lit interior. Image definition is progressively sacrificed the more a film is pushed (*see* FILM SPEED).
Linhof 6 x 12, 65mm, Agfa 1000 (rated at ISO 4000), 1 sec, f22

Polaroid

Polaroid produce a wide variety of films that incorporate the chemicals necessary to process them. The snapshot film is popular at parties and on holiday. Peel-apart instant film is used by professionals to assess exposure, props and so on in a scene before shooting on conventional film (*see* POLAROID CAMERAS). Polaroid also produce 35mm instant transparency films developed in a purpose-made processor that can be used on location. Slides are dry and ready for viewing within three minutes. These films include PolaChrome and High Contrast PolaChrome colour films; and PolaPan continuous-tone and PolaGraph high-contrast black and white films.

Print film, also available in black and white or colour, come in $3^1/_4$ x $4^1/_4$ inch or 5 x 4 inch packs, or as sheet film to fit 5 x 4 or 8 x 10 holders. Most commonly used film ranges in speed from ISO 40 to ISO 800.

The Polaroid AutoProcessor is used to develop 35mm instant slide film, which is exposed in a normal 35mm camera. Because it is hand-powered, it can be used on location.

This demonstration of fibre optics lighting was shot on PolaGraph 400 high-contrast black and white film.

The double exposure of a man with a crop was shot on medium-contrast colour print film. An outline of the first exposure, on the left, was traced on the viewing screen, including the grille effect produced with a window gobo over a focus spot (*see* STUDIO LIGHTING). A second exposure of the man's face was made in this 'window' area. The surreal effect was created by processing the image with a sheet of Polaroid Type 804 black and white film.
Sinar 8 × 10, 360mm, Polaroid Type 809 (ISO 80) and Type 804 (ISO 100), 1/60 sec, f32

CHECKLIST

Because Polaroid film is not DX coded, remember to set the film speed manually when loading a conventional camera.

Handle Polaroid transparency film with care as it scratches easily. Special slide mounts that prevent scratching are available.

Polaroid film provides an instant assessment of a scene, invaluable when on location away from a processing lab.

PolaPan is a medium-contrast 35mm black and white slide film. It is useful when ascertaining general picture quality, and has a similar depth of field to Plus-X. To achieve the semi-solarized effect, the Multigrade print was developed in Agfa Neutol for 15 minutes.
Nikon F4, Tokina 50-250mm zoom at 65mm, PolaPan 125, 1/250 sec, f11

Infra-red and Tungsten Films

Certain films developed for specialist uses also offer interesting creative possibilities. Tungsten film can be used with flash and filters. Infra-red film, although unpredictable in inexperienced hands, can produce surreal effects. Designed for aerial surveys, infra-red black and white and infra-red false-colour film are sensitive to infra-red and visible light, but require filters to be effective. A visually opaque filter used with black and white infra-red film transmits infra-red wavelengths only. A yellow filter is recommended for false-colour infra-red film, although it is worth experimenting with different coloured filters. As metering systems respond to visible light, exposure is rather hit and miss. In normal daylight conditions start by rating the film at ISO 100 and bracket +/− two stops. Focus black and white film using the infra-red focusing index marked on the lens. Focus normally with colour film, but use a small aperture. Automatic cameras should give correct focus if a wide-angle lens is used giving a large depth of field.

Different effects can be achieved using coloured filters with infra-red colour film. It records the invisible infra-red light which is reflected by the subject. Bracket exposures, with an emphasis on under-exposure to bring out the colour differences. Infra-red colour film increases contrast.

Left: Nikon, 28mm, Ektachrome Infra-red, red filter, 3 sec, f22
Centre: Nikon, 28mm, Ektachrome Infra-red, green filter, 1 sec, f22
Right: Nikon, 28mm, Ektachrome Infra-red, yellow filter, 1/2 sec, f22

With the camera on a tripod, a long exposure recorded the '25' created with cigarette lighters during an anniversary party (*see* FIREWORKS AND FUNFAIRS). A yellow filter over the flash helped restore flesh tones altered by the artificial light film.
Nikon 801, 28-85mm zoom at 28mm, Kodak tungsten 340, 4 sec, f5.6

Tungsten film was used with fill-in flash covered by two layers of yellow gel to 'clean up' the foreground in this scene lit by both tungsten and fluorescent light (*see* TUNGSTEN AND FLUORESCENT LIGHTING).
Nikon, 25-50mm zoom at 25mm, Kodak tungsten 160, 1/160 sec, f4.5

If you have a dedicated flashgun/camera which incorporates a 'rear curtain' function you will be able to show movement by combining available light with flash. During a two-second exposure, zoom in and the flash will be triggered at the end of the exposure.
Nikon 801, 28-85mm zoom, Kodak tungsten 340, Nikon, SB24 flash, 2 sec, f8

Equipment

CHECKLIST

Load and unload infra-red film in complete darkness, as it is vulnerable to fogging.

Experiment with varying exposures and filters. Start by rating the film at ISO 100 with a Wratten 12 filter for colour film, or a Wratten 87 for black and white.

Use strong filters for dramatic effects.

People get bored quickly when posing so experiment with difficult shots before involving them.

To avoid yellow/orange pictures, use tungsten film when the main light source is tungsten.

When using tungsten film, warm up the blue and green casts of daylight and fluorescent light with a 10M (magenta) and 81B filter.

Exposure Meters

Most popular 35mm cameras have their own metering systems that are quite adequate for the majority of photographic situations. Some through-the-lens (TTL) meters take an average overall reading. Centre-weighted TTL meters have a bias towards the central area. Spot meters concentrate on one small area. Multipattern meters give emphasis to different areas within the frame. A separate, hand-held direct or reflected light meter measures light that bounces off the subject, as does a TTL meter. An incident light meter is pointed towards the light source to measure the amount of light falling on the subject.

Take exposure readings from the sky and from the middle of the building, then expose halfway between the two.
Nikon 801, 28-85mm zoom, Kodacolor 200, 1/125 sec, f11

A spot meter is a direct (reflected light) meter that takes a reading from just a 1° angle of view. It can be used to take precise readings from several spots within the frame, then give an average exposure. It is particularly useful when photographing spotlit stage performances, backlit subjects, or animals at a distance.

A spot meter was used to read the exposure of the background and of the dog. The shot was exposed midway between the two.
Nikon 801, 28-85mm zoom at 40mm, Ektapress 1600, 1/125 sec, f5.6

A colour temperature meter is helpful when shooting with mixed light sources. It indicates which filters are needed for correct colour balance by measuring the 'colour' of the light in degrees Kelvin.

This spot meter takes direct (reflected light) and flash readings. The versatile and robust Lunasix meter can take direct (reflected light) and incident light readings as well as flash readings. An incident light reading is not affected by the brightness of the subject itself.

A Lunasix meter indicated that the contrast between the dark and light areas was such that fill-in flash was needed to bring out detail in the shadow areas.
Nikon F2, 28mm, Kodachrome 64, 1/125 sec, f8

CHECKLIST

Use all meters intelligently. Compensation may be needed when shooting snow, bright subjects against dark backgrounds, and dark, backlit subjects.

Take a selective reading from the subject you want to expose correctly.

For an average reading point the meter at a grey card or at your hand.

If in doubt bracket +/– two or three stop in one-third increments.

Note exposure readings for difficult lighting situations and learn from mistakes.

Take a reading for the subject in sunlight and for the foreground shadow, then expose midway between the two. If in doubt, bracket.
Nikon FE, 28mm, Ektachrome 200, 1/90 sec, f5.6

Electronic Flash

Electronic flash provides one solution to the problem of shooting in low light. It can also supply added illumination to daylight subjects (*see* FILL-IN FLASH). Most hand-held flash units have a photocell or sensor that automatically measures light reflected from the subject and shuts off the flash when enough light has been emitted for a correct exposure. Light falls off rapidly: at 20 feet (6 metres) the flash has to cover four times the area covered at 10 feet (3 metres). Many compacts and some SLR cameras have built-in flash. Although convenient as the flash is always readily available, it is restrictive in that the flash cannot be detached from the camera and may result in red-eye.

When the flash is positioned 2 feet above the camera (above) it produces a hard, dramatic light with more texture than on-camera flash. An umbrella (above right) gives a soft illumination as it spreads the light over the area of the umbrella. Using a Boxlite (right), three flash heads, each individually adjusted, can be powered by one power pack. The 1500 rapid-charge Elinchrom is shown.
Above: Nikon 801, Kodak Plus X (ISO 125), 1/60 sec, f16
Above right: Hasselblad, 120mm, Polaroid pos-neg (ISO 75), 1/60 sec, f11

A multiflash sequence can be shot in a darkened room against a plain wall. Here the model began by leaning to her right, then moved slowly during the 10 sec exposure. With the flash on quarter-power, the Elinchrom fish fryer recharged every one and a half seconds.
Hasselblad, 50mm, Kodak Plus X (ISO 125), 10 sec, f11

A slave unit is a useful little gadget, into which the sync lead of a flashgun can be plugged. The photocell inside the slave unit senses the flash from the main light source and triggers the supplementary flash. Several slave units and auxiliary flashguns can be used to provide light from a number of sources. In this shot, the flash on the camera held by Olympic skier Pietsch Muller triggered the built-in sensor of an Elinchrom flash 404 pack, which illuminated the set.
Hasselblad, 60mm, Ektachrome 100, 1 sec, f16

The vibrant light comes from a S35 powered by an Elinchrom 101 pack 3 feet above the subject. Even at a shutter speed of 1/250 sec, movement is visible in his hand. Electronic flash can produce lively results that don't always freeze movement. Different flash heads can fire at speeds between 1/60 and 1/1500 sec, creating a variety of types of movement.
Hasselblad, 140-280mm zoom at 180mm, Ektachrome 200, fish fryer, 1/250 sec, f22

The fish fryer can provide a soft light source if brought in close – 4 feet from the subject. The shot is further softened with a Rosco diffuser over the flash.
Hasselblad, 120mm, Ektachrome 200, 1/125 sec, f22

CHECKLIST

Insert new batteries before an important shoot.

Note on a label when batteries were inserted and how many flashes were used.

A battery tester is an economical way of assessing if new batteries are needed.

Soften the effect of the flash by using a cloth or tissue paper as a diffuser, or by bouncing the light off a ceiling or wall. Colour can be added to a shot by using a coloured umbrella or coloured wall.

Make sure the diffuser does not cover the sensor.

Adjust the amount of light emitted by the flash by changing the film speed dial on the flashgun.

Equipment

Fill-in Flash

Fill-in flash opens up a new range of picture possibilities. It offers an alternative to silhouettes on backlit subjects, it provides a solution to the problem of harsh shadows on sunny days and it brings out detail that would otherwise appear dull. A dedicated or integrated flash unit is used with automatic cameras. When both camera and flash are set to automatic, the shutter speed is automatically synchronized with the flash. As camera technology becomes more sophisticated, more models have this fill-in flash mode. When the exposure is set for the ambient light it automatically works out the correct power to balance the flash with daylight.

Without a little fill-in flash provided by a dedicated flash unit, this young lady would have been almost silhouetted against the light. *Nikon 801, 28-85mm zoom at 60mm, Kodachrome 64, Speedflash SB24, 1/250 sec, f8*

On a dull day flash is often needed to bring out detail. By exposing for the sky and lighting the foreground with an umbrella flash, the sky (which was three stops brighter) was not burned out.
Hasselblad, 50mm, Ektachrome 200, 1/30 sec, f22

CHECKLIST

Even with a fixed flash you can vary the amount of light put out. Tissue paper over the flash will diffuse and reduce the light.

Cover part of the flash with tissue paper or coloured gels to warm up or enliven the foreground.

When in doubt, bracket exposures.

Carry an extra little flashgun and a slave unit to highlight a specific subject.

Take a small clamp to fix a flashgun or camera on to a post, table or railing (see TRIPODS, POUCHES AND CASES).

The intensity of light produced by flash units falls away with distance. Foreground subjects may be overexposed while more distant objects are too dark. Small flashguns have little effect over about 20 feet. When using flash to photograph a group, you can obtain even illumination by arranging all the people about the same distance from the flash unit.
Nikon AW, 35mm, Kodachrome 64, auto-exposure

Studio Lighting

Most studio lights incorporate a tungsten modelling light that indicates the direction from which the electronic flash will illuminate the subject. A fish fryer, a large light measuring about 2 ft x 3 ft, is suitable for still life shots. A larger version of a fish fryer is a swimming pool, which is big enough to provide even, diffused illumination for a large group of people (*see* ORCHESTRATING ORGIES). Strip lights have long, straight flash tubes, about 5 feet (1.5 metres) long, and are suitable for lighting studio backdrops. A studio system can use single power packs, each supplying several flash heads, or integrated flash units combining both power and head.

Gobos are cut-out shapes or masks placed in front of a focus-spot flash head to create interesting shadows in the form of window frames, clouds, palm trees or abstract patterns.

The Elinchrom S35 light is equivalent to a 2-kilowatt spot used in the movie industry (*see* TUNGSTEN AND FLUORESCENT LIGHTING). It can give a soft but definite light (*see* JEWELLERY). Barn doors, snoots and reflectors are used to control the spread of light, while diffusers soften the light.

Fibre optics comprise a flexible Perspex tube down which light travels. It can be used to create strange 'dashes' of light, as in the shot of the punk opposite (top right).

A Square 44 (SQ44), used here, is a square reflector with a white matt surface (*see* TUNGSTEN AND FLUORESCENT LIGHTING). It gives a hard light suitable for still life and portraiture.
Hasselblad, 60mm, Ektachrome 200, 1/60 sec, f16

The model held one fibre optics flash tube in her hand like a microphone, shining an unusual character light on her face. Another fibre optics tube lit her earring.
Hasselblad, 140-280mm zoom at 280mm on macro, Ektachrome 200, 1/60 sec, f22

An improvised palm-tree-shaped gobo was cut out of plywood and placed in front of the main light source.
Hasselblad, 60mm, Ektachrome 200, 1/60 sec, f16

CHECKLIST

When mixing different types of flash, test the colour, especially on a white background.

Assess the speed of the flash units using a bouncing tennis ball or person jumping.

Experiment with different coloured gels over the flash.

Add reflectors and mirrors to increase the output of light.

Practise memorizing readings to allow you to shoot more quickly.

Equipment

Basic Lighting

The trick with lighting is to allow yourself plenty of set-up time to experiment with different angles and types of lighting. Aim to provide lighting that suits the subject and the mood you want to create. Harsh, undiffused lighting brings out imperfections in a person's complexion. Direct light and diffused light can disguise blemishes (*see* COSMETICS). Supplementary lights can be used to fill in shadow detail. Alternatively, white or silver cards or umbrellas can be positioned to reflect the main light source. By bouncing or diffusing light, you can create softer, more natural lighting.

Top, left to right: Late-afternoon window light is unkind to the subject's face. The soft sidelight is provided by an Elinchrom SQ44 18 inches from the subject, diffused with one layer of tissue. The light from a small round reflector may be too hard if not bounced. Bottom left to right: A silver umbrella is positioned 4 feet from the subject on the right. A focus spot and a gobo are positioned above the camera to the right (*see* STUDIO LIGHTING). An Elinchrom S35 to the right above the camera is 6 feet from the subject.
Nikon 801, 85mm, Ilford XP2, (top, left to right) 1/15 sec, f1.8; 1/60 sec, f11; 1/60 sec, f32; (bottom, left to right) 1/60 sec, f8; 1/60 sec, f22; 1/60 sec, f22

By bouncing light into card or polystyrene a soft light is produced.
Hasselblad, 140-280mm zoom at 180mm, Ilford XP2, 1/125 sec, f5.6, printed on Kodagraph paper

The sidelight was provided by an Elinchrom S35 5 feet from the subject. When using a long lens on large format, a very small aperture (f64) is needed to produce a hard-edged image.
Sinar 8 x 10, 360mm, Ektachrome 200, 1/60 sec, f64

CHECKLIST

Set up a preliminary test shoot using 35mm (C41) to check lighting.

Experiment with different lighting types and angles to create dramatic results.

Use different flash speeds to produce different movement effects (see ELECTRONIC FLASH and MOVEMENT).

Diffuse light through different materials, for example tracing paper, muslin and netting.

Carry a white cloth or sheet of paper to bounce the main light into shadow areas.

The old man was lit using a 7 ft 6 in x 4 ft fish fryer powered by 5000 joules from a Strobe City Pack. This light can be made hard and dramatic by masking certain areas.
Sinar 8 x 10, 360mm, Ektachrome 200, 1/60 sec, f45

Tungsten and Fluorescent Lighting

Tungsten and fluorescent lights have a marked effect on the colours of daylight film. To restore normal colours in tungsten light, use tungsten film or an 80B filter with daylight film or override the ambient light with flash. Fluorescent light produces a green cast that can be corrected by using filters. The amount of filtration depends on the type and age of the fluorescent tubes, but a 10-30CC (Colour Correction) magenta filter over the lens should do the trick (*see* INFRA-RED AND TUNGSTEN FILMS *and* EARLY DAYS).

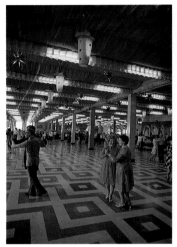

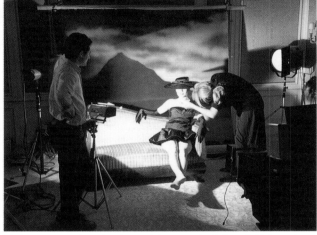

When a scene is partially lit by artificial light, don't automatically resort to using tungsten film, flash or filters. Here, daylight film without filters coped well with three different light sources: fluorescent, tungsten and daylight. Even if the results appear unrealistic, the effect can be pleasing.
Nikon FE, 28mm, Ektachrome 200, 1/90 sec, f5.6

An Elinchrom SQ44 on the left and S35 on the right provide tungsten modelling lights for a jewellery set-up. Tungsten studio lighting provides an effective way of lighting large areas. The 'Red Head' near the model provides the extra light needed to facilitate focusing when the lens is stopped down to f64.

In addition to the daylight illumination, fluorescent strips produced a green cast that enhances the aquamarine logo of the Pan Pacific Hotel in Kuala Lumpur, Malaysia. A magenta filter could have been used to compensate for the green, but the result would have been less eye-catching.
Linhof, 65mm, Ektachrome 100, 3 sec, f16

Equipment

The warm light of a desk lamp was combined with a blue gel over the flash aimed at the background. The SQ44 Head has a moon-shape cut-out and Diffuser Two.
Hasselblad, 60mm, Ektachrome 200, 1/15 sec, f11

The fluorescent light in the sign on the left was balanced using a green gel on an electronic flash head, which illuminated the young lady and the cat. To compensate for the overall green cast, a 10 red and 20 magenta filter was placed over the lens, with one layer of red gel over a flash on the right. The man was lit by a flash inside the building, the flash covered with two red gels to make him look devilish, and to blend with her red hair and accessories.
Hasselblad, 60mm, Ektachrome 200, 1/15 sec, f8

CHECKLIST

Red Heads are 750-watt tungsten halogen light sources that provide useful extra lights to help with focusing.

To counter the warm orange glow of tungsten light use an 80B filter, tungsten film or flash.

Have an extinguisher handy: carbon dioxide for equipment, water for props and paper. Tungsten lights can be dangerous, damaging surfaces or setting fire to diffuser paper.

Experiment with different filters over the lens. A 10-30 CC magenta will compensate for fluorescent lighting.

In fluorescent lighting, try using flash with a 20CC magenta filter.

Candle and Strange Lights

With the advent of fast, relatively grain-free film (ISO 1000-1600), exposure needn't be a problem when taking photographs in candlelight. Even with slow film (ISO 25-64) shutter speeds of up to $1/4$ second will give good exposures with the aperture wide open and the camera on a table or tripod. Take a reading off the subject not the flame. Bracket exposures to give a variety of moods. Candlelight is very complimentary to facial complexion as it smooths out wrinkles. The candle(s) can provide the sole light source, if the subject is close enough, or they can be used effectively with electronic flash and tungsten light.

By experimenting with different films and a variety of light sources, such as street lights, desk lamps and fluorescent lighting, you can create unusual colours and a variety of moods. Neon is vivid, tungsten is warm and fluorescence gives a green or cyan cast to daylight film (*see* TUNGSTEN AND FLUORESCENT LIGHTING). Shop windows can be photogenic, especially at night, when daylight film produces a warm atmosphere. Use a wide-angle lens and place it up against the window. Besides avoiding reflections this ensures that the lens is vertical. It also helps to stabilize the camera during a long exposure and prevents flare caused by light bouncing back from the flash.

Without flash the scene has more atmosphere and the children are not distracted by repeated flashes. However, the open aperture produces a very limited depth of field (*see* DEPTH OF FIELD).
Nikon FE, 35mm, Ektachrome 200, 1/60 sec, f2.8

Flash can be used to illuminate a scene, while a slow shutter speed captures the warmth of candlelight. In this case movement of the monk's left arm creates the illusion that a flame is coming from his sleeve. A salmon/straw filter over the flash helps retain the atmosphere.
Hasselblad, 50mm, Ektachrome 200, 1 sec, f22

CHECKLIST

Carry a miniature torch with a pivotal head, small enough to hold in your mouth to help when reloading or checking camera settings in the dark.

Take different types of film, including tungsten.

Use a lightweight tripod to support the camera during exposures longer than 1/30 sec, and use a cable release or self-timer.

Take an exposure reading from a person about 1 foot from the candle, then add at least one stop. Bracket exposures.

Put dark tape over auto flash to avoid destroying the ambience. Peel it back slightly if you want some illumination from the flash.

Experiment with different coloured gels/filters over electronic flash, e.g. a salmon, gold or red filter for candlelit scenes.

Try smearing Vaseline on a UV filter or piece of optical glass placed in front of the lens.

A tungsten film gives an accurate colour rendition at night when tungsten is the dominant light source. Flash would have overridden the ambient light, diluting its impact.
Nikon, 50mm, Ektachrome 160 Tungsten, 1/60 sec, f4

By keeping down the power of the flash, the candlelight is not completely swamped by the harsh flash. This can be done by reducing the output of the flash unit or partially taping over the flash.
Nikon FE, 85mm, Ektachrome 200, 1/30 sec, f8

Creative Lighting

A studio can be anything from a converted garage to a room in your house. It is a space – ideally one larger than 12 ft x 15 ft – where you can use numerous variations in lighting in a controlled way in order to create photographic effects (*see* STUDIO LIGHTING). Consider enlarging a room by installing folding doors that lead into a hallway or another room. Experiment with different types of lighting using still-life subjects that won't complain if you take a long time. Then practise with animals, friends and their children. Ideally paint the walls a 30 per cent grey to minimize unnecessary light bouncing back into the set. Black is most suitable if still-life is your forte.

The light breaks up as it shines through the different shapes cut in a piece of card – called an 'ulcer' in the film business. The main light was a Strobe with SQ44 silver reflector.
Hasselblad, Ektachrome 200, 1/60 sec, f45

A test shot (above) revealed fillings that were disguised in the final shot by positioning the model's head up for a more statuesque pose. An Elinchrom S35, equivalent to a 2000 watt spotlight, was positioned a few feet above the model's face, to the left. It has a Fresnel lens that enables you to vary the angle of coverage from 25 to 70° (*see* JEWELLERY).
Sinar 8 x 10, 360mm, Ektachrome 100, 1/60 sec, f45

A Strobe fish fryer and two strips on stands were positioned to the left and right of the white background paper. Two strips in the foreground were bounced into white polystyrene to soften the shadows. The model swung her hips to add movement to her skirt. The fish fryer is a large light source supported on a flexible stand (*see* STUDIO LIGHTING).
Sinar 5 x 4, 90mm, Ektachrome 200, 1/60 sec, f22

A slow shutter speed was used in conjunction with tungsten and electronic flash to achieve movement in the trumpet and double-bass player.
Hasselblad, 60mm, Ektachrome 100, 1/4 sec, f22

CHECKLIST

Experiment with different light sources, different distances from the subject and diffused through different materials, such as muslin, layers of netting or tissue paper.

Try using mirrors and hard reflectors to reduce the amount of lighting equipment needed.

Test a new technique using black and white film, where you can study the effect without being distracted by the colours.

Use a flash meter when hiring lighting equipment to calculate the amount of light required.

The silhouette on the background was created by using a focus spot and window gobo with a plant-shaped mask.
Hasselblad, 140-280mm zoom at 175mm, Fujichrome 400, 1/60 sec, f45

Light Control

If you don't like the look of reality, you can change it. Photography gives you that control. You can use light creatively to produce a particular mood or illusion. Cool winter light can be warmed up with a 81C filter over the lens. Bright exterior light can be balanced with the interior by having a neutral density filter over the windows and using electronic flash to illuminate the room. You can turn an interior daytime shoot into a night scene by covering the windows with one-stop blue gel. And with flash and long exposures or multi-exposures, you can play all sorts of games! (*See* ELECTRONIC FLASH.) To achieve movement combine tungsten and flash with a dark background. Fire the flash at the subject then get them to move backwards or sideways.

When faced with an uninvitingly cool interior and cold wintery daylight, you can place a layer of orange gel over a single strip light to warm up the hallway and an 81C filter over the lens to warm the blueness of the ambient light.
Hasselblad, 50mm, Ektachrome 200, 1/15 sec, f11

The head belongs to a man kneeling behind a dummy body. During the exposure the foreground model light was switched off so any movement was not recorded. A long exposure allowed the tungsten lights in the house to be seen. Smoke from a small smoke gun helped diffuse the harsh foreground light provided by an Elinchrom SQ44 (*see* SPECIAL EFFECTS).
Hasselblad, 60mm, Ektachrome 200, 5 sec, f22

CHECKLIST

Experiment with different light sources, especially balancing tungsten, flash and daylight.

Try various coloured gels over the flash to create different moods.

Use baking foil as a cheap reflector.

Try bubble wrap, tracing paper and tissue paper as diffusers. Remember that the pattern in bubble wrap or muslin will appear on a face positioned within about a foot of the diffuser.

Experiment with multiple exposures using flash or 'paint' with flash or torchlight in the dark.

Sunlight was hitting the man by the window, but the interior appeared dim. The aim was to make the lighting appear natural. The sunlight effect in the office was provided by a focus spot (through a 404 pack) with a window gobo (*see* STUDIO LIGHTING). The desk was illuminated by a hard top light (Elinchrom SQ44 through a 404 pack) on a boom arm. This was masked so that the light only went straight down. The skylight was created by shining a mini-spotlight obliquely on to the wall through a 101 pack.
Linhof 6 x 12, Ektachrome 100, 1/8 sec, f32

Natural daylight from above was supplemented by a 3-foot Strobe strip light covered with orange gel on the right. This was reflected in the equipment on the left, giving it a warm glow as if from a fiery furnace.
Fuji 6 x 17, Ektachrome 200, 1/30 sec, f8

Fun Filters

Liven up grey days, put an extra sparkle into lights or play visual games with prism filters. Used in moderation, a wide variety of fun filters can help you create head-turning pictures (*see* FIREWORKS AND FUNFAIRS *and* CANDLES AND STRANGE LIGHT). It will not always be clear from examining the filter itself what effect it will have on the photograph, but with the filter on a single-lens reflex (SLR) camera you can see how the the colours are changed, the image is split or the light refracted. Filters such as the Colorburst, Starburst, Cosmos, Galaxy and Nebula refract (deflect) or diffract (break up) light. They are most effective when used with points of light. Rotate the filter to find the most appealing angle for the radiating lights. By combining several different filters you can enter a world of surreal creativity.

Shooting into the setting sun with a Starburst filter over the lens produced warm shafts of light radiating out from the light source.
Nikon, 85mm, Starburst filter, Kodachrome 64, 1/125 sec, f5.6

The setting sun behind a yacht in Jamaica is photogenic without the help of filters, but for variety it is often worth shooting several pictures of a scene using different filters. Besides the halo of spectra that frames this picture, the Nebula and Skylight filters have produced two double suns.
Olympus OM-1, 50mm, Hoya Nebula filter, Kodachrome 64, 1/60 sec, f11

CHECKLIST

Use colour filters to change the mood, diffracting filters to create spectra from light sources and Vario prisms to split the image.

Shoot both with and without filters for variety.

Rotate the filter to observe the changing effects.

Combine several filters for more bizarre results.

Try using pieces of mirror in the foreground.

Cokin produce a Colour Creative Kit with twelve coloured filters in a portable plastic box. Used together with a Diffuser One to soften the outline, a purple filter enhances the romantic scene in keeping with the nostalgia of the old railway station.
Hasselblad EL, 120mm, Ektachrome 200, 1/60 sec, f8

The shot of the hairdresser was made more vibrant with a Vario prism.
Nikon FE, 35mm, Ektachrome 200, 1/60 sec, f2.8

A three-way Vario prism was used to split this picture of singer/guitarist Ralph McTell, which was taken for an album sleeve.
Nikon FM2, Vario prism, Kodachrome 64, 1/60 sec, f16

Grads and Polarizers

Polarizing filters emphasize contrast and cut down on reflection, whether in windows, lakes or swimming pools, revealing more of the detail behind the reflective surface. When you expose for the highlights, shadows appear blacker, skies turn darker and white clouds and buildings stand out more prominently. This can produce very powerful, graphic images, with strong, saturated colours.

A shot of a beach in the Bahamas that does not re-create the vivid colours looks disappointing. A polarizing filter, which requires an extra exposure of one to two stops, restores the vibrance of the scene, turning the sky a richer colour, the sea a deeper blue and cutting the glare on its surface to reveal some of the coral detail below. Bracket the exposures on a promising shot to ensure the most dramatic results.
Above: Nikon, 25-50mm zoom, Kodachrome 64, 1/125 sec, f8-11
Below: Nikon, 25-50mm zoom, Kodachrome 64, with polarizing filter, 1/60 sec, f8

A polarizing filter was used above to increase the contrast, turning the sky deep blue while leaving the white building unaffected. Bracket such shots. Rotate the filter to vary its effect, as the results are not entirely predictable. With a polarizer on the lens, exposure needs to be increased by one or two stops, depending on the position of the filter. A through-the-lens (TTL) metering system will take this into account.
Nikon, 25-50mm zoom, Kodachrome 64, polarizing filter, 1/125 sec, f8

As the sun rose, the sky brightened faster than the foreground, increasing the contrast between the two. The first shot was taken without a graduated filter, just as the sun appeared. Within three minutes the sun was bright enough to require a two-stop grad and one stop less exposure. The grad toned down the sky to give a balanced result in which foreground detail was retained. Without the grad, either the sky would be burnt out or you would expose for the sky and the foreground would be lost in shadow.
Left: Nikon, Kodachrome 64, 1/30 sec, f8
Right: Nikon, Kodachrome 64, with two-stop graduated filter and starburst filter, 1/60 sec, f8

Coloured grads can enhance the appearance of skies, giving a picture vitality and drama. The pink grad tempers the threatening nature of the clouds. Grads can also be used to tone down a bright sky and bring out its detail.
Linhof 6 x 12, 65mm, Agfachrome 1000, pink graduated filter, 1/60 sec, f22

CHECKLIST

Make sure filters are clean by using lens-cleaning fluid, a lens tissue and Dust-Off.

Most compact cameras do not have the facility for filters but you can hold or tape a filter in front of the lens.

Shoot the scene with and without a filter.

Adjust the position of the filter to vary the effect. Mark the top of the filter with a silver marker pen or tape at the point where it works best for you.

Equipment

Tripods, Pouches and Cases

There is a huge selection of photographic accessories to help you carry, support, adapt and repair your camera equipment. You can also improvise, using tape, string and clips, or modify gear to extend its use. A bracket or clamp can hold a camera or flashgun in an unusual or awkward position; a remote control unit can trigger a camera or multiflash from a distance; clips and grips can hold props or clothing in position. A soft camera bag can be stowed under the seat in an aeroplane, and be used as a padded platform for your camera. A robust aluminium case with foam padding offers greater protection, reflects the sun's heat, and can be used as a seat or stand. When you need both hands free to climb, sail or ski use individual pouches threaded on to a belt or harness, or a multi-pocketed jacket with a regular place for everything: sunglasses, passport, notebook and pen in top pockets; exposed and unexposed films in sleeve pockets, one on either side; lenses in side pockets; lens-cleaning cloth, blower brush, gaffer tape, knife and filters in inside pockets.

A sturdy tripod or other support is needed to steady a camera during long exposures or when a long lens is used, as with the 200-600mm zoom and 1000mm lenses shown here.

Tripods and clamps come in many sizes and designs, with a variety of ball-and-socket or pan-and-tilt heads. A lightweight model is more portable and can be stablized by adding weights. A monopod is a lighter, one-legged support used to help steady the camera. A pistol grip also helps steady a hand-held shot, especially when using a long lens.

A small, lightweight tripod is adequate for most occasions, although a less portable, more elaborate platform might be required for a professional assignment.

If equipment is neglected it will stop working or produce inferior pictures. Keep a range of tools and accessories to hand for regular cleaning, maintenance and improvisation: cans of Dust-Off, lens cleaning fluid, blower brush, toothbrush, lens cleaning tissue, chamois leather, cotton buds, jewellers' screwdrivers, Allen keys, tweezers, pliers, scissors, knives, coloured tape, gaffer tape, double-sided tape, string, pins, clips, clamps and a whistle for attracting attention or signalling.

CHECKLIST

A set of boxes that fit inside one another can be used to store accessories, support cameras, and raise models and props.

Car battery clips are strong and cheap. Two can be screwed together to clip masks on to lights etc.

Carry a pocket tape recorder to record data during a shoot or while travelling.

Use a small radio to check weather and road reports.

Create your own lens shades and filter-, diffuser- and mask-holders, using rejected Polaroid-holders or thin aluminium sheeting.

Technique

Early Days

This special period provides excellent opportunities for photography. Consider original ways of documenting the different stages of development. If your partner is having a baby you will feel emotionally involved in the event, but try to approach it with a sense of humour, and be on the lookout for amusing pictures and poignant scenes. In the hospital, make it clear to the staff that your photography will not impede the progress of their work, and that having something to occupy you will reduce the chances of your fainting!

If fluorescent lighting is the main light source, use a 10-20CC (Colour Correction) magenta filter over the lens with daylight film to cancel the green cast. By taking advantage of the ambient light, you can shoot quickly without worrying about the time it takes for the flash to recharge. If flash is necessary, bounce it off the ceiling to avoid the very harsh direct light, or diffuse it with a cloth or handkerchief over the flash. A 20CC magenta filter over the flash will also improve skin tones under fluorescent lights by restoring their natural colour.

As she is especially conscious of her weight at this time, a picture of the expectant mother weighing herself will be very evocative.
When photographed without a filter, the scene looked rather bland. Adding an orange filter suggested the warm, baby-in-the-womb moment. A diffused flash was positioned just off-camera, and daylight through the window behind her emphasizes her shape.
Nikon, 85mm, Kodachrome 64, 1/60 sec, f8

CHECKLIST

Be sensitive and shoot quickly, as a pregnant woman may not feel comfortable about a lengthy photographic session.

Look beyond the obvious when recording the different moods and stages of pregnancy and birth.

Indicate to hospital staff that you are serious about taking good photographs, but will try to keep out of their way. A medium telephoto will help you keep your distance.

A fast film, such as ISO 400 or 1000, will enable you to use available light rather than flash, and a grainier film may enhance the mystery of birth.

Where possible use daylight on its own to retain the atmosphere, otherwise different filters may be necessary to correct the colour balance, depending on the dominance of the different light sources. Use a 10 magenta filter where there is a mix of fluorescent and daylight, and a 20M if totally lit by fluorescent light.

If flash is essential, diffuse it with a handkerchief or bounce it off the wall or ceiling, and use the reading lamp as a filler.

As nowadays babies are seldom turned upside down at birth, this is an unusual picture. The aim was to capture the drama of a momentous moment, not to create a clinical record. Flash would have killed it. Despite the daylight being stronger than the fluorescent light, the midwife's forearm still picked up some fluorescence, making it green. A medium telephoto was used, so that the photographer did not get in the way.
Nikon, 85mm, Kodachrome 64, 1/30 sec, f2.8

Tiny fingers reaching for Daddy's hand present a strong visual image because of the contrast in size. This was shot into the available light to emphasize the outline. The hands are not in silhouette because the light is bounced around the white walls enough to illuminate the shaded side.
Nikon, 85mm, Ektachrome 200, 1/60 sec, f1.8

By giving siblings a task, such as helping to weigh the baby, they are made to feel more useful and involved. The light here is diffused by net curtains.
Nikon, 28mm, Ektachrome 200, 1/60 sec, f4

World of Children

When children are engaged in their own pastimes they provide enchanting subjects for your camera. Be ready to snap them whenever the occasion arises, but you can also initiate activities by providing something to play with such as bubbles, balloons or face paints. Then stand back ready to photograph their reactions. They may notice you at first, but will soon ignore you as they become more and more involved.

Autofocus and autoexposure cameras help save time when capturing fleeting moments. Compacts are unobtrusive and easy to use. And a zoom lens enables you to frame shots quickly. Be prepared to shoot lots of film, some expressions are unrepeatable (*see* DECISIVE MOMENTS *and* SHOOT AND SHOOT AGAIN).

Expressions of delight combined with amusing and oversized clothes invariably produce appealing pictures. A diffuser over an electronic flash softened the flash's light.
Hasselblad, 120mm, Ektachrome 200, 1/125 sec, f8

Engrossed in technology, he presents an endearing picture. The soft diffused light from a window does not interfere with his preoccupation.
Nikon, 85mm, Ektachrome 200, 1/60 sec, f2.5

Try to move in close, without upsetting the natural progress of the activity. In this shot tungsten light casts a golden glow over the hair and warm colours of the pine while daylight from the window helps keep the colours realistic.
Nikon, 35mm, Ektachrome 200, 1/60 sec, f2.8

Good fortune and good photography occasionally come together to produce an irresistible image. The colours tone beautifully, the composition and pose are balanced, and the body language speaks volumes. Although the sisters are sharing the drink, the older one is keeping the other at bay with her foot.
Nikon, 80-200mm zoom at 150mm, Kodachrome 64, 1/500 sec, f5.6

A medium telephoto lens throws the background out of focus, concentrating attention on the softly backlit subject.
Nikon, 105mm, Ektachrome 200, 1/30 sec, f2.5

The girl on the left is in command of the balloons while the one on the right is preparing for a confrontation. Apart from the absorbing narrative, the picture works thanks to a harmonious blend of colours, lack of distracting background and a distinctive shadow on the pier.
Nikon, 80-200mm zoom at 80mm, Kodachrome 64, 1/125 sec, f5.6

CHECKLIST

Provide the photogenic toys then stand back and shoot the resulting activities.

For a feeling of involvement move in close with a wide-angle lens (such as 35mm), but try not to upset the mood.

Use a medium telephoto if your presence is likely to divert the children's attention, and try a self-timer so they do not know when the shot will be taken.

Avoid distracting backgrounds by careful composition or selective focus.

Fireworks and Funfairs

Fireworks and bonfires are visually exciting and very photogenic. Don't automatically resort to using flash. A combination of fill-in flash and a long exposure can be especially effective when photographing sparklers or use a multiple exposure for a series of separate fireworks. As the 'sprays' of light are usually moving, a long exposure will not necessarily burn out the image.

Funfairs are all about movement, excitement, garish signs and coloured lights. Capture the mood on fast film (ISO 200 or over) using filters such as Cross Star, Galaxy and Andromeda (see FUN FILTERS). Dusk is a good time to shoot, when the exposure for daylight is a half to one stop under tungsten light. On horror rides take a small flash to catch some wonderful expressions. A layer of gold or green gel on the flash will liven up the scene.

The firework display over Disney World in Florida was captured from a rooftop, with the camera resting on a wall.
Nikon 301, 50mm, Fujichrome 100, 5 sec, f5.6

Children can use sparklers to spell out their name in the air or draw glowing light-pictures. With the shutter open for ten seconds at f2.8 or f4, trigger the flash when the person is in the desired position either at the start or the finish of the exposure. Consider flipping the image so that the writing is legible (*see* FLIPPING).
Nikon, Kodachrome 64, 10 sec, f4

With daylight film the light from a bonfire produces a warm glow on people's faces. With a fast film you can avoid using flash, which would destroy the atmosphere.
Nikon AW, 35mm, Ektachrome 200, auto-exposure

CHECKLIST

Use flash sparingly or risk destroying the atmosphere you are trying to capture.

Take a tripod and shutter-release cable to keep the camera still during long exposures.

Use the 'B' setting to hold the shutter open at f4 or f5.6 (with ISO 200 film) for long exposures (3-30 sec) of fireworks, covering the lens with black card or the lens cap between explosions.

Experiment with eccentric filters.

At funfairs, shoot at dusk with fast film (ISO 400-1600) to make the most of coloured lights whilst also retaining some daylight detail.

Take just one camera on the rougher rides.

Panning with the boat catches the expressions of enjoyment and sense of speed of this ride in Disneyland, California. A faster shutter speed would increase your chances of achieving a sharp image (see MOVEMENT).
Nikon FE, 80-200mm zoom, Ektachrome 200, 1/125 sec, f8

A fast grainy film is not enough to freeze all the movement, but it does capture the feelings of speed and apprehension on the 'octopus' ride. Focus on a spot you know the car will pass, or pan with the moving vehicle.
Nikon FE, GAF, 1/60 sec, f5.6

A Galaxy filter over the lens adds further excitement to the canopy of coloured light bulbs.
Nikon AW, Ektachrome 200 rated at ISO 400

On the more turbulent rides make sure your equipment is secure. Carry the minimum of gear, perhaps leaving all but one camera with someone else. Watch the ride beforehand and anticipate the best moments. Keep the camera on auto-exposure.
Nikon FE, Ektachrome 200, 1/250 sec, f8

Technique

Sporting Chances

Action photography can be doubly exciting if you are taking part as well as taking pictures. The added sense of involvement gives the resulting pictures more drama and vitality. The key to good sports photography is planning, preparation and timing. Some situations call for long telephoto lenses on tripods, others are best handled with wide-angle lenses tucked in close to the activity. Where you need to freeze movement, especially in low light conditions, choose a fast film (ISO 400 or faster) and use a fast shutter speed (1/250 sec or faster, depending on the vibration or action involved). Alternatively, panning with the subject on a slow shutter speed creates a graphic background blur. An understanding of the sport will help you select suitable vantage points and shoot at peak moments (*see* MOVEMENT *and* DECISIVE MOMENTS).

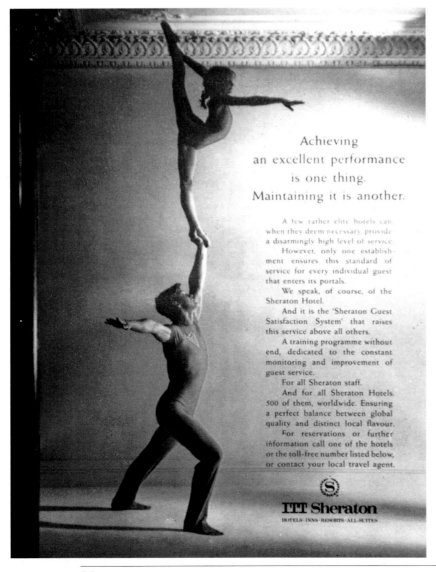

Flash and fast reactions were needed to capture this acrobatic moment, as the girl could hold the position for just two seconds. The set was lit using a X-head and two SQ44 packs (*see* STUDIO LIGHTING). *Sinar 8 x 10, 360mm, Ektachrome 200, 1/60 sec, f22*

Technique

For certain shots you have to become totally involved in the activity. Here, an eye-catching viewpoint was achieved by turning around to photograph the glider pilot in the middle of a loop-the-loop.
Olympus OM-2n, 16mm, Kodachrome 64, 1/250 sec, f11

Water skiing looks most impressive when a sheet of spray fans out during a turn. If you are in the boat, use a fast shutter speed to avoid camera shake as well as to freeze the movement of the skier.
Nikon FE, 85-250mm zoom at 250mm, Kodak Tri-X (ISO 400), 1/500 sec, f8

CHECKLIST

Plan to capture key moments in a sport – a golfing swing, a football tackle, a tennis serve.

Shoot at slow shutter speeds (1/30 or 1/60 sec) during the tense pause as a basketball player reaches the highest point in a jump, or just before the starting signal of a race.

Make sure there's a new roll of film loaded before the start of the action.

Be ready for the unexpected crash or fall.

Try using a remote triggering device to fire a camera strapped to the wing of a hang glider or to the mast of a windsurfer. Gaffer tape is very strong.

Use an underwater or waterproof camera for water sports to allow you to move in close.

However involved you become in adventurous sports, protect yourself first, and then your equipment. Use a safety belt where appropriate and take advice from the professionals.

Does your insurance exclude dangerous activities?

Day on the Beach

The beach is a marvellous stage where people unwind, animals go berserk and children enter a world of their own (*see* IMPROMPTU PORTRAITS *and* WORLD OF CHILDREN). It's a venue for recreation and relaxation, a place to photograph sandcastles, bodies buried in the sand and close-up shots of pebbles, seaweed and shells (*see* MACRO). Most cameras dislike water, sand and salt. But don't let that stop you shooting pictures on the beach; just try to keep equipment clean and dry in plastic bags, and take a cool bag for film and soft drinks. Waterproof or all-weather cameras are sealed against the harmful effects of sand and water (*see* BENEATH THE WAVES). A zoom lens facilitates rapid framing (*see* ZOOM IN). Also, look after yourself; you won't feel like taking pictures if you are suffering from sunstroke or sunburn.

Deckchairs are very photogenic, presenting an almost endless variety of shapes, patterns and colours. The characters who use them and the poses they strike offer great scope for images full of atmosphere. After twenty years the deterioration of colour in this shot actually contributes to the mood.
Nikon, 85-250mm zoom at 250mm, Agfacolor 100, 1/500 sec, f5.6

An all-weather compact camera is unobtrusive and less likely to suffer from flying sand than a normal land camera. The date stamp on this shot of a donkey race in Tunisia is a useful reminder and aid to cataloguing pictures later.
Nikon AW, 35mm, Kodachrome 64, auto-exposure

CHECKLIST

Avoid sand and spray by keeping equipment in plastic bags sealed with rubber bands or tape.

Change lenses and film away from the water and blowing sand.

Use a lens hood to help protect the lens and cut down on flare when shooting into the light. Black card can be used to make an improvised hood.

Experiment with sunset and graduated filters to add blue or pink to an otherwise dull sky (see GRADS AND POLARIZERS).

Don't leave cameras or exposure meters in the hot sun. Keep them in a bag or covered with a cloth.

A white umbrella can keep the sun off you and your gear, and also act as a reflector.

Using a long lens and wide aperture will keep skin tones soft and concentrate attention on the subject by throwing the rest of the picture out of focus (*see* DEPTH OF FIELD).
Nikon, 85-250mm zoom at 250mm, Kodachrome 64, 1/500 sec, f5.6

Technique

Besides the drama of sun on waves, sunsets offer great opportunities for silhouettes. Add a little action, such as splashing in the water, and you have a pleasing picture.
Nikon, 80-200mm zoom at 150mm, Ektachrome 200, 1/125 sec, f5.6

Happy Snaps

People, especially children, look more natural if you can snap them quickly. Keep a camera handy and always be on the lookout for picture opportunities. If they put on a show for the camera, be ready to capture the joy and excitement of the moment. Children will soon lose interest if you spend a lot of time setting up a shot, so involve them only when you're ready (*see* WORLD OF CHILDREN *and* IMPROMPTU PORTRAITS).

This girl in Tokyo was so engrossed in her chalk design that the photographer did not intrude into the child's fantasy world.
Nikon, 28mm, Ektachrome 100, 1/60 sec, f8

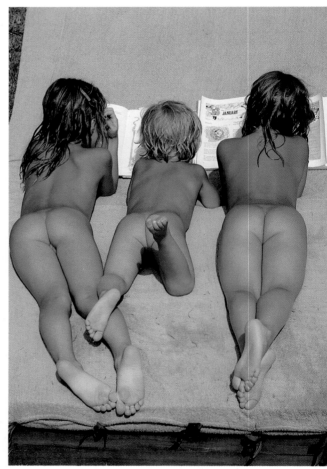

Unconcerned by the presence of the photographer, the sunbathing trio displays the uninhibited charm of childhood.
Nikon, 85mm, Kodachrome 64, 1/250 sec, f8

The inner tube holds the girls close together, making them a captive audience. By shooting against late afternoon light, and overexposing by one stop, there are no unpleasant shadows over their faces. Determine the correct exposure by zooming in and setting the exposure when the subject fills the frame, then pull out again to compose the picture. Bracket to give a greater choice of mood.
Nikon EM, 80-200mm zoom, 1/125 sec, f8

CHECKLIST

Shoot quickly to capture the fleeting moments, and don't stint on film (see SHOOT AND SHOOT AGAIN).

Take pictures while the children are engrossed in something (see FIREWORKS AND FUNFAIRS and IMPROMPTU PORTRAITS).

Be ready for rapid changes of activity.

Enter the child's world by crouching down and shooting from their level.

Prepare in advance amusing props such as flowers, ice-creams, outsized clothes, a large cardboard box, masks or bouncy toys.

Use a telephoto lens to keep your distance and not interfere with the activity (see TELEPHOTO AND TELECONVERTERS).

The small backlit group by the sea in former Yugoslavia is focusing its attention on a recent catch. One of the boys glances up and reacts to a throwaway comment by the photographer, thus providing an added personal touch.
Nikon 801, 28-85mm zoom, Kodachrome 64, 1/250 sec, f8

Impromptu Portraits

When out and about shooting unplanned pictures you need to be able to think on your feet, and think fast, or the moment may pass. Anticipate events and be aware of all the elements in a picture. Is the background cluttered? Is the main subject looking self-conscious? You can usually solve these problems by waiting until the people in the background move away, or by repositioning yourself.

Most people consider being photographed a compliment. But if they feel uncomfortable about having their picture taken respect their wishes (*see* POSING PEOPLE).

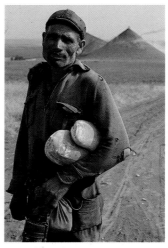

The noise of the train camouflaged the sound of the shutter, and the lady was unaware that six shots were taken. Besides attracting her attention, a flash would have destroyed the muted atmosphere of this meditative moment.
Nikon, 85mm, Ektachrome 200, 1/125 sec, f2.8

This poignant portrait of a Bulgarian miner contains many clues to the man's story. His face, threadbare clothes and two loaves of bread tell of a life with few comforts. The soft afternoon light implies that he is on his way home from work.
Nikon F2, 35mm, Ektachrome 200, 1/125 sec, f8

CHECKLIST

Know your camera well enough so that you can shoot quickly.

Be ready to capture interesting portraits whenever they present themselves, whether it is an eccentric character, an intriguing juxtaposition or a harmonious blend of colours.

After shooting one frame consider how the picture might be improved – wait for the background to clear, find a better angle, suggest a different activity – and shoot again.

A motor drive helps make sure you are ready for the next shot as soon as the subject is.

Use a zoom lens for fast framing.

Give Polaroid prints as presents.

People don't have to be smiling, though you can lighten a solemn mood with an amusing comment or gesture.

Respect people's privacy.

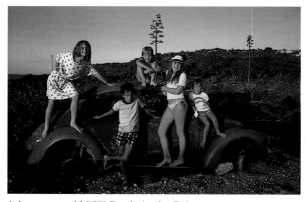

A burnt out old VW Beetle in the Bahamas provided a wonderful platform for an unplanned snap of family and friends. The late afternoon sunlight gave the scene a warmth and vibrance that was absent earlier in the day when the overhead sun cast heavy shadows over the faces.
Nikkormat, 25-50mm zoom at 45mm, Kodachrome 64, 1/125 sec, f8

Technique

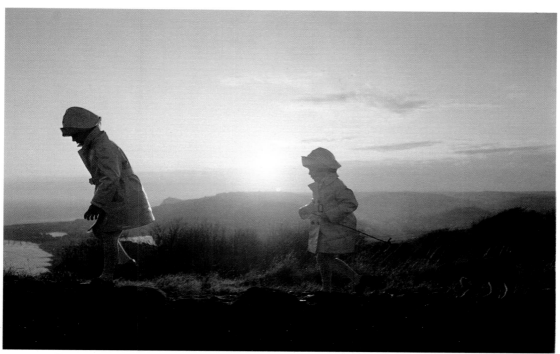

By setting up a scenario in which children enter a world of their own, you can help them forget about the camera. Assemble appealing props in an interesting location, then suggest an activity that will engage their attention. These girls had to concentrate as they picked their way along the uneven stone wall of Dover Castle. The yellow rainwear tones in with the setting sun, and the puppy adds a further element of cuteness.
Nikon, 35mm, Kodachrome 200, 1/250 sec, f8

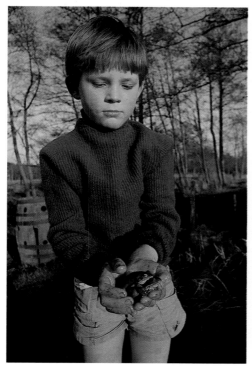

This picture oozes charm. The early evening sun has bathed the scene in a rich light. The viewer looks first at the boy's face, and then follows his gaze down to the focal point of the photograph.
Nikon FE, 35mm, Ektachrome 200, 1/60 sec, f11

Let children strike their own poses to reflect how they feel. This hollowed beech trunk was once a favourite haunt, and the girl's nostalgic expression and relaxed, pensive position convey the feelings of ownership, cherished memories and time passing. A telephoto lens softened the background.
Nikon, 80-200mm zoom, Kodachrome 64, 1/125 sec, f5.6

Posing People

Most people are happy to co-operate if you appear friendly and outgoing, even if you do not share a language. People invariably prefer to look into the camera, and this can produce a strong picture, often with a confrontational edge to it. At the sight of a camera many will respond instinctively, with no need for prompting (*see* WORLD OF CHILDREN *and* IMPROMPTU PORTRAITS).

Be both persistent and sensitive. Reassure people by talking and/or gesticulating as you are shooting. You can quickly establish a rapport by treating people with respect and showing an interest in their products, their attire or their surroundings. Try indicating what a lovely day it is, even if it's raining; you will probably evoke expressions of amusement and delight (*see* ZOOM IN *and* SHOOT AND SHOOT AGAIN).

When perched on a table holding a glass, the cellar master at the Château du Cauze in France looks a little nervous. A change of position makes the picture work much better. A wall of wine cases provides a wonderful and appropriate backdrop, and the act of sniffing the wine is a perfectly natural gesture for him. The spotlight effect is created by programming a speed flash to cover only two-thirds of the picture area. Many flash guns have a zoom mode.
Nikon 801, 28-85mm zoom, Ektapress 1600, 1/125 sec, f16

CHECKLIST

Be friendly and open, giving Polaroid prints as presents, and people will reward you with their co-operation.

When there is a language barrier use exaggerated gestures or cartoons/sketches to put across your message.

Photograph people engaged in an activity as well as looking straight at the camera.

Don't be afraid to ask people to change their position for the photograph. Consider variations for stock libraries (see STOCK SHOTS).

Collect caption information by asking people about their lives, their jobs, their opinions.

Take model release forms (see PRE-PRODUCTION).

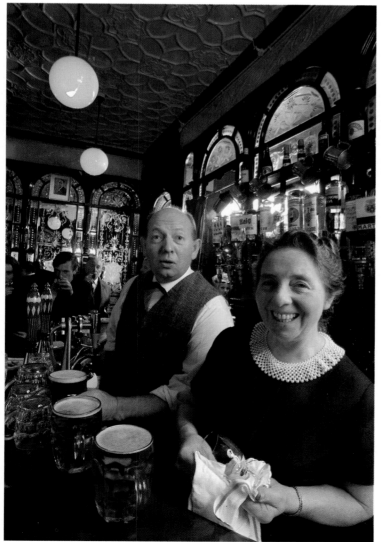

At the launch of his exhibition at Hamilton's Gallery in London, photographer Norman Parkinson was persuaded to hold a huge bunch of decorative balloons. The bizarre prop turned an ordinary portrait into a memorable photograph.
Nikon AW, 35mm, Kodacolor 400, auto-exposure

When you have time as well as people's consent and co-operation, you can arrange a scene to produce a balanced picture. Besides stimulating an animated performance from the main characters in the Red Lion pub in Jermyn St, London, the photographer should notice the elements surrounding them: the globe lights reflected in the mirrors resemble the heads of the three pints of beers on the bar, and are also echoed in the man's head and lady's white collar.
Nikon FM, 28mm, Ekatchrome 200, 1/30 sec, f16

Nudes

Nude photography can be artistic, innovative, romantic, sensuous, titivating, erotic or humorous, depending on how the pictures are shot and how they are viewed. When preparing a session help the subject feel confident, relaxed and uninhibited. Before you begin discuss with them the purpose of the shoot. Draw a rough sketch to illustrate what you have in mind and help them feel involved in the creative process.

On commercial assignments make sure the model is acceptable to the client, and that you understand the mood required – passive, pensive or provocative. Conceal blemishes in shadow or by careful choice of camera angle or make-up. The room temperature should be warm enough for the model to feel comfortable, and to avoid goose pimples.

The 'pool ladies' could only hold this awkward pose for a short time so each burst of exposures was shot rapidly. Four 6-foot strip lights (5000 joules each) provided a hard light from the opposite side of the pool about 20 feet from the models.
Hasselblad, 80mm, Kodak Tri-X (ISO 400), 1/250 sec, f16

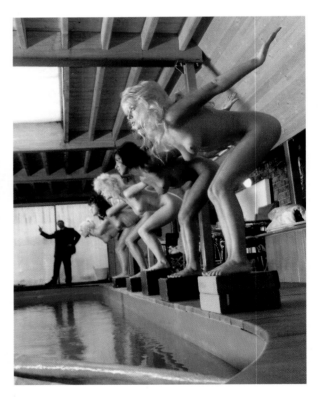

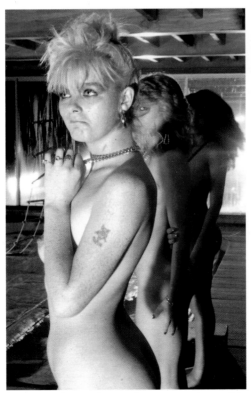

During casting sessions make sure you shoot all angles that may be required of the model. Tattoos or birthmarks could spoil a shoot.

CHECKLIST

Underclothes should be removed several hours before the session to give any marks time to disappear.

Nipples can made 'livelier' using an ice pack.

Play suitable music to help everyone relax.

Accentuate shape by lighting from the side.

Explore a variety of poses around a single theme.

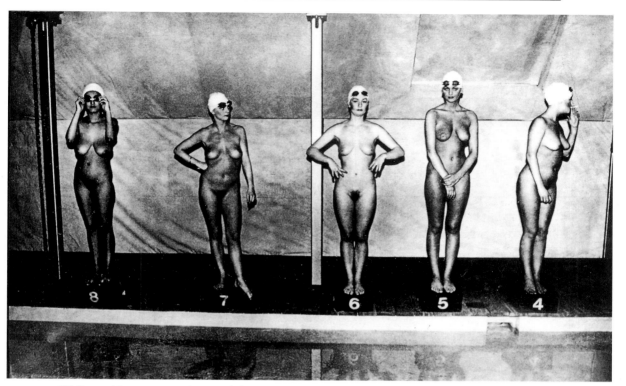

While an elaborate group shot was being set up,
one of the ladies took time out for a cigarette.
Always be ready for an amusing aside.
*Nikon 801, 28-85mm zoom at 40mm, Kodacolor 400,
1/60 sec, f5.6*

A transparency projected on to the nude form
can produce exciting results. A light blue filter in
front of the projector was used to keep the skin
tones natural.
*Hasselblad, 80mm, Ektachrome 200, 20 Blue CC filter,
1/15 sec, f2.8*

The fine-grained film produced a sculptured
quality, and for a high-key result was printed on
Kodalith paper with less exposure and longer
development time.
*Hasselblad, 140-280mm zoom at 200mm, Kodak
Plus-X (ISO 125), 1/125 sec, f16*

Lookalikes

People who resemble famous characters are in demand for advertisements, movies, television programmes, cabaret shows, pop promos and to liven up parties. By photographing them well you could establish for yourself a lucrative sideline (*see* STOCK SHOTS *and* CREATIVE CASTING).

Before photographing a lookalike study reference material relating to them in magazines, books or videos. Track down appropriate costumes, props and make-up and even, occasionally, unusual vehicles (*see* COSTUME DRAMA). Lookalikes with a strong character face do not have to rely so much on producing appropriate mannerisms, but Marilyn Monroe is evoked most strongly by imitating her expressions and gestures. It can be helpful to give the lookalike an appropriate catch phrase to enhance his or her expression, for example 'Who loves you baby?' for Kojak, or 'Here's looking at you kid', for Humphrey Bogart.

Everyone's favourite image of Marilyn Monroe shows her dress being blown by air from an air duct. This dynamic pose from the movie *The Seven Year Itch* was, therefore, the strongest way to depict her in this English ad for Holsten beer. Although the street scene in the movie was harshly lit, the softer, more flattering lighting used here better evokes the classic picture that people have in their minds. Two large fish fryers were positioned on either side and a hard light was shone up through the grille (*see* STUDIO LIGHTING). *Hasselblad, 120mm, Ektachrome 200, 1/500 sec, f16*

The 'Queen' is guest of honour at a tea party. The camera is at head height and the people in the background are raised slightly on a series of steps. The scene is lit by four striplights with Diffuser One, suspended from the ceiling (*see* STUDIO LIGHTING).
Hasselblad, 60mm, Ektachrome 200, 1/60 sec, f22

CHECKLIST

Study movies and photographs of the people you are planning to depict.

Pay attention to detail – clothes, make-up, props, setting, lighting.

Shoot from angles that emphasize the similarities and disguise the less convincing aspects.

Keep your eyes open for potential lookalikes.

For the cover of *Stern* magazine, the royal couple in the bath were played by lookalikes. An umbrella was used to reflect a T-head, and two striplights illuminated the background (*see* STUDIO LIGHTING).
Hasselblad, 80mm, Ektachrome 100, 1/250 sec, f16

Telly Savalas in his role as Kojak is portrayed by careful propping and a small light source creates dramatic sidelighting to suit his toughness. His bald head, sunglasses and the lolly all help the characteriztion. The picture has a strong diagonal shape created by the light on the top of his head, the bright red lolly and his hand.
Hasselblad, 120mm, Ektachrome 200, 1/60 sec, f22

Weddings

Enjoy a wedding but don't let the excitement of the occasion impair your judgement. Take advantage of the official photographer by shooting from behind him, then look for different angles and zoom in to pick out individual expressions. When you're photographing a group, arrange people so that they fill the frame. Make sure no one is hidden at the back by raising them up on steps, a bench or bricks, and ask if everybody can see the camera. To ensure a good group picture, shoot at least six frames and then choose the best.

Remember to keep the groom on the bride's right. Check that the dress is arranged attractively. Encourage natural smiles with a few light-hearted comments. People love a touch of humour as a change from more posed pictures. Keep an eye on the young children, who often embrace the enthusiasm of the event. Try setting up some funny situations – encourage the children to borrow hats from the adults or even get one of the bridesmaids to put on the bride's shoes. Then turn around to shoot the delighted expressions of those looking on.

Cover yourself by shooting both with and without flash. Avoid harsh direct sunlight because of the dark shadows it will create. Keep the scene in the shade or with the sun behind the subject and use fill-in flash.

On a sunny day, the soft diffused light under the tree created a more serene ambience. To mark the grandness of the occasion, a wide camera was used (*see* WIDE CAMERAS).
Linhof, 65mm, Fujichrome 400, 1/125 sec, f8

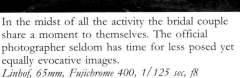

In the midst of all the activity the bridal couple share a moment to themselves. The official photographer seldom has time for less posed yet equally evocative images.
Linhof, 65mm, Fujichrome 400, 1/125 sec, f8

In a mingling crowd, whisper the bride's name and capture her unguarded smile as she turns. As these are unrepeatable moments, shoot fast and crop the picture later.
Linhof, 65mm, Fujichrome 400, 1/60 sec, f11

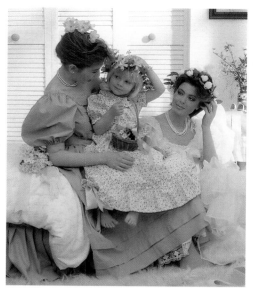

A Diffuser One over the lens has given this scene a romantic, nostalgic feel. Electronic flash was bounced into a large umbrella and the white carpet below helped bounce light up to the subject.
Hasselblad, 120mm, Ektachrome 100, 1/125 sec, f16

The low viewpoint of the camera gives the picture drama and highlights the architecture. The boy sitting on the step breaks up the line of heads.
Hasselblad, 50mm, Ektachrome 200, 1/60 sec, f11

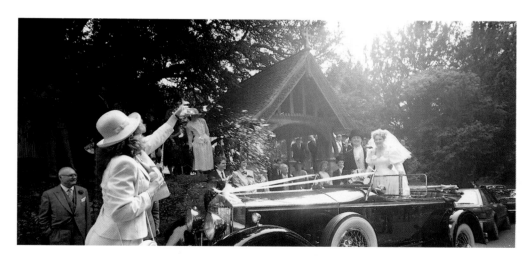

Confetti-throwing is always a happy and lively time. Be ready for it. If you know that somebody is going to throw confetti, ask them not to throw it all in one go as you plan to take three shots.
Linhof, 65mm, Fujichrome 400, 1/125 sec, f16

CHECKLIST

Make use of the official photographer's groupings, but do not get in his way.

Look for different viewpoints and amusing details, especially the children's reactions.

In posed group shots make sure everyone can see the camera and shoot several frames of each pose as the perfect shot can be illusive.

Shoot with and without flash.

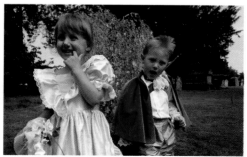

Children look charming when dressed up. Their reactions to the wedding are well worth capturing. Bored with the proceedings, the boy stuck a drum stick down his neck. Seeing the camera, the girl giggled self-consciously.
Linhof, 65mm, Fujichrome 400, 1/125 sec, f16

Wedding Sequences

A good way to tell the whole story of a wedding day is with a photo sequence that shows the events as they evolve. Be ready to capture the magic moments – signing the register, coming out of church and cutting the cake.

Start with fresh batteries in the flash and in the camera, and take spares. Take two cameras, perhaps with colour negative film in a compact camera and transparency film in the main camera, depending on how you plan to use the pictures. Take plenty of spare film, including a couple of rolls of fast film (ISO 1000) for shots inside the church. The results are grainier than a slower film and this can give the pictures atmosphere. There should be enough ambient light to shoot with a wide-open aperture at 1/60 sec without having to use flash. At shutter speeds slower than 1/30 sec, steady the camera on a pew or against a pillar and shoot several pictures as some may show movement or camera shake. In the church, flash may be considered too intrusive, and should be kept to a minimum. Many churches will not allow photography or video, although the professional may have permission. If allowed, try to be discreet during the service by concealing yourself behind a pillar and using the available light.

Find out the names of the bridesmaids and pageboys so they will respond to you more quickly and co-operatively. It is useful to enlist the help of the best man or of a relative when arranging people into groups, as they can call out names.

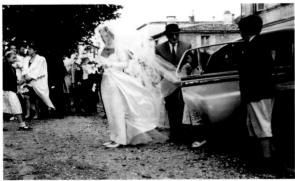 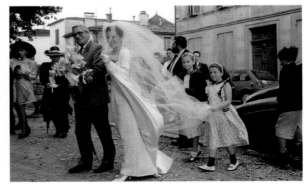

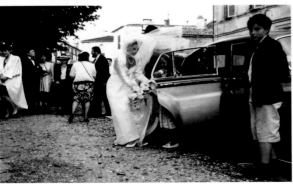

Find out where the bridal vehicle is going to stop. To eliminate unsightly background, shoot from low down so that the car conceals it. Don't expect the bride to wait longer than a brief pause. Let her know how many more pictures you plan to shoot, or she will think each one is the last.
Nikon 801, 28-85mm zoom, Kodacolor 400, 1/125 sec, f8

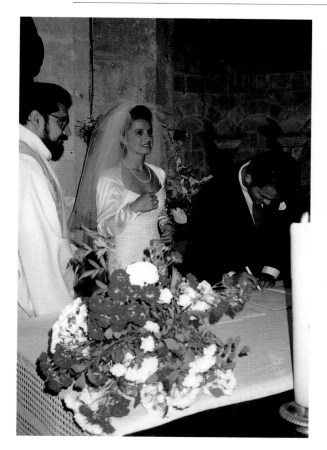

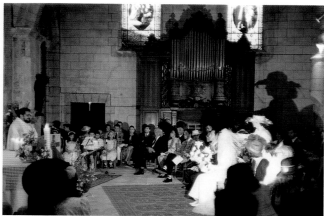

During the 1/30 sec that the shutter was open, the person in red flashed her camera and illuminated the lady on the right, casting a giant shadow on the wall behind. The camera that shot this picture was set for ambient light.
Nikon AW, 35mm, Kodacolor 400, 1/30 sec, f2.8

Signing the register is one of the key moments in a wedding sequence. Make sure the batteries are charged up and that you are in a good position. Use flash to ensure a sharp picture, and also shoot one or two frames without flash to capture the quieter atmosphere.
Nikon AW, 35mm, Kodacolor 400, auto-exposure

Sequences work especially well when the subject moves through a variety of positions, activities or expressions. Use motor drive and take several shots. Even if you miss the cork flying out of the bottle, the range of expressions will still be worth catching. Zoom or step forwards or backwards for different perspectives.
Nikon 801, 28-85mm zoom, Kodacolor 400, 1/125 sec, f5.6

CHECKLIST

Use fresh batteries for the flash unit and the camera, and carry spares.

Be ready for the highlights – signing the register, coming out of the church, throwing confetti, cutting the cake.

Find out the names of key people and they will respond more positively to your requests.

Do not skimp on film. They won't rerun the wedding for you.

Use motor drive and have more film unwrapped and labelled.

Be discreet during the service and shoot fast film to avoid using flash.

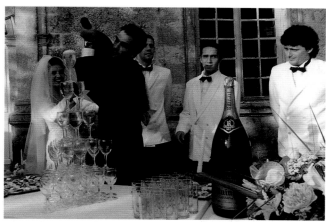

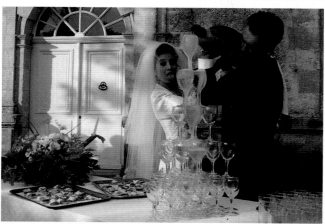

Ceremonies

Whether you feel personally involved or simply enjoy a sense of occasion, ceremonies provide a host of opportunities for your camera. The secret lies in the preparation. Find out what the programme involves so you are ready for the high points. Have plenty of film suitable for the conditions. And try to strike a balance between taking liberties and being sensitive to the atmosphere (see WEDDINGS).

Unless you can remain inconspicuous, it is much better to obtain approval before taking photographs during a devout or solemn ceremony, even if you are a relation. It is then easier to take more direct pictures, as at this bar mitzvah.
Nikon, 28mm, Kodak Tri-X (ISO 400), 1/60, f5.6

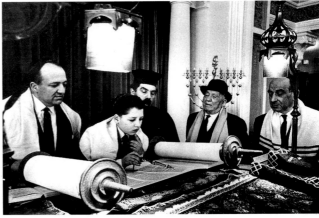

Photographing a Greek baptism without disturbing those involved calls for quiet movements and fast film to avoid using flash.
Nikon, 28mm, Ektachrome 200 rated at ISO 800, 1/30 sec, f5.6

A compact camera can take good record shots in the subdued lighting of a church when loaded with fast film and supported on a pew. Dark tape over the flash will retain the ambient atmosphere, including candlelight, and avoid an embarrassing intrusion. This confirmation picture is a good example.
Nikon AW, Kodacolor 400, auto-exposure

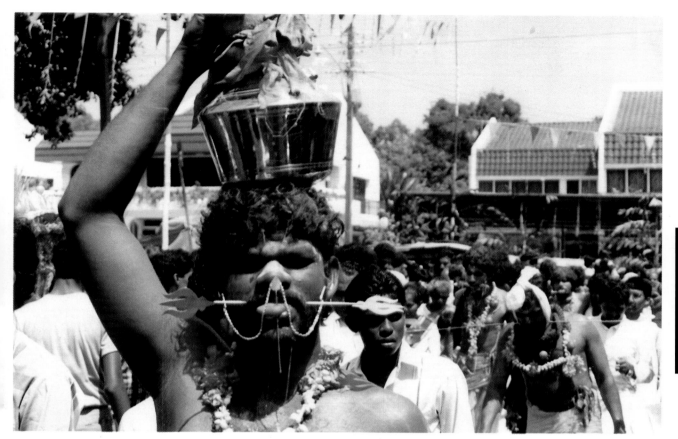

Trooping the Colour in London is a great spectacle full of rich colours and graphic shapes. Arrive early to establish a good vantage point, then use a variety of lenses to capture the overall scene. Focus on the lines and patterns that evolve as the pageant progresses.
Nikon 301, Vivitar Series 1 70-210mm zoom at 150mm, Fujichrome 100, 1/250, f5.6

In Penang, Malaysia, the Indians don unusual garb and pierce their mouths with pointed arrows during the festival at Tai Posam. Mingling with the crowd and using a fast film with an autofocus lens creates many photogenic moments (*see* IMPROMPTU PORTRAITS).
Nikon 801, 28-85mm zoom at 35mm, Kodacolor 400, 1/125 sec, f16

CHECKLIST

Arrive early.

Find out the programme of events or the route of a procession and pick a good vantage point.

For a better view stand on a camera box or on small folding steps, which can also be used as a seat.

Use fast film, such as Ektapress 1600, in dull light or when flash is frowned on.

Stick dark tape over the automatic flash on a compact camera to prevent it disturbing the proceedings.

Check guidebooks for ceremonies.

Strap a small umbrella to the bottom of your camera bag in case of rain.

Workers of the World

People at work are interesting photographic subjects and provide scope for exciting action shots. Because they are involved in an activity with which they are familiar, they feel less self-conscious about being photographed (*see* IMPROMPTU PORTAITS *and* POSING PEOPLE) and consequently reveal a lot about their character and lifestyle, giving an honesty and integrity to the photographs. Be open, and people will usually co-operate.

Besides providing a silver lining for the woodcuttters, the backlighting emphasizes the flying sawdust. Selective focus helps concentrate attention on the activity.
Nikon FE, 85mm, Kodachrome 64, 1/250 sec, f5.6

Portuguese fishermen repairing their nets. A medium telephoto produces a tightly framed picture without distracting the attention of the subjects.
Nikon FE, 105mm, Ektachrome 100, 1/125 sec, f5.6

A fairly slow shutter speed shows the movement of the hammer, thus giving the picture life while keeping the instrument itself clear enough to identify. The open door provides soft daylight and the blazing fire gives a glow to the shadow side of the blacksmith's face.
Nikon FE, 35mm, Kodachrome 64, 1/60 sec, f2.8

Sparks are usually visible against a dark background or clothing. Because they are generally brighter than daylight, expose as normal.
Nikon FE, 85mm, Kodachrome 64, 1/125 sec, f5.6

CHECKLIST

Pre-set the exposure to the ambient reading and focus the lens to 7 feet, ready to shoot quickly (see IMPROMPTU PORTRAITS)

...

Carry a Polaroid camera for instant prints to give people who help you.

...

Take a notebook to record details of people's occupations and addresses.

...

Take model release forms (see PRE-PRODUCTION).

...

Experiment using magenta and red filters with daylight film to compensate for the green cast produced by fluorescent lights in offices and factories (see TUNGSTEN AND FLUORESCENT LIGHTING).

...

Technique

To keep the line of Italian grapepickers in focus required quite a small aperture. In the fading evening light this meant using a slow shutter speed, which brought to life the foreground bunch of grapes.
Nikon, 35mm, Kodachrome 64, 1/30 sec, f8

Pets

Your own pets are sitting targets for you to photograph at different times and in a variety of situations. The greatest advantage is that they know you and are unlikely to be frightened away. Understanding their behaviour will help you get the best out of them. A few choice titbits will usually help ensure their co-operation. Other people are generally complimented if you want to photograph their pets, and may even buy a print. Use flash or fill-in flash, preferably off to one side for a better modelling light, to bring out the detail in a dog's or cat's fur, especially if it is black. Animals can be unpredictable. After you have taken a shot, always be on standby for another. Sharpen your reactions by practising focusing and zooming in and out (*see* ZOOM IN *and* SHOOT AND SHOOT AGAIN). The high pitched sound of a whistle or squeaky toy just before you take the picture will usually alert the animal and cause it to prick up its ears and look attentive. Don't overwork or risk hurting the animal. For a difficult set-up have a practice run before involving the star performer.

The pets' corners found in many country parks are ideal places to photograph tame animals. Concentrate on animals in an appealing pose and photogenic setting (*see* FRAME UP).
Olympus OM-2, 135mm, Kodachrome 64, 1/125 sec, f5.6

Electronic flash is needed to freeze movement and bring out the detail in the cats' coats.
Nikon, Tokina 50-250mm zoom at 125mm, Kodacolor 100, 1/125 sec, f22

CHECKLIST

Keep a whistle or squeaky toy handy to attract an animal's attention, but remember that overuse will make it ineffective.

Create simple backgrounds using sheets of coloured material or rugs.

Use a brush to groom the animals.

Set up action shots by throwing sticks and encouraging the animals to play.

Sticky tape can be used to remove cat and dog hairs.

A well-lit, calendar-like portrait calls for a studio set-up. Here light was shone through a T-23 head and reflected off a silver umbrella (*see* STUDIO LIGHTING).
Hasselblad, 150mm, Ektachrome 100, 1/250 sec, f16

A setter retrieving a stick on a carpet of autumnal leaves provides the ingredients here for a good action shot. By panning with the dog, its body is acceptably sharp while the undergrowth is blurred.
Nikon FE, 25-50mm at 50mm, Ektachrome 200, 1/60 sec, f5.6

You need fast reflexes to catch the vigour and vitality of animals at play. When presented with such an opportunity don't stint on film; you may end up with a sequence of winners.
Nikon F2, 85-250mm zoom at 250mm, Tri-X (ISO 400), 1/500 sec, f8

Handling Animals

Taking good photographs of birds and animals is a challenge which requires planning and patience, but can produce rewarding results. A tripod is a useful accessory, especially with telephoto lenses, although you may have to hold the camera when following a moving subject. Pre-focus on a nest, favourite perch or feeding place. Where possible ensure that the background is clear, or set a wide aperture to separate the subject from the background. Avoid sudden movements or noises. If you want to win the co-operation of more sensitive domesticated animals such as sheep or horses, it helps to have the owner present to control or comfort them. Try to ensure that the animal does not feel threatened or frightened. Sheep can actually pass out if it is very noisy! Some animals feel more secure if fenced in. Coaxing with titbits of food will work for a while, but don't overwork the animals or they will become fractious.

The exposure setting chosen for this contrasty scene was a compromise between the grass and the shadow area. If the shot had been exposed for the sky, detail in the golden eagle would be lost in shadow.
Nikon FE2, 105mm, Ektachrome 200, 1/125 sec, f8

To photograph sitting ducks, go to a wildlife or waterfowl santuary. By crouching still, with a telephoto focused on the nearer black swan, a series of shots were taken in slightly different positions. Intimate images are possible as they have largely overcome their fear of people.
Nikon 301, Vivitar Series 1 70-210mm zoom at 200mm, 1/250 sec, f8

When you are photographing temperamental, erratic or potentially dangerous animals, the owner should be present and take responsibility for them. A nylon lead holds the iguana in place and a gentle prod keeps the baby crocodile at bay while the trainer grapples with the boa constrictor. Other animals are stuffed.
Hassleblad, 40mm, Ektachrome 200, 1/60 sec, f22

Besides adding character to this shot, the ladder, together with another one just out of frame, helped keep the sheep together. Some of them are standing on a convenient mound of earth, thus making them more visible. The models in the background were briefed to keep watching the sheep and the shutter was released when they all made a pleasing shape. Inside the barn a small flash covered with orange gel was triggered by a slave unit responding to a small on-camera flash.
Nikon FM, 85mm, GAF 1000, 1/125 sec, f8

This studio shot was lit using electronic flash – an Elinchrom SQ44 – with a crescent-shaped mask placed over it to create the moon effect in the owl's eyes (*see* STUDIO LIGHTING). In addition, side lighting is more dramatic and brings out the texture of the feathers.
Hasselblad, 140-280mm zoom on macro, Ektachrome 200, 1/250 sec, f22

CHECKLIST

Check local guide books for bird sanctuaries and zoos.

By holding the camera close to a wire mesh, with the aperture wide open, the mesh will be too far out of focus to be noticed.

Conceal yourself behind vegetation and wear camouflage colours to avoid disturbing birds.

Take bread or other titbits as a lure.

On Safari

Wildlife safaris combine the thrill of the hunt with the sense of privilege you feel when you are close to wild animals and become part of their environment. This is an occasion when a simple compact camera is not sufficient. Although there are opportunities to photograph stunning panoramas, you usually need a substantial telephoto in order to see the whites of the animals' eyes! Ideally take two camera bodies fitted with 28-85mm and 80-200mm zoom lenses, or something similar. Consider using a teleconverter or hiring a longer lens (300-500mm), although you will often drive too close to be able to use it. Load a faster film (ISO 200 or 400) into the camera with the longer lens. This will enable you to use a faster shutter speed and avoid camera shake, which is more likely when using a telephoto lens (*see* TELEPHOTO AND TELECONVERTERS). Take time to observe and photograph animal behaviour rather than dashing off simply to notch up another species. Tripods are seldom practical in a vehicle, but useful when photographing from the game lodge.

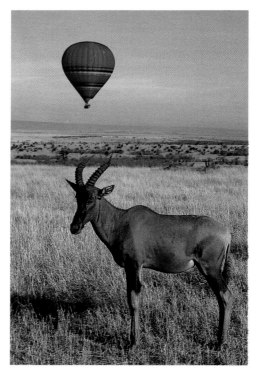

If a ride in one of the Masai Mara's hot-air balloons seems too expensive, you can at least photograph one with an obliging topi in the foreground.
Nikon 301, 35-70mm zoom at 70mm, Fujichrome 100, 1/125 sec, f11

In Kenyan game parks many of the animals pay little attention to the safari vehicles, enabling you to drive close to them. Neverthless, don't be tempted to leave your mobile hide for a closer look.
Nikon 301, 80-200mm zoom at 200mm, Fujichrome 100, 1/250 sec, f5.6

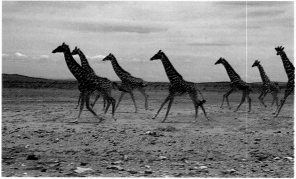

Moving animals are invariably more exciting than static portraits. These galloping giraffes in Kenya were photographed from a moving vehicle, using a fast shutter speed.
Nikon 301, 35-70mm zoom at 70mm, Fujichrome 100, 1/500 sec, f5.6

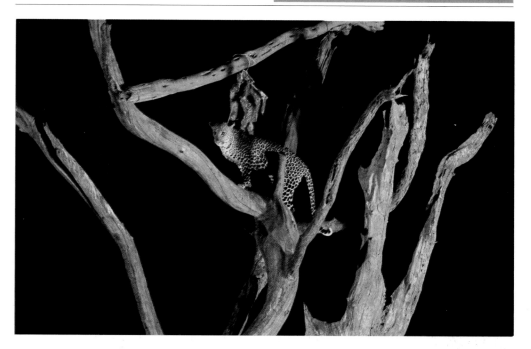

The cheetah feeding on meat tied to a floodlit tree was photographed from the security of the terrace at Ngulia Lodge, Tsavo West, Kenya. With the camera on a tripod, a series of images could be taken, bracketing the shots, with the cheetah in different positions.
Nikon 301, 80-200mm zoom at 200mm, Fujichrome 400, 1/125 sec, f5.6

Look for something that will elevate your photograph, whether an amusing expression, an endearing interchange between animals, or an interesting shape, as with this elephant's trunk mirrored by her baby's trunk.
Nikon F3, 28-85mm zoom at 75mm, Kodacolor 100, 1/250 sec, f8

Hippos snoozing in the cool water can become tetchy and suddenly thrash out at each other. Be ready to snap the drama from a safe distance. Photographed into the light, the hippos' wet backs glisten, adding vitality to the shot.
Nikon 301, 80-200mm zoom at 200mm, Fujichrome 100, 1/250 sec, f8

CHECKLIST

Test new or hired lenses before embarking on the trip.

Jot down or tape record the names of the different animals photographed. The end of the day is too late.

Whistle to attract the animal's attention for a confrontational picture.

Use fill-in flash for animals in the shade of a tree or in a cave (see FILL-IN FLASH).

Flip through publications such as National Geographic for ideas and inspiration.

Flowers

Flowers present an opportunity to experiment with lots of different photographic techniques – macro, wide-angle, fill-in flash, selective focus and so on. Consider the best times of day to photograph them, and the time of year to catch the fullest blooms. Before travelling abroad, research the flora to look out for and where to find them. Tourist boards and guidebooks will give you advice.

The lily is isolated by the speed flash held 4 feet from the camera on a 6-foot extension lead. The camera is on a mini-tripod on top of the camera case. The shot was exposed for the sky to keep the rest of the picture sombre (*see* FILL-IN FLASH). *Nikon 801, 28-85mm zoom, Kodacolor 200, 1/60 sec, f22*

Selective focus is an effective way of framing a single flower with a soft halo of colour. By lying down and using your elbows as a tripod, set the aperture wide open to give a very small depth of field. The longer the lens, the smaller the depth of field (*see* DEPTH OF FIELD). *Nikon, 105mm, Kodachrome 64, 1/250 sec, f5.6*

Technique

A wide-angle lens and small aperture ensured that the sunflowers were in focus from 3 feet to infinity. A wide-angle enables you to show prominently a few flowers in the foreground yet also include the whole field. The soft, slightly hazy afternoon sunlight helped reduce the contrast. If the sun had been bright, the shadowy areas would be very dark.
Nikon FE, 35mm, Kodachrome 64, 1/60 sec, f16

CHECKLIST

Explore different ways of photographing the same flower, including bounce and fill-in flash.

Most flowers are at their best in the morning.

Find out which seasonal flowers to look out for when travelling.

Take a small tripod and/or clamp, green garden wire and poles, a soft cloth, a water spray, cotton buds, and scissors to snip off extraneous leaves or twigs (see TRIPODS, POUCHES AND CASES).

A long lens compresses the elements of a photograph. If a wider angle lens had been used, the footscraper would have been too imposing.
Nikon, Tokina 50-250mm zoom at 150mm, Kodachrome 64, 1/250 sec, f8

Food and Drink

A two-dimensional picture has to be larger than life if it is to evoke a response from four of our senses. You can almost touch, smell and taste a good photograph of food or drink. The aim is to prepare the best possible ingredients, place them in an appealing setting, come in close so as to show every pore and drop of detail, and light the subject to bring out its texture and colour. Soft, diffused overhead lighting makes food look natural, and is a good starting point for experimentation. Carefully chosen props such as herbs and spices, cutlery and condiments enhance a display of food and drink. Fruit can be made appetizingly moist by brushing it with glycerine or spraying it with a fine water spray.

Contrary to appearances, 'peaches and cream' was not a simple shot. Deciding on an aesthetically pleasing arrangement was difficult, but locating suitable peaches proved the real nightmare. Crates of peaches were shipped in from New Zealand and California, yet eventually plastic window-display fruit was used. In order to increase the depth of focus and give the foreground peach a sculptured quality, the front of the lens was swung from left to right. Together with stopping down the aperture, this gave sufficient depth of focus to keep everything sharp.
Sinar 8 x 10, 165mm, Ektachrome 100, black net diffuser, 1/60 sec, f45

CHECKLIST

Squirting sliced fruit with lemon juice stops it turning brown.

Shaving foam can be used in place of whipped cream, and add gelatin to keep beer froth in place.

To simulate steam, blow cigarette smoke down a tube into or behind the food.

Use a dark background to highlight steam.

Electronic flash is easier on food as it is cool and will stop movement. Add tungsten light to give it a warm glow or to colour the background.

A chef proudly presents his buffet. Rather than use electronic flash, which would have killed the natural colours, the food display was shot in daylight.
Nikon, 28mm, Ektachrome 200, 1/60 sec, f4

A Strobe flash was placed inside the Tiffany lamp and powered by a 5000-joule pack, permitting a small aperture. Three silver reflectors were placed around the set to reflect light back into the hand and bottle.
Sinar 8 x 10, 300mm, Ektachrome 100, 1/30 sec, f45

Technique

Photographed on the stone floor of the office, the moody Brazilian-type light was created by a round head with a round reflector shining through slatted blinds.
Sinar 5 x 4, 150mm, Ektachrome 200, 1/30 sec, f32

A fish fryer provided the top light. White polystyrene bounced light back up into the model's face. As the fruit was real, the display was heavy and had to be shot quickly.
Sinar 8 x 10, 360mm, Ektachrome 200, 1/60 sec, f45

Table Tops

Still life studio photography is a precise, time-consuming craft, requiring meticulous attention to detail, cleanliness and great patience. Medium or large format plate cameras produce the quality needed for advertising and top editorial work. Also, their movable fronts and backs allow you to alter the perspective distortion and to control depth of field. Build up the picture piece by piece, assessing the impact of each additional prop or light. For a basic lighting set-up begin with top back lighting, which makes the object stand out from the background, and a front reflector. An infinity background can be created by curving a sheet of backdrop paper up behind the subject. Black velvet and satin provide ideal non-reflective backgrounds that do not show shadows.

Clear glass can be very photogenic. You can achieve a black edge to a bottle by placing black card either side of it, just out of shot, which is then reflected in the glass. Here, the background is an enlargement of a macro shot of a dictionary's vodka section.
Sinar 5 x 4, 150mm, Kodak Plus-X (ISO 125), 1 sec, f32

How would you illustrate an ad with the copyline 'To check if your spaghetti is cooked sling it at the wall'? Here, the shape of a hand was cut out of card and placed on an Elinchrom focus spot.
Sinar 5 x 4, 360mm, Fujichrome 100, 1/60 sec, f32

The lens on a plate camera can be angled to achieve sharp focus across the entire image. For this jigsaw puzzle, the lens was tilted forward 15°.
Sinar 8 x 10, 360mm, Ektachrome 100, 1/30 sec, f64

CHECKLIST

Study old masters for arrangements and lighting.

Consider coloured gels to warm or cool different areas.

A soft overall light can be created using a 'tent' of diffusing material around the subject and shining three or four lights through it.

Add one mini spotlight to give jewellery an extra 'ping'.

Place a two-way mirror in front of the lens so that it is not seen in reflective objects, and the same in portraiture, so that the subject is not confronted by the camera.

When using a plate camera with the bellows extended for close-up shots, allow one stop if the object appears half size on the ground glass screen, two stops if the image is the same size.

An old log riddled with woodworm provides a striking background for the necklace. Sufficient light was provided by a focus spot and two reflectors positioned around the wood. A small aperture was used to maximize depth of field as focus is critical when using a large format camera.
Sinar 8 x 10, 360mm, Ektachrome 200, 1/60 sec, f45

For the background a 6 x 6 colour transparency was blown to make a 20 x 30 inch Limitran which was taped vertically to a lightbox. The bottle was top lit by a fish fryer through a Strobe 5000 joules pack.
Background: Hasselblad, 80mm, Ektachrome 200, 3 min, f16
Foreground: Sinar 5 x 4, 360mm, Ektachrome 100, 1/60 sec, f64

Cropping

A few purist photographers refuse to allow their pictures to be cropped, but sometimes it is difficult to frame a shot perfectly. You may decide to crop into an image to isolate one element, or to move in closer than you were able to at the time, or because you have had second thoughts about the emphasis you want to give the picture. Cropping a picture can make it much punchier, eliminating anything distracting and concentrating attention more directly on the main subject. It can be hard to decide whether to shoot some subjects vertically or horizontally. The square format gives the option of cropping the image either way or leaving it square.

CHECKLIST

Make a pair of L-shaped matt black masks using black card, about 6 in x 2 in. Move these around on the transparency to find the desired crop.

Use masking tape or red Chinagraph over the plastic transparency sleeve to indicate crops; this also enables you to see the image through it.

Use a waterproof pencil to mark Polaroids.

Crop creatively. By cropping diagonally the picture is given extra strength and dynamism. Besides producing a more intimate image, the angle makes it more appealing.
Hasselblad, 120mm, Ektachrome 100, 1/60 sec, f11

While shooting you may miss extraneous items in the frame, or know that you intend to crop the sides later, as with these legs on the left.
Hasselblad, 80mm, Ektachrome 100, 1/125 sec, f11.5

By cropping into her left sleeve and the top of her hat, the eye is led more quickly to her face. A Diffuser One gives the shot a hot and hazy look.
Nikon, 105mm, Kodachrome 64, 1/125 sec, f8

Better composition can be achieved later by cropping into an image. Also, if you leave space around the subject when the picture is taken, a photograph can be published with a headline, text or a product shot printed over it.
Hasselblad, 120mm, Fujichrome 100, 1/60 sec, f11

By losing the foreground, the picture gives the impression that she is in a tranquil spot away from it all.
Hasselblad, 120mm, Ektachrome 100, 1/60 sec, f16

Flipping

You can often make a photograph more appealing by reversing or flipping it. The decision to flip may be a subjective one, but many believe that a picture works better when the elements are arranged so that the eye is led from left to right (*see* READING PICTURES).

If you know you are likely to flip a picture, try to avoid or cover up signs such as posters, logos, wedding rings, breast pockets and men's partings. Be careful when flipping photographs of people belonging to certain religions and cultures where there are strict rules about the use of the left hand (because it performs acts of personal hygiene). Do not suggest they are using this hand to eat, drink or for shaking hands.

The photograph of the trumpet player was originally the other way round. By flipping the image, the eye is drawn more naturally from the high area on the left to the man's face and then down to his hands. Fortunately, the badge on his cap is symmetrical, and left-handed trumpet players do exist!
Nikon, 105mm, Ektachrome 200, 1/125 sec, f8

If you ask someone to tilt his or her head or turn around, you will lose spontaneity. It's often better to shoot first and decide later to flip the picture to make it flow more naturally.
Nikon FE, Kodachrome 64, 1/125 sec, f8.5

The Frenchmen in the Café des Sports in Monségur were oblivious of the small compact camera, which was using only available light. The man in the foreground is the dominant figure, and although you cannot see his face, this is his story. The picture has more impact when printed with his powerful frame on the left and his head looking around to the billiard players on the right. Note how the man on the left is almost 'lost' on the machine print. By printing the whole negative a more dynamic composition is achieved.
Nikon AW, 35mm, Kodacolor 400, auto-exposure. Main picture printed on Kodagraph paper with Kodalith developer

CHECKLIST

Keep an open mind on flipping your pictures, appreciating that they may 'flow' better when reversed.

Remember that images shot in a mirror can be flipped.

Avoid or conceal notices, signposts, watches, clocks and so on.

Be aware of local habits and customs regarding the use of the left hand, especially in some Middle Eastern, African and Asian countries.

Movement

You have the choice of freezing movement with a fast shutter speed and/or flash, or emphasizing it by using a slow shutter speed. A moving object becomes a blur with a slow shutter speed, but, by panning with it you can keep it sharp while the background blurs.

At night and with an exposure of several seconds you can play games with movement by standing in one position for a few seconds then moving to another. An open shutter and series of flashes can record a sequence of positions in a dance routine or golfing stroke (*see* FIREWORKS AND FUNFAIRS, ELECTRONIC FLASH *and* DECISIVE MOMENTS).

Blurred movement often brings a picture to life. Although quite small, these grapes were emphasized by being held a few inches from the lens.
Nikon F2, 28mm, Ektachrome 200, 1/60 sec, f11

By panning with him the moving cyclist is almost pin-sharp whilst the background is blurred.
Hasselblad, 120mm, Ektachrome 200, 1/125 sec, f11

A slow shutter speed used in conjunction with electronic flash gives a sense of movement. Whilst daylight blurred the wheels, flash made the face sharp.
Hasselblad, 120mm, Ektachrome 200, 1/30 sec, f8

CHECKLIST

Try different shutter speeds on the same moving subject to see how much movement is evident.

Practise holding the camera steady at shutter speeds slower than 1/30 sec.

Make your body a rigid support, with legs apart and elbows tucked in. Breathe in when ready and hold your breath as you shoot.

Practise depressing the shutter release as you continue a smooth panning action.

Try panning using a tripod with the pan head loose.

Anticipate the peak of the action.

Experiment using flash with long exposures.

Oliver Scott shot this action picture to illustrate 'drop-offs' in an international mountain bike magazine, where it was used horizontally. Scott lay on the ground next to a ledge and exposed for the background. As the rider jumped over him, fill-in flash illuminated the bike and rider, and panning produced the blurred canopy (*see* FILL-IN FLASH). *Minolta 7xi, 28-105mm zoom at 28mm, Kodachrome 200, 1/8 sec, f8*

Special Effects

A can of cobwebs or spray mist can transform an ordinary scene into one full of mystery and drama. A more elaborate set-up might include a smoke or wind machine. Dry ice, often seen on stage, should be used in moderation and with care as it can cause breathlessness and make floors slippery. You could be sued if someone slips and breaks a rib! (*See* PERIOD PIECES *and* COSTUME DRAMA.)

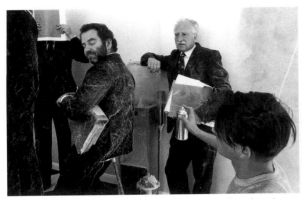

You can create effective fantasies cheaply using spray cobwebs. Use second-hand clothes or be prepared to have outfits dry-cleaned.

Set-up shot: Nikon, Kodachrome 64
Finished scene: Hasselblad, 60mm, Ektachrome 200,
1/125 sec, f22

A small amount of dry ice was used to create an ethereal mood appropriate to the ballerinas. The lighting on the leading lady had one layer of salmon gel to distinguish her from the others, who were lit through a light blue gel.
Hasselblad, 60mm, Ektachrome 200

CHECKLIST

Marine shops or theatrical specialists usually supply smoke bombs and flares.

Smoke bombs should be kept dry and isolated in an old biscuit tin as they get very hot. Use the lid or gloves to carry the smoking bomb.

Don't overdo the effects.

Rehearse the 'actors' and special effects so that you can see how they look through the viewfinder.

Carry a lighter and matches (as backup) to light the smoke bombs.

Take a brush and pan to clean up before and afterwards.

Cobwebs could damage valuable clothing.

Have fire extinguishers handy – carbon dioxide, water and sand – as special effects can be dangerous.

A steam machine behind the bath created occasional bursts of steam which added to the atmosphere and also perked up the horse.
Hasselblad, 120mm, Ektachrome 200, 1/250 sec, f22

In this scene reminiscent of Chicago in the 1930s a smoke bomb was let off in the foreground, then walked through to the back and around in a circle.
Hasselblad, 40mm, Ektachrome 200, 1/30 sec, f16

Long Exposures

Discovering long exposures opens up a whole new area of photography, creating images that are frequently not visible to the human eye.

Exposures longer than about thirty seconds may start showing reciprocity failure, that is, the dye in colour film reacts differently, causing a colour cast. Allow an extra stop to achieve richer, more saturated colours. A twenty-minute exposure of the night sky will show the stars as a series of white streaks due to the rotation of the Earth. You can shorten the exposure by using fast film and having the aperture wide open. With the camera on a tripod and the shutter held open, you can 'paint' a scene with light from a flashgun by multi-exposing it to illuminate a large area.

Take several shots when using long exposures on people, as they will inevitably move. The soft light was created by candlelight and tungsten lamps. The ghost image by the fireplace was created when Michael Joseph stepped into position half-way through the exposure.
Linhof 6 x 12, Agfa 1000, 10 sec, f45

CHECKLIST

Use a tripod, clamp or other support.

To give the camera an opportunity to settle down, use the self-timer rather than triggering the shutter directly.

As the sun is setting, keep checking the exposure to avoid underexposing by two or three stops.

Bracket exposures, since the results are seldom completely predictable.

A spot meter is the most accurate way of measuring the exposure of small areas as it has an angle of acceptance of only 1°.

Cover the lens with the lens cap or black card and tape for multi-exposures.

Carry a pocket torch small enough to hold in your mouth when reloading film or checking camera settings.

Technique

The background trees were illuminated with a
separate hand-held flash covered in light blue gel.
*Nikon, 28-85mm zoom at 35mm, Ektachrome 100,
cross-star filter, 3 sec, f11*

Just after sunset the camera was hand-held,
resting on a window ledge. The richness of the
evening sky changes every minute, providing a
variety of opportunities for pictures.
Nikon, 105mm, Ektachrome 100, 1/4 sec, f2.5

An automatic exposure of this scene would have
produced a washed-out image with none of this
atmosphere. To ascertain the exposure for the
illuminated window, a reading was taken from a
similarly lit room.
Nikon, 105mm, Agfa 100, 5 sec, f5.6

Reading Pictures

The eye is naturally attracted to lighter and brighter colours and to areas of activity (*see* COLOUR CO-ORDINATION). We are deflected away from out-of-focus subjects in favour of something in sharp focus (*see* DEPTH OF FIELD). We are also drawn to the human figure, especially if it is nude or outrageously clad. A photographer can use these principles to concentrate attention on key elements of a picture. If every part of an image has equal emphasis it can seem jumbled and confusing; the eye hops around randomly and the brain finds interpretation difficult or disconcerting.

There are rules to help you produce a balanced composition, for example having the main subject in one of the thirds. You are also taught to have the subject leading into the picture and not to have the horizon bisecting the photograph. But rules are made as starting points, and can be broken.

The break in the sky draws the eye to the cranes, hovering like spectators in the top left of the picture. From there you are led down to the two ladies in white and then across to the man in a beret on the right.
Nikon FE, 85mm, Kodachrome 64, 1/125 sec, f8

Selective focus is a very effective way of highlighting one section of a photograph. Here, the eye moves away from the out-of-focus subjects and lingers on the soldier in the middle, who is sharp.
Nikon FE, Tokina 50-250mm zoom at 130mm, Kodachrome 64, 1/125 sec, f5.6

The rows of twisted vines lead the eye towards the detail on the gate and picturesque roof of Château Cos d'Estournel in France.
Nikon 801, 28-85mm zoom at 40mm, Kodachrome 64, 1/125 sec, f16

CHECKLIST

Be aware of how a picture will be 'read' by the viewer.

Use composition and lighting to lead the eye around a picture.

Make sure the main subject is well lit and, perhaps, wearing something red, yellow or patterned.

Include a device such as a road, pathway or railing to lead the eye to the point of interest.

When composing a picture you should consider the angle of view, the shape of the image, the main focus of attention, what lens to use and so on. Here the road leads the eye up to the château, while shooting from a low angle incorporates an attractive foreground, giving the picture depth and drama.
Linhof, 65mm, Ektachrome 100, tripod, 1/8 sec, f45

Technique

139

Frame Up

Photographers spend so much of their time looking through a frame – the viewfinder – that placing a border around the subject comes naturally. Besides the viewfinder, additional framing within the picture can help hold it together, drawing the eye towards the subject and giving the scene depth. You can use clouds, a gateway, railings – or even actual picture frames! Put the frame out of focus to concentrate attention on the subject, or make a feature of it by using a small aperture and keeping it in focus (*see* DEPTH OF FIELD).

CHECKLIST

Look for unusual frames, especially ones appropriate to the main subject.

Use a long lens and/or wide aperture to throw the frame out of focus.

Use a wide-angle lens and/or small aperture to keep both the frame and the subject in focus.

A glimpse of the painter at work through the tools of his trade is an illuminating view of the activities in Montmartre, Paris. A wide aperture gives less depth of field, thereby separating him from the background.
Nikon, 50mm, Ektachrome 200, 1/60 sec, f5.6

The act of looking through the frames gave rise to these happy expressions. By bunching close together, an engaging interplay of hands was created. The group was lit by one soft 3-foot umbrella in an Elinchrom T23 head. It was shot on square format and cropped for a more compact picture.
Hasselblad, 140-280mm zoom at 140mm, XP2 (ISO 400), 1/125 sec, f16

Technique

The spray of snow provides an unusual frame for this skier in Zermatt. The backlit curtain creates an ominous shroud that is apparently pursuing him down the slope. A tobacco graduated filter was used (*see* GRADS AND POLARIZERS). *Nikon F3, 80-200mm zoom, Kodachrome 64, 1/250 sec, f5.6*

Dominated by the railings, London's Big Ben looks almost like a model. A small aperture keeps everything in focus from 2 feet to infinity (see DEPTH OF FIELD). *Nikon FM2, Agfachrome 100, 1/60 sec, f16*

The view of Istanbul would have been very ordinary without the bridge's decorative frieze, which is characteristic of the region. The frame focuses attention on the dome and small boat. *Nikon FE, Ektachrome 200, 1/125 sec, f8*

Zoom In

Once you have taken one shot of a scene, consider how it might be improved. Moving in closer will often produce a 'cleaner' image with greater impact. By zooming in you isolate the subject and also begin to notice additional details. Try to vary the pictures in an album or slide show, as they can easily become repetitive (*see* SHOOT AND SHOOT AGAIN, SEQUENCES *and* ODD ANGLES).

With two zoom lenses, for example 25-50mm and 50-250mm with macro, you can cover almost any situation. A zoom lens helps you compose a shot quickly rather than spend time changing lenses (*see* ZOOM LENSES).

The exterior of the Temple of the Reclining Buddha in Kuala Lumpur, Malaysia presents a busy image full of many elaborate elements, all competing for attention. It is complemented by a simple shot of a single statue, revealing exciting detail.
Above: Nikon, Tokina 50-250mm zoom at 50mm, Kodachrome 64, 1/125 sec, f11
Right: Nikon, Tokina 50-250mm zoom at 250mm, Kodachrome 64, 1/250 sec, f8

CHECKLIST

Every time you take a picture consider shooting another (better) one of the same scene.

Shoot a sequence of shots, moving progressively closer, focusing on a specific element.

With moving subjects, act quickly. Practise zooming in, especially if you have to focus manually.

The sun has caused some flare and stopped the exposure down in the first shot. A pink grad was used on this image to darken the sky and give it a little colour. By zooming in, interesting shapes and patterns can be highlighted. In the final shot, water droplets from the melting snow appear as streaks.

Nikon, Tokina 50-250mm zoom at 50mm, 150mm and 250mm respectively, 1/125 sec, (first image) f.8, (other two images) f5.6

Technique

You can achieve this effect even without a tripod. Set the shutter speed to 1/30 or 1/60 sec and zoom out as you trigger the release. Try this three or four times to increase the chances of success.

Nikon 801, 28-85mm zoom, Kodachrome 64, 1/60 sec, f8

Shoot and Shoot Again

When you've taken one picture there is a natural tendency to stop, especially if you feel self-conscious about photographing people. It takes a lot of discipline to reassess a scene, checking the exposure, composition and focus, and then shoot again. It comes more easily with practice (*see* ZOOM IN *and* DECISIVE MOMENTS).

A quick snap of someone makes a good record. If he then disappears or disapproves of another photo, at least you have an insurance shot. A second shot will catch his changed expression. He may relax or be turning away thinking that you've finished. Look again for more interesting detail, such as attractive headgear, best captured by zooming in close (*see* DETAILS *and* IMPROMPTU PORTRAITS).
Nikon, 105mm, Kodak EES 1600, 1/125 sec, f16

When you come across an interesting set-up, don't stint on film but keep shooting as the scenario unfolds. Move in closer, look for different angles, consider turning the camera on its side, catch candid moments as well as posed shots (*see* FIGURES IN A LANDSCAPE *and* SEQUENCES).
Nikon, 25-50mm zoom, Ektachrome 200, 1/125 sec, f8

The irony of the contrast between the nuns' appearance and the provocative abstract art in the Guggenheim Museum made it worth pursuing the theme in search of the most pleasing combination of shapes.

Nikon, 28mm, Ektachrome 200, 1/30 sec, f2.8

CHECKLIST

Shoot first, then consider how to improve the composition or pose.

If the elements of a picture are not very exciting, wait until they change, or orchestrate them into the image you want.

Check focus by zooming in before shooting again.

A zoom lens enables you to reframe quickly.

A motor drive or autowind will help ensure you are ready for the next shot.

Try to overcome feelings of self-consciousness when photographing people.

Be sensitive to any objections, but don't be intimidated by them.

Consider using two cameras to give both print and slide, or black and white as well as colour.

Sequences

A sequence of pictures can be a narrative or a story that unfolds, as in the launch of a hot-air balloon. Or it can be a progression of ideas, different ways of looking at a subject, different approaches you have to it. The pictures can then be framed together on a wall or used to illustrate a magazine article. The light may change dramatically during the day; return to a scene to show it in different lights (*see* SHOOT AND SHOOT AGAIN).

 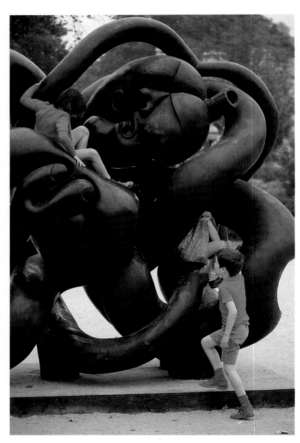

As on television or in the movies, the first picture in a sequence is usually a wide shot, establishing the location. Here, the Eiffel Tower is just visible through the mist. Then a tighter crop focuses on children wearing colours that contrast vividly with the sculpture. The final image concentrates on a small detail, providing a striking finale (*see* ZOOM IN *and* DETAILS).

Above left: Nikon, 80-200mm zoom at 80mm, Ektachrome 200, 1/125 sec, f11
Above right: Nikon, 80-200mm zoom at 120mm, Ektachrome 200, 1/250 sec, f8
Right: Nikon, 80-200mm zoom at 200mm, Ektachrome 200, 1/250 sec, f8

Choose the key moments in the sequence, which clearly tell the story (*see* DECISIVE MOMENTS). In this narrative the red helmet provides continuity between the shots, which begin with the drama of the pilot and burner and lead into the overall view of the hot-air balloon showing the helpers.
Nikon, 25-50mm zoom, Ektachrome 200, 1/60 sec, f8

CHECKLIST

Check batteries before embarking on an important sequence.

Use a motor drive on continuous mode to capture a fast-moving sequence of events such as a race.

Practise zooming in and out and focusing quickly on moving subjects.

Think in movie terms as you try different lenses to give a variety of perspectives. A zoom lens makes this much easier (see ZOOM IN).

Make a note of missing shots from a sequence so you can try again to fill in the gaps.

Consider arranging several small images around the single most eye-catching shot of the sequence, which could be printed much larger.

Decisive Moments

A good photograph is often the result of a combination of factors coming together at one time to create a visually exciting moment. Anticipation, patience and a willingness to shoot lots of film are the keys to capturing that moment. Follow the activity, attend rehearsals and plan your approach. What's the best angle? Which lens? Is a fast film necessary? Should you use a motor drive on single frame or continuous? Will a motor drive be too noisy, for example in a theatre? If you delay pressing the shutter until the decisive moment actually happens, you will miss is. Determine exposure beforehand, then wait with a finger on the button. Don't be discouraged if you miss the moment, just keep trying (*see* SHOOT AND SHOOT AGAIN).

There's a moment of great tension as the bull turns to eye the fallen picador. A second picador runs towards them and the crowd is transfixed.
Nikon, 85-250mm zoom at 85mm, Kodak Tri-X (ISO 400), 1/250 sec, f11

The split-second drama of the braking bull and swirling cape is strengthened by the position of the spectators. Good judgement and good luck both played a part in capturing the moment when the bull's horns were still within the area of the cape and the spectators balanced the scene perfectly.
Nikon, 85-250mm zoom at 250mm, Kodak Tri-X (ISO 400), 1/250 sec, f11

Technique

The decisive moment may not be an obvious culmination of an activity or activities, but rather a pleasing arrangement of elements in a scene, such as people's positions and expressions.
Nikon 801, 28-85mm zoom at 35mm, Kodacolor 400, blue-toned on Kodachrome paper, 1/125 sec, f11

An air of anticipation links the lady at the top of the stairs with the waiters. The lady on the left adds tension as she strides into this scene.
Nikon AW, Kodacolor 400, auto-exposure

Unless the shutter release is linked electronically to the rifle trigger you'll probably need several attempts to capture such a moment. When composing the picture anticipate where the projectile will go, then half depress the button and wait for the sound of the shot.
Nikon 801, 20mm, Fujichrome 100, 1/250 sec, f8

Colour Co-ordination

Because people react strongly to colour, your photography will be enhanced if you know the feelings evoked by different colours. Red signals passion, anger or danger; white and red indicate optimism; yellow is cheerful; brown is rich and secure; green denotes abundance or calm; blue is cold, distant, contemplative or reliable; white is a symbol of purity or coolness; black is either sinister or sophisticated. Red and white leap out of a scene and demand attention. A subtle blend of colours provides an appealing and contiguous image, while vivid contrasts present a striking and assertive picture.

Use colour to draw the eye to the main subject. Sometimes the repetition of a single colour or the strident juxtaposition of different colours can turn a mundane tableau into a stimulating scene.

The colour continuity looks prearranged, with the red, blue and blonde of the young lady echoing the colours of the shop front.
Nikon FE, 85mm, Kodachrome 64, 1/125 sec, f8

The two ladies came suitably clad to London's Chelsea Flower Show, in harmony with the rich displays. The sumptuous reds stand out strongly despite the soft, diffused light inside the marquee.
Nikon AW, 35mm, Kodachrome 64, auto-exposure

The reds, greens and blues of this fruit and vegetable market in Paris provide a continuity that holds the picture together. Led by the sunlit red dress, all the colours stand out to varying degrees from a bland blend of boxes.
Nikon FE, Kodachrome 64, 1/90 sec, f8

CHECKLIST

Concentrate on the colours that create the atmosphere you want.

Enhance colours with Kodak Wratten filters – 10-20CC will strengthen the colour mood.

Red and white are powerful attention-grabbers.

Notice how one colour can link different items together.

Look for strong colour combinations.

Study the work of painters such as Matisse and photographers such as Chico Biales and Pete Turner.

Kodachrome is an ideal film to bring out the vibrant colours of the Morris dancers' costumes in the sunlight. Even in overcast conditions the colours would look exuberant. The slower the film speed, the punchier the photograph.
Nikon FE, 80-200mm zoom, Kodachrome 64, 1/125 sec, f4.5

Four schoolgirls perched themselves on the steps of a beach hut near Cape Town in South Africa. Their cardigans and blazers match the hut, while their dresses and hats reflect the colour of the sand.
Nikon F2, Kodachrome 64, 1/125 sec, f8.5

The elements of this seascape in the South of France work well together. Fragments of red and white leap out from an essentially blue scene. The fish leads you into the picture. The white of the fish echoes the sail of the windsurfer. The man's red trunks and towel are similar in colour to the red of the fish.
Nikon FE, 35mm, Kodachrome 64, 1/60 sec, f22

Details

An interest in photography helps you notice beautiful or peculiar details you might otherwise miss. By making a conscious effort to look closely at things, you become more aware of shapes, textures and patterns in nature, as well as the fine craftsmanship invested in a wide range of artefacts.

A shot of the entire Column of Life in Oslo's Vigeland Park shows the sculpture in context, but it is hard to take it all in. Zoom in to one section of it and you can concentrate on a few of the figures you find appealing.
Above: Nikon 301, 28-85mm zoom at 35mm, Kodachrome 200, 1/250 sec, f11
Right: Nikon F2, 85-250mm zoom at 200mm, Agfachrome 50, 1/250 sec, f5.6

CHECKLIST

Shoot an overview, then seek out and isolate details.

Look for abstract shapes, patterns and textures
(see **SHAPES AND SHADOWS** and **REFLECTIONS**).

Move in close with a macro lens or close-up rings
(see **MACRO**).

Consider a hand-held flash on an extension lead to add character light.

This bundle of cork floats in Portugal makes an almost abstract picture. Coming in close emphasizes the shapes and texture, creating a piece of sculpture inspired by Christo's thought-provoking wrapped objects.
Nikon FE2, Ektachrome 100, 1/125 sec, f8

The texture of the wood and flaking paint would be lost in a wide shot of this Portuguese fishing boat. A close-up reveals the age and character of the subject.
Nikkormat, 80-200mm zoom at 120mm, Ektachrome 100, 1/250 sec, f5.6

The rusted, crumbling water-hydrant covers in Portugal are full of character and charm. Only by taking time to examine the detail would you see this opportunity for a photograph.
Nikkormat, Kodachrome 64, 1/250 sec, f8

Technique

The whole façade of a wine shop in Provence in the South of France contains a lot of detail. A stronger, more vibrant image is created by coming in close to the bacchanalian head.
Nikon FE, Ektachrome 200, 1/125 sec, f5.6

Shapes and Shadows

Sunlight, water, landscapes, architecture, clothing … unusual shapes and shadows appear in many different and often unexpected places, providing excellent subjects for photography. In nature, leaf patterns make a striking image with the sun shining through them. Dappled light on a leaf-strewn path, shadows on a wall, the arrangement of paving stones or shapes of modern buildings are all valid targets. Alternatively you can produce your own patterns by creatively lighting someone's face or body, or by constructing a lattice structure which throws shadows across your subject. This can add another dimension to an otherwise straightforward shot (*see* DETAILS).

The sombre evening shadows of a cemetery in Duras, France, required a wide aperture and slow shutter speed.
Nikon, 55mm, Agfa 200, 1/60 sec, f2

In Disneyland, California, strong sunlight cuts a contrasting diagonal shadow across a flamboyant assembly of pinks.
Nikon, Kodachrome 64, 1/60 sec, f11

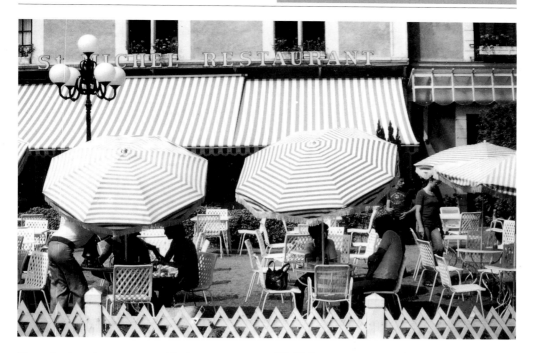

The striped awning contrasts with the octagonal umbrellas. The zig-zag of the fence in the foreground provides the base of the picture and echoes the lattice pattern of the chairs (*see* MONOTONE).
Nikon FM, 80-200mm zoom, Kodachrome 64, 1/125 sec, f8

The parallel lines of sunlight through the striped sunshade turn the sand into a large blanket whose pattern continues over the towel and the young lady!
Nikon FE, Kodachrome 64, 1/125 sec, f5.6

CHECKLIST

Look for patterns in a range of subjects by varying your viewpoint – move in close, pull back, try different angles.

Think of shadows as the subject of a photograph or as a way of enhancing a subject.

Over-expose by 1/2–1 stop when you want to retain shadow detail.

Make your own patterns by arranging people or objects into lines, curves or zigzags.

Examine the work of photographer Man Ray.

The lattice of stripes, created by sunlight through the slatted roof over the Marrakesh souk, leads the eye to the bright focal point of the arch, which is full of rich detail.
Nikon, 35mm, Kodachrome 64, 1/125 sec, f8

Technique

Reflections

Reflections can be visually exciting and can be found on a variety of unexpected surfaces. With the sun shining on the subject, glass buildings and shop windows provide interesting reflections of city life and architecture. Calm water reflects the land and sky to create a perfect mirror image, whereas a slightly disturbed surface breaks up the picture in a way that is often very attractive. A close look at any reflective surface – the chrome on a car, cutlery, puddles or a wet pavement – can lead to new picture ideas. Mirrors in all their shapes and guises offer many possibilities. Think of the convex mirrors in shops or on sharp bends in the road, wing mirrors or rear view mirrors in cars, or mirror sunglasses. You can even take your own mirror and position it to photograph a scene without people realizing what you're up to (*see* DETAILS).

Exposing for the shadow area of the chrome-balls sculpture in this French car park means that the glistening reflection is correctly exposed, but the sky is too bright. As the reflection itself is sharp, focus on that, not infinity.
Nikon 801, 28-85mm zoom at 40mm, Kodachrome 200, 1/125 sec, f11

Well-lit garish colours make good reflections, as in the lettering for this French casino bouncing off the polished surface of a car.
Nikon, 28mm, Ektachrome 100, 1/125 sec, f8

Technique

The still water of Salt Pond in Jamaica reflects almost perfectly the fiery sunset and line of palm trees. An amusing exercise is to invert a flawless reflection and see if anybody notices!
Pentax Spotmatic II, 50mm, Kodachrome 64, 1/60 sec, f5.6

CHECKLIST

Either shoot at an angle to the reflective surface or wrap your camera (and yourself) in black felt or cotton to avoid being visible.

Carry a small mirror to reflect subjects or to bounce light on to the subject.

Experiment with distorted reflections on uneven surfaces.

Take a clamp or stand to support mirrors and reflectors.

A mirror image can help create an unusual and eye-catching portrait or fashion shot. Mirror foil stretched over a frame is a safe, light and inexpensive alternative to a glass mirror
(*see* ROOM SETS).
Hasselblad, 140-280mm zoom at 280mm, Ektachrome 200, 1/60 sec, f22

Odd Angles

A different viewpoint often produces head-turning shapes and perspectives. Look straight up or down and discover a new range of photographic possibilities. From the air, a beach becomes a pattern of people on a coastal collage, buildings appear to be redesigned, and a landscape becomes a map. Many skyscrapers have an observation platform open to the public (*see* DETAILS, TAKE ANOTHER LOOK, HOVERING *and* ARCHITECTURE).

This bizarre viewpoint was recorded by placing the camera, fitted with a fish-eye lens, on a counter in the Galeries Lafayette in Paris. Focus was not a problem as the depth of field on a fish-eye lens is invariably from a few inches to infinity. A self-timer was used.
Nikon, 8mm, 1/8 sec, f8

If you have the opportunity to fly in a light aircraft, hot-air balloon or parasail, take a camera and plenty of film. A small compact is easier to handle. If permitted, open the window of a light aircraft to avoid reflections on the glass. Use a fast shutter speed to freeze any vibration.
Nikon, 28-85mm zoom at 65mm, Kodak Tri-X (ISO 400), 1/500 sec, f11

Skyscrapers provide a good vantage point from which to look down on ornate architecture that cannot be appreciated from street level. The position of the yellow cab just makes the shot. *Nikon 801, 28-85mm zoom at 40mm, Kodachrome 64, 1/125 sec, f8*

Looking down to a red mobile in the atrium of the Guggenheim Museum in New York, the balconies form strong curved patterns, echoing the circles of the mobile and the floor design. *Nikon, 28mm, Kodachrome 64, 1/60 sec, f3.5*

CHECKLIST

Keep your eyes open – in all directions!

Look for vantage points such as tall buildings and bridges, gliders and helicopters.

Consider putting the camera on the ground and using the self-timer.

If shooting through glass, take black card with a hole for the lens in order to reduce reflections.

Monotone

Monotone images on colour film can be very satisfying. With a limited number of colours in the picture, attention is drawn to the form and content. Colour contrast is kept to a minimum when the light is subdued, for example in the shade. Existing light can be enhanced to create monotone effects with the considered use of filters (*see* COLOUR CO-ORDINATION).

Both pigeons tone in with the mottled backdrop. In fact, one blends so unobtrusively with the doorway that it might remain unnoticed, without the gaze of the other pigeon leading the viewer's eye in that direction.
Nikon FE, 80-200mm zoom at 135mm, Kodachrome 64, 1/250 sec, f8

There is a lot of character and detail in the crumbling walls, wooden panelling and faded green shutters, yet these do not detract from the two French ladies and their crochet-work, which provides the focal point of the story.
Nikon FE, 80-200mm zoom at 80mm, Ektachrome 200, 1/125 sec, f5.6

The low evening light in rural Iran provides a suitably muted atmosphere that emphasizes the unity of material and colour. Even the dry vegetation is in harmony with the soft tones of the sheep and the shepherd boy's clothing. The only warm glow comes from his sunburnt face directly confronting the camera from the centre of the frame (*see* IMPROMPTU PORTRAITS).
Nikon F2, 80-200mm zoom at 135mm, 1/60 sec, f4

Even when a scene includes many vibrant colours, a low-key picture is created by shooting in the shade and underexposing by $1/2$ a stop or 1 stop.
Nikon FE, 80-200mm zoom at 150mm, Kodachrome 64, 1/125 sec, f5.6

CHECKLIST

Shoot in subdued, low-contrast light.

Create your own monotone image by careful selection of clothing and props, or even by painting elements within the picture.

Use CC filters on the lens to enhance existing colours.

Use coloured gels over the flash to wash a scene with a uniform colour.

Remove or avoid items with distracting colours.

Signs of the Times

Each day we are confronted by hundreds of signs and statements that provide information, advertise products or services, express anger, frustration or delight, or indicate the passage of time. Besides affording many photogenic opportunities they give you the chance to make a comment on, or document, modern life (*see* DETAILS).

Neon lights are well defined against dull backgrounds or at night. Auto-exposure on daylight film gives a good result.
Nikon, Tokina 50-250mm zoom at 150mm, Ektachrome 200, 1/60 sec, f5.6

From corny cliché and illegible scrawl to social comment and sophisticated art form, graffiti evokes a variety of responses, whether in the Dominican Republic or elsewhere.
Pentax SPII, 50mm, Kodachrome 25, 1/60 sec, f8

A collection of amusing signs on a single theme, such as animals, can form the basis of a magazine article or book (*see* SELLING YOUR PICTURES).
Nikon, 50mm, Ektachrome 100, 1/125 sec, f3.5

Whether motivated by a sense of humour or a prim sense of decency, someone felt the need to tear off the kiss from this perfume ad.
Nikon 801, 28-85mm zoom at 85mm, Ektachrome 200, 1/125 sec, f5.6

The wear and tear of time has created an abstract collage out of a Japanese poster that appears to be blowing in the wind.
Nikon, 50mm, Ektachrome 200, 1/125 sec, f8

The functional notice and the signs of urban decay paint a desolate picture full of atmosphere and narrative.
Nikon FE, 105mm, Ektachrome 200, 1/60 sec, f4.5

Controlled graffiti verges on art. Here, the stance of the artists reveals their attitude to the mural. Speedflash on camera produced appropriately punchy lighting.
Nikon 801, 28-85mm zoom at 40mm, Kodacolor 400, 1/60 sec, f11

CHECKLIST

Constantly be on the lookout for interesting signs, posters and statements about our world.

Carry a small flash, preferably with an extension lead.

Look for abstract designs and patterns in examples of urban decay and weathered posters.

Take Another Look

There's nothing wrong with shooting predictable views of well-known landmarks. But don't leave it there; look again. Try to find a viewpoint that tells a story or shows the subject in a fresh light. Shoot in dramatic weather conditions or using creative techniques. In a new city take a sightseeing tour to decide which locations are worth spending time at, and exploring different ways of photographing them (*see* SHOOT AND SHOOT AGAIN *and* ODD ANGLES).

The eagle looking down from the roof of the American Embassy in London has added impact when viewed from below.
Nikon, 35mm, Ektachrome 100, 1/125 sec, f8

This shot of the Washington Monument is given greater depth by the foreground car, which almost seems to have flags growing out of its roof.
Nikon, 55m, GAF (ISO 1000), 1/250 sec, f16

By including the silhouette of father and son, this picture of the Lincoln Memorial in Washington is given a narrative, one that can be used to evoke the theme of following in someone's footsteps.
Nikon, 55m, GAF (ISO 1000), 1/125 sec, f5.6

The skyscrapers of New York present a poignant contrast to the statue of a hunched Mahatma Gandhi picking his way through the streets of Manhattan.
Nikon 301, 28-85mm zoom at 60mm, Fujichrome 100, 1/60 sec, f16

By concentrating on the dramatic gesture and by exposing an extra half-stop to show some of the shadow detail, the Lafayette statue seems to come to life.
Nikon, 55m, GAF (ISO 1000), 1/250, f16

The columns and flags identify this as the White House without having to include the entire building. The classic view of the familiar landmark is given new life when it forms the backdrop to a transient human scenario.
Nikon, 85mm, GAF, 1/250 sec, f11

CHECKLIST

Look through travel books and magazines for landmarks with the potential for imaginative pictures.

Look for unusual angles and zoom in close to isolate details (see ZOOM IN and DETAILS).

Shoot on video as an audio-visual diary, then review the subjects later when you have time to consider novel ways of approaching them.

Technique

Dawn to Dusk

The quality of light, as well as its direction, changes throughout the day. The early morning and late afternoon generally provide the best light for photography. When the sun is low in the sky, its rays pass obliquely through the Earth's atmosphere, which acts as a diffuser, scattering blue and ultraviolet wavelengths. Dawn often presents soft, muted pinks, then, as the sun rises higher, the light becomes harsher, contrast greater, and shadows deeper and shorter. At midday the sunlight is passing through a relatively thin layer of atmosphere, so more white light penetrates. Afternoon light turns progressively warmer and more golden as the shadows lengthen.

Dawn light can be exhilarating, fresh, cold and well worth the effort of rising early. The sky over the Penang Bridge is enhanced using a tobacco grad. This decreases the contrast between the sky and foreground (*see* GRADS AND POLARIZERS). You must work fast, as dawn light lasts only minutes (*see* GOLDEN HOURS).
Linhof 6 x 17, 90mm, Ektachrome 100, 1/30 sec, f11

The four cypress trees stand out dramatically in the mid-afternoon light. With the horizon at the bottom of the picture the shot is opened out, emphasizing the sky. A spreading filter is necessary to spread the light right across this wide-angle lens, and an extra stop is required. A tripod was used because of the slow shutter speed.
Linhof 6 x 12, 65mm, Ektachrome 200, 1/15 sec, f32

The late afternoon sun in the Bahamas is warm, golden and flattering to skin tones. It often possesses a crispness that makes every grain of sand appear tactile.
Nikon FE, 85mm, Kodachrome 64, 1/125 sec, f5.6

In the late morning as the sun nears its zenith, hard shadows are cast across people's faces, especially if they are wearing hats. Illuminate shadow detail with fill-in flash or a reflector.
Nikon FE, 85mm, Kodachrome 64, 1/60 sec, f8

Technique

At dusk the filtered sunlight from below the horizon illuminates the sky to provide a dramatic backdrop to this Singapore skyline. Photographs of city lights are usually more impressive when some light remains in the sky to provide a context for the buildings.
Nikon 301, 35-70mm zoom at 35mm, Fujichrome 100, 1 sec, f8

Into the Sun

Probably one of the first things you learned in photography was to have the sun behind you. Forget it. Shooting into the sun can create more dramatic pictures when rays of sunlight break through the clouds or burst over rooftops, whilst reflections on water produce stunning effects and flare lends impact to a shot. An automatic exposure setting will take into account the intense light from the sun and close the aperture, producing a dark picture, so you may need to compensate for this by overexposing by half or one stop. If using an automatic camera that automatically cuts out the flash if the scene is bright enough, direct the camera to a dark area, then half depress the button to activate the flash (*see* THE GOLDEN HOURS *and* FILL-IN FLASH).

As the sun bursts over the Opera House in Sydney, Australia it creates a stunning silhouette. This effect can be achieved by setting the exposure to automatic and positioning the camera at the edge of the shadow of a building, statue, sail or person. *Nikon 301, 35-70mm zoom at 35mm, 1/500 sec, f16*

Shooting straight into the sun produces flare, where light is reflected by the interior of the camera or lens. A 4 ft x 6 ft silver reflector placed on the snow just out of frame below the deckchair bounced light back on to the man, thereby avoiding a silhouette. *Hasselblad, 50mm, Ektachrome 200, 1/60 sec, f22*

Technique

Rays of sunlight burst through clouds and are reflected on the surface of the water, a recipe for an inspiring picture.
Nikon FE, 25-50mm zoom at 50mm, Kodachrome 64, 1/125 sec, f5.6

CHECKLIST

Clean greasy marks and dust off the lens as these will cause extra flare when shooting into the sun.

Reduce flare by using a lens shade for backlit subjects, although it will have no effect when shooting directly into the sun.

To avoid silhouettes, use fill-in flash, a reflector, or overexpose by half or one stop.

If in doubt, bracket the exposures.

Photograph the sun bursting over a ridge or rooftop, or through a statue's arms.

Use a graduated filter to reduce the contrast between a bright sky and darker foreground (see GRADS AND POLARIZERS).

Give the top half of the picture a rich orange hue and warm the overall image with a sunset filter.

A normal exposure was appropriate as the light source was not very bright. The 3-D effect of the water's movement is the result of a slow shutter speed.
Nikon FE, 35mm, Ektachrome 100, 1/30 sec, f8

The Golden Hours

Sunrises and sunsets both give a very appealing golden light, although sunsets are richer. The quality of light is more flattering than harsh daylight. This is a time when, because the sun is lower in the sky, it highlights particular subjects and produces graphic silhouettes and long, photogenic shadows.

The first light of a February morning is cold in Eastbourne, England, yet the Mediterranean quality to the scene made the discomfort worthwhile. The pinky-golden light on the young lady's face had to be caught within three minutes of the sun rising. *Hasselblad, 140-280mm zoom at 140mm, Ektachrome 200, 1/60 sec, f8*

CHECKLIST

As the light changes quickly at sunrise and sunset be ready to respond accordingly.

Use shadows to frame the picture or lead the eye to the main subject.

Look for interesting silhouettes and subjects spotlit by the low sun.

Experiment with graduated filters, including sunset filters, to enhance the existing light (see **GRADS AND POLARIZERS**).

Shoot close-up portraits in the soft evening light using a medium telephoto lens.

The evening sun picks out the line of buildings across the canal, while the almost silhouetted gondolas in the foreground give the picture depth. With the low light and fairly wide aperture, a wide-angle lens ensured a good depth of field so that both the gondola tails and St Mark's in the distance are sharp. If auto-exposure had been used, the golden buildings would have been overexposed because the camera would have taken its reading from the dark foreground occupying most of the area. This more dramatic exposure can be determined by pointing a spot meter at the buildings, or by bracketing the shots. *Nikon F2, 28mm, Kodachrome 64, 1/125 sec, f5.6*

The rich evening light throws heavy shadows on to the tombstones and stark statues in this Parisian cemetery. The picture is framed by shadows.
Nikon, Tokina 50-250mm at 75mm, Kodachrome 64, 1/60 sec, f4.5

The low winter sun draws the eye towards the warm glow in the centre of the Albert Memorial in London's Kensington Gardens.
Nikon, 105mm, Ektachrome 200, 1/125, f8

Grey Days

Bad weather should not prevent you from taking out your camera. Snow, rain, mist, drizzle and hail can produce very powerful, evocative photographs (*see* SNOW TIME). The elements can provide an exciting backdrop, add atmosphere to a scene or create the photogenic activity. Imagine the drama of giant hailstones bouncing off a car roof or people struggling against a violent wind. Rain gives the street a shine that reflects lights and colours (*see* REFLECTIONS).

Protect your camera in a plastic bag, with a hole for the lens to protrude through and another hole for the eyepiece, and use a long, improvised lens shade.

Undeterred by the dripping trees, art continues to flourish in Montmartre, Paris. The canopy of leaves prevents the bright sky from being distracting.
Nikon FE, 35mm, Ektachrome 200, 1/60 sec, f4

Powder snow can be deceptively soft. Use a piece of board to support you and your tripod.
Nikon AW, 35mm, Kodacolor 200, auto-exposure

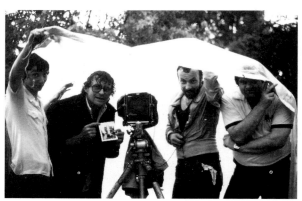

An umbrella or large plastic sheet will keep the rain off while shooting. Wear suitable protective gear.
Nikon AW, 35mm, Kodacolor 200, auto-exposure

Mist produced soft, muted colours around these olive trees in Majorca. Most of the detail is gone, accentuating the statuesque shapes of the trees. Mist and fog can have a similar effect to selective focus, isolating one prominent feature, while causing others to recede into the background.
Nikon FE, 80-200mm zoom at 100mm, Ektachrome 200, 1/90 sec, f5.6

A subdued, sombre light seems fitting for the Chinese cemetery in Malaysia. The designs on the tombstones are sufficiently rich and colourful to stand out despite the dull day.
Linhof 6 x 12, 65mm, Ektachrome 100, 1/4 sec, f32

CHECKLIST

Use a waterproof or 'all-weather' camera.

Take a mini umbrella and/or plastic sheet and bags to protect the equipment.

Seek out interesting shapes, patterns and textures that do not need bright sunlight.

Take advantage of the absence of harsh shadows by shooting close-ups of people.

Try a light gold or salmon-straw filter (81C) over the lens to warm up skin tones against a cool background.

Consider using fill-in flash to pep up the foreground (see FILL-IN FLASH).

Professional flash can be dangerous in very damp conditions. Take rubber mats or polystyrene boards for people and equipment to stand on.

Dress appropriately in moon boots and anorak with a hood or protective hat.

Take a flask of soup or hot chocolate!

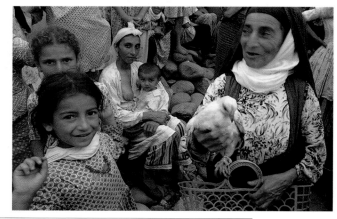

An overcast sky has produced even tones in this Turkish market. Strong sunlight would have created deep shadows and less relaxed expressions.
Nikon, 28mm, Ektachrome 200, 1/60 sec, f16

Low Light

Keep your camera handy after the sun goes down. With fast film and/or a tripod you can shoot amazing images in very low light. Try not to resort to using flash, although fill-in flash, possibly covered with coloured gels, can be used to highlight foreground activity (*see* FILL-IN FLASH). An ISO 1000 film will be fast enough for dull conditions, and the film can be pushed (uprated) one to three stops (*see* COLOUR TRANSPARENCY). Generally, faster film is grainier and a little redder, especially in the shadow areas, but this can be eliminated during duplicating or printing. Alternatively, a tripod, wall or tabletop will provide support, allowing you to use slow shutter speeds without the risk of camera shake (*see* GREY DAYS).

Low-light photography opens up a whole range of possibilities. By kneeling down with elbows tucked in, the camera can be held still enough for the slow shutter speed.
Nikon FE, 85mm, Kodachrome 64, 1/30 sec, f2.8

Dusk is a good time to shoot as street and house lights give the picture a warm glow, while a glimmer of light in the sky provides added depth and drama. The top of the car provided a substitute tripod.
Nikkormat, 28mm, Kodachrome 64, 1/30 sec, f3.5

Even when set at a wide aperture, a wide-angle lens gives a good depth of field. This photograph of fountains in Paris is sharp from about 12 feet to infinity. The shot was intentionally underexposed by one stop to make the clouds more dramatic.
Nikon F2, 28mm, Kodachrome 64, 1/60 sec, f2.8

Dramatic shapes and different light sources give this shot more impact than a daytime picture.
Nikon, 28mm, Kodachrome 64, 1/60 sec, f4

The clear late-evening sky merges perfectly with the water casting a tranquil light on this line of Portuguese fishermen. The image was flipped, as it reads better this way (*see* FLIPPING).
Nikkormat, 50mm, Ektachrome 100, 1/60 sec, f4

Although a tungsten film would have reproduced the colours inside the Blue Mosque in Istanbul, Turkey, more accurately, daylight film has produced a warmer atmosphere. A wide-angle lens gave sufficient depth of field to keep both the foreground lights and the top of the domes in focus (*see* DEPTH OF FIELD). If a tripod is too unwieldy or unwelcome in such a place, use a fast film. Take an average exposure reading, then underexpose by one stop and overexpose in half-stop increments. Make a note of the settings used.
Nikon F2, 35mm, Ektachrome 200, 1/60 sec, f4

CHECKLIST

Use a tripod or clamp for long exposures, or rest the camera on a wall or table.

Consider uprating (pushing) fast film one to three stops; for example, when EktaPress 1600 is pushed three stops it becomes ISO 6400 (see COLOUR TRANSPARENCY).

Make notes of exposures and filters used in unusual conditions, especially when testing new filters.

Carry a small flashgun with an extension lead of about 12 feet to give a more dramatic and even light.

Consider putting a gold or orange gel even if only on part of the flash.

Snow Time

Whether you're tramping the city streets or skiing in the mountains, snow provides scope for humorous scenes and graphic images. Snow acts as a huge blanket reflector, softening shadows. Tobogganing and skiing are especially colourful situations.

Snow stimulates people to react in a variety of ways, often with photogenic results, as with this harmless transient graffiti.
Nikon 801, 28-85mm zoom at 85mm, Konica 100, 1/125 sec, f8

A snow-laden sky gives a dull, flat light. Use a fast film for sufficient depth of field.
Nikkormat, 35mm, Ektachrome 200, 1/60 sec, f8

Be ready to catch people's responses to snow. A fairly slow shutter speed gives a little movement in the falling snow.
Nikkormat, 85mm, Ektachrome 200, 1/60 sec, f4

CHECKLIST

Carry an all-weather compact camera with a fast film (ISO 400).

Protect other camera gear in plastic/waterproof bags.

Don't let batteries or film get too cold. Batteries slow down and film becomes brittle.

Use a small blow-brush to blow snow off the lens, then a lens tissue for the final clean.

When skiing carry a lightweight camera bag, ideally worn on a belt at the front.

If you fall try to fall to one side so you don't damage either yourself or your equipment.

Take a piece of board as a platform to prevent you or your tripod from sinking into powdery snow.

Carry a selection of grads to invigorate a dull sky – blue, pink and tobacco.

Allow extra time to perform tasks.

A misty effect can be achieved by breathing on the lens. Within five seconds the lens will be clear enough to produce an atmospheric image.
Nikon, 28mm, Ektachrome 200, 1/60 sec, f4

A light blue grad positioned at an angle added drama to a dull sky. A fairly slow shutter speed picked up the movement of the foot and ski pole.
Nikon 801, 28-85mm zoom at 75mm, Kodachrome 64, 1/60 sec, f16

The bright conditions ensured a good depth of field. The two skiers with touches of red on their skis echo the blood on the cross.
Nikon AW, 35mm, Kodachrome 64, auto-exposure

Hovering

Shots from the air can provide an exciting view of the world. It's a great opportunity to photograph interesting shapes, patterns and Lilliputian scenes.

On a scheduled flight try to find out which side of the aircraft will afford the best views, and check in with plenty of time to reserve a window seat. Clean any obvious marks off the window and then shoot through the cleanest section. With a shutter speed of at least 1/250 sec, aperture as wide as possible and focus on infinity, hold the camera close to the window. On certain pleasure trips in light aircraft the pilot will make a point of trying to give passengers the best view. If possible explain to the pilot beforehand what you would like to achieve. In general the clearest pictures are shot from a low altitude, with a minimum of haze between the camera and subject.

Whenever possible enlist the co-operation of the pilot. Discuss maps and diagrams of pictures you hope to shoot. Work out the ideal altitude for both subject and equipment. If the pilot appreciates how wide an angle of view you have, as with the Fuji 6 x 17, he will know how low to fly.
Nikon, 28mm, Kodachrome 64, 1/125 sec, f8

From above, a busy beach scene becomes almost abstract. The shot can be cropped into any number of different shapes. The glinting sunlight on the waves contrasts starkly with the sandy beach.
Nikon, 28-85mm zoom at 65mm, Kodak Tri-X (ISO 400), 1/500 sec, f11

Shot through the window of a helicopter, the P & O Crown Princess looks impressive with all lights blazing. A fast film and steady hand were needed to obtain a good result.
Nikon 801, Tokina 50-250mm zoom at 60mm, Agfacolor (ISO 1000), 1/60 sec, f4.5

Parasailing is an effective way of viewing the beach from above, as in this shot overlooking Sandals Hotel in Jamaica. Strapped into a parachute harness, you are lifted aloft and towed by a speedboat. Unless you have great faith that you will land on the beach, a waterproof camera is advisable.
Nikon 301, 20mm, Fujichrome 100, 1/250 sec, f8

The Pulau Suluq Islands in Saba are the stuff of dreams and travel brochures. Shot from a helicopter at 2000 feet, a fast shutter speed has picked up individual branches and pieces of drift wood. The focus was set on infinity as depth of field was not a problem. A polarizing filter was used to enhance the richness of the sea (*see* GRADS AND POLARIZERS).
Fuji 6 x 17, 90mm, Ektachrome 200, 1/500 sec, f5.6

CHECKLIST

Focus on infinity and hold the camera off the window to avoid vibration.

To avoid reflections in the window, hold a dark coat against the glass or a piece of black card with a hole cut out for the lens.

Take a backup camera whenever shooting unrepeatable or costly photographs.

Make a note of the locations as you photograph them.

Be ready to combat a strong wind if you have the opportunity to open the door or window.

Use a polarizing filter to add to the drama of the sea. The filter will decrease the exposure by one to two stops.

Technique

Flying Time

Air travel presents a host of picture possibilities just when you have time on your hands. Instead of curling up with a novel or worrying about the delayed flight, use the time to test, clean and check your equipment. If a one-hour processing lab (C41) is open, shoot a test roll and examine the results. Check for sharpness at slow shutter speeds and check focus accuracy. Experiment with shots inside the airport where different light sources may give unusual colours. Look at the often incongruous dress or behaviour of people travelling. Try to avoid putting film, especially the more sensitive fast film (ISO 1000 and faster) through X-ray machines at airports; ask for a hand search or use an X-ray bag.

Fellow passengers can provide good subjects, as in the case of this contemplative face. With a wide-open aperture focus is critical because there is very little depth of field.
Nikkormat, 85mm, Kodachrome 64, 1/60 sec, f2.8

The reflection of the window frame echoes the spinning propeller over the Bahamas. A shutter speed of about 1/8000 sec would have been required to halt the movement, as the propeller was so close.
Nikon, 25-50mm zoom at 25mm, Kodachrome 64, 1/500 sec, f8

CHECKLIST

Take a tripod.

Use waiting time at airports to check equipment, and consider buying accessories at duty free prices.

Look for reflections and abstract designs as well as bizarre and interesting clothing styles.

Consider shooting airport exteriors, destination boards and lines of plane tails for business magazines or stock libraries. But note that in some countries this is illegal.

Technique

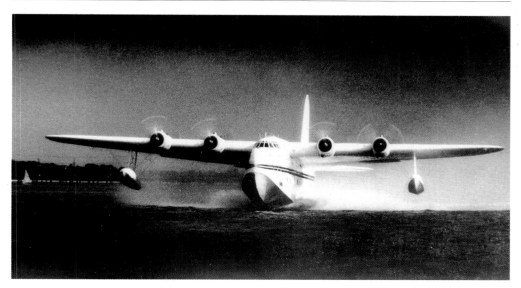

A shutter speed of 1/125 sec is needed to show this much blur in the propellers. With the plane advancing towards you at 90 knots, a zoom lens is essential. This black and white shot has been printed to darken the sky and water for added drama, then sepia- and blue-toned. Photograph by Etienne.
Nikon F3, 80-200mm zoom at 200mm, Agfapan 400, 1/125 sec, f11

The messages board has been spun around to bring the picture to life. The green cast is caused by the fluorescent lighting. This can be avoided by using a 10-20CC (Colour Correction) magenta filter over the lens with daylight film.
Nikon, 85mm, Kodachrome 64, 1/60 sec, f2.8

An automatic exposure camera would react to all the high key tones (whites) by underexposing the shot. Compensate for this and avoid underexposing her face by exposing it half a stop brighter.
Nikon, 35mm, Kodachrome 64, 1/60 sec, f2.8

The 'spider's web' roof beams at Geneva Airport are exaggerated with a wide-angle lens. When it is dull or dark outside, the indoor lighting is reflected in the glass. Photographs of airports are useful as link shots in slide shows.
Nikon, 25mm, Ektachrome 200, 1/60 sec, f2.8

Figures in a Landscape

Put people in their place. Portraits and landscapes. View the two together and you have a story that tells more than the sum of its parts. When workmen, farmers or city folk are seen in context, their environment completes the picture, and landscapes are given greater meaning when peopled by those who live and work there. Look at shoppers scurrying about the marketplace, children in the playground, craftsmen at work. People and place together make a very strong statement. The eye is drawn automatically to a figure, especially if the person is wearing something striking or typical of a particular region. Try to overcome any reluctance you may have about approaching people to take their photograph; they may well be flattered or amused.

Photographed from a car window, these peat diggers having their lunch on the west coast of Ireland looked at the camera without concern and without altering their natural poses. They blend in with their environment much as their predecessors must have done through the generations.
Nikon, 35mm, Ektachrome 200, 1/125 sec, f8

CHECKLIST

Always carry a camera with you. A small compact can easily be slipped into a pocket or bag and is quick and easy to use.

Give people a Polaroid snap of themselves and they will usually co-operate with your directions (see POSING PEOPLE and WORKERS OF THE WORLD).

Carry a map and mark the locations of each shot for future reference or captions.

Return to the scene if the light is uninspiring or certain elements are not right.

The baby lamb being cradled by a shepherd in the South of France was not noticed when this grab shot was taken from a car window. With the focus pre-set to 10 feet, the background is almost sharp.
Nikon AW, Ektachrome 200, auto-exposure

With a compact camera on your lap in the car, look around when you wait at stop lights or are caught in a traffic jam. Point and shoot instantly before anyone realizes you are taking a picture. Use fast film (ISO 400) to minimize movement and maximize depth of field.
Nikon AW, Kodacolor 400, auto-exposure

The boy with the umbrella draws the eye away from the crazy sculpture at La Défense in Paris and adds life to an otherwise almost abstract picture.
Nikon FE, 28mm, Ektachrome 200, 1/125 sec, f11

Street Cred

The host of visual delights offered by street life make it well worth overcoming any shyness you might have about photographing people in public places. By remaining unobtrusive you can capture enchantingly natural poses, and even if you are spotted, direct confrontation between subject and camera can produce equally striking results. Consider using a tripod or bench, using the self-timer so that people don't see your finger on the button (*see* IMPROMPTU PORTRAITS *and* POSING PEOPLE).

A low-angle shot of soldiers preoccupied with preparations for a parade in St Peter's Square, Rome, creates converging vertical lines that draw the eye towards the Pope's palace and decorative statues.
Nikon FE, 28mm, Kodachrome 64, 1/125 sec, f8

The sight of your camera may arouse a mild interest that helps elevate the scene without destroying its authenticity. When photographing swarthy faces against a light background, overexpose by half a stop to retain facial detail. As the subjects were all the same distance from the camera, no great depth of field was needed.
Nikon FE, 85mm, Kodachrome 64, 1/125 sec, f2

Technique

Be ready to respond to the activities of people in the street, such as performers, vendors or local characters. This snake charmer in Marrakesh is separated from the background by the use of a medium telephoto lens.
Nikon FE, 85mm, Kodachrome 64, 1/125 sec, f8

Extroverts may expect payment for photographs. Carry small change and point out that you're not a rich tourist! Smile and remain friendly.
Nikon 801, 28-85mm zoom at 40mm, Kodachrome 64, 1/125 sec, f8

Few of the punks in Sloane Square, London were aware of the camera 20 feet away. Some of the most interesting character studies evolved through zooming in (*see* ZOOM IN).
Nikon 801, Tokina 50-250mm zoom at 200mm, Kodacolor 200, 1/250 sec, f8

CHECKLIST

Overcome your reticence about using a camera in public. Many people, particularly eccentrics, enjoy being photographed, especially for a tip!

Carry a small tripod and use the self-timer.

Use a zoom lens for fast framing.

Shoot into a mirror to picture unguarded poses and expressions, and create unusual images.

Seascapes

The sea is inspiring, providing a wide variety of opportunities for memorable pictures, from tranquil reflections in a calm bay to the wild turbulence of crashing waves against a backdrop of towering tumulus. When taking photographs from a small boat or by the water's edge, protect your camera and lenses in a waterproof container, such as a cool bag or cool box, which can also contain food and drinks. The electronics in a camera show their objection to water by stopping. Salt water is a double enemy because it corrodes. Keep the camera in a plastic bag with holes for the lens and viewfinder, and wipe off any splashes with a clean cloth. If your camera is drenched in salt water, dunk it immediately in fresh water, then dry it thoroughly by removing the lens and leaving the back open. A waterproof camera is a safer option. Besides a skylight or ultraviolet filter which should remain on the lens at all times to protect it, experiment with a polarizing filter to cut out the glare from the surface of the water. A graduated filter adds drama to the sky and cuts down its brightness (*see* GRADS AND POLARIZERS).

King Neptune obligingly posed for the camera amidst the colour and charm of the Newcastle Fish Festival in the north of England. Because of the dull lighting conditions the film was pushed one stop and a Blue 1 graduated filter was used to darken the sky.
Linhof 6 x 12, 65mm, Fujichrome 400 rated at ISO 800, 1/125 sec, f22

Sunlight shining through leaves, wings or sails is very pleasing, especially with the dark background of a landscape in shade. Windsurfers are invariably photogenic, whether pictured close up, slicing through the water or like distant colourful butterflies flitting across the surface of the Mediterranean.
Nikon 801, 28-85mm zoom at 60mm, 1/125 sec, f8.5

The sun's rays streaming through dark clouds and reflecting on the water in Sardinia creates a striking picture. The exposure reading was taken from the sky, causing the foreground to go dark.
Nikon, 28mm, Kodachrome 64, 1/125 sec, f8

CHECKLIST

Change film somewhere that is shielded from the spray, and wind-blown sand, and out of direct sunlight.

Stow your camera gear in a protective container and do not leave in the hot sun.

Protect yourself from the elements, especially strong sunlight, with suntan lotion, a hat, long sleeves and an umbrella.

Indicate on a map where different shots were taken for future reference.

Use a graduated filter to lend drama to dull skies and a polarizing filter to cut some of the glare from the surface of the water.

Overlooking a peaceful bay of colourful boats, these lobster pots in Malta create unusual shapes, like ladies' hats. The positioning of foreground, middle-distance and background subjects, all in focus, gives the shot a sense of depth.
Nikon FE2, 25-50mm zoom at 30mm, Kodachrome 64, 1/125 sec, f11

Beneath the Waves

Taking a camera underwater opens up an exciting new realm of photography, but you can also take underwater pictures with a land camera. Using a polarizing filter to cut through surface reflections, you can shoot river beds and coral platforms (*see* GRADS AND POLARIZERS). You can photograph marine life in an aquarium, or synchronized swimming through the viewing window in the side of a swimming pool. You can use the 'window' in a glass-bottomed boat, or, even simpler, a glass bottomed-bucket. A variety of all-weather and waterproof compacts are available, many with built-in flash and some with autofocus and zoom lenses. The most popular and robust 35mm underwater camera is the Nikonos.

Michael Portelly produced this symbolic photograph inspired by the concept of the ocean being the mother of life. This simple yet compelling image uses natural elements and reflections.
Hasselblad, 38mm SWC, Ektachrome 64, 2 Strobes with red filters, 1/60 sec, f4

Close-up shots can be vibrant even when visibility is poor. You can attach a frame that protrudes 10 inches from the front of the lens. By placing this on or around the subject, correct focus is assured. *Nikonos III, macro lens, 1/60 sec, f11*

CHECKLIST

Proper Scuba training is essential before diving with a camera.

Test equipment and techniques in a swimming pool before venturing into open water.

Correct colour casts in open water with flash or a 10CC red filter at 3 feet (1 metre) and 20CC red at 6 feet (2 metres).

To reduce the number of particles illuminated by the flash, hold the flash away from the camera. This also gives a better modelling light.

A plastic frame or Sportsfinder can be attached to the camera to facilitate viewing when wearing a mask.

Use a wide-angle lens and move in close.

Before a dive, discuss with your buddy the pictures you plan to take. Michael Portelly positioned himself by the coral drop-off in the Red Sea 16 feet (5 metres) below the surface and photographed the approaching diver using Strobe light and a red filter to accentuate the colour of the fish.
Hasselblad, 38mm SWC, Ektachrome 64, 1/60 sec, f5.6

In an environment where most divers are pre-occupied with survival, Michael Portelly has pioneered techniques for working with models underwater in almost zero gravity. Model Lauren Heston is attached to a hidden weight by means of a quick-release mechanism. Her air is supplied by a support diver via a mouthpiece attached to an extended hose from a cylinder of compressed air.
Nikon F3, 18mm, Kodak Ektar 25, 1/125 sec, f5.6

Shopping

Shops provide a telling insight into different societies around the world, and often present amusing, bizarre and colourful subjects to photograph. Pictures that sum up the feel of a country are frequently used by magazines, books and picture libraries. Shop windows are often imaginatively dressed and make an interesting backdrop or a picture in their own right. A polarizing filter helps cut out reflections in shop windows, and starburst and other special effect filters create interesting shapes and patterns with the lights (*see* FUN FILTERS).

The eye-catching techniques people use to advertise their wares are often fitting subjects for photography. As a lucky coincidence, the yellow car in the background echoed the colour of the baskets and saluting cowboys in this Mexican roadside stall.
Nikon, 25-50mm zoom at 40mm, Kodachrome 64, 1/125 sec, f11

The irony of the combination of services offered by this shop is a poignant comment on contemporary life (*see* SIGNS OF THE TIMES).
Nikon, 25-50mm zoom at 30mm, Kodachrome 64, 1/125 sec, f5.6

CHECKLIST

Keep your eyes open for interesting window displays near where you live.

Use a polarizing filter to reduce reflections in windows.

Consult guidebooks for unusual artefacts or impressive shops to look out for on your travels.

Record the specialist goods that typify the wares of a country or region.

Photograph items you might consider purchasing in the future or could borrow as props.

Technique

Nudie's in Los Angeles captures the 'smell' of the American cowboy. The proud salesman has even covered the windows with cellophane to protect the leather goods from fading. This casts a warm glow over the interior.
Nikon, 25-50mm zoom at 35mm, Ektachrome 200, 1/60 sec, f8

Adding to the appeal of this shot in Mexico are small personal touches such as the handbag matching the girl's green trousers, and the tiny, intricate roosters she is offering for sale.
Nikon, 25-50mm zoom at 50mm, Kodachrome 64, polarizing filter, 1/125 sec, f5.6

Architecture

Modern architecture is so diverse that we are presented with innumerable exciting variations of shape, pattern, texture and colour. Buildings can be viewed as suitable targets for abstract images, for documentary photographs, or for backdrops for fashion, portrait or car shots. Make use of reflections in coloured glass and unusual lighting at dusk (*see* REFLECTIONS). When the camera is tilted up to photograph tall buildings, the verticals converge. To avoid this either position the camera a long way from the building or use a perspective correction lens or shift adaptor (*see* SPECIAL EFFECTS LENSES *and* LARGE FORMAT). This tilts the lens and corrects converging verticals while also effectively making the lens longer; for example a 40mm lens on a Hasselblad becomes 53mm with a shift adaptor attached. Nikon produce a 28mm and 35mm lens with built-in shift mechanism. The Linhof 6 x 12 camera is designed specifically for architecture and landscape photography. The lens is permanently tilted to show one-third foreground and two-thirds sky.

Converging verticals need not always be avoided; they can add to the drama of the picture, exaggerating the height of the building. A spreading filter, for which you need to allow an extra stop, ensures even exposure over the whole film plane of a panoramic scene.
Linhof 6 x 12, 65mm, Ektachrome 100, 1/125 sec, f11

The canopy of this building on Canary Wharf in London's Docklands was designed to complement the ships moored nearby. The lady and child help to humanize the picture, their blue and reds working well with the background colours.
Linhof 6 x 12, 65mm, Ektachrome 100, 1/125 sec, f8

This shot in Milton Keynes, England, illustrates one of the pitfalls that can be encountered when trying to produce a 'clean' architectural picture. The drain cover detracts from the pristine scene and could have been concealed with card or with a person. *Sinar 5 x 4, 90mm, Ektachrome 200, tobacco grad, 1/30 sec, f11*

The Lloyd's Building in London is an example of modern architecture that lends itself to abstract interpretation. A fish-eye shot of the entrance distorts the straight lines in a graphic, if bizarre, way (*see* WIDE, ULTRAWIDE AND FISH-EYE LENSES). *Hasselblad, 30mm, Ektachrome 100, 1/125 sec, f8*

The escalator, glass roof and walkways draw strident diagonals across the interior of the Louvre pyramid in Paris. *Nikon 301, 20mm, Fujichrome 100, 1/60 sec, f11*

CHECKLIST

Look at architectural details as well as the overall shape of buildings (see DETAILS).

Take a roll of tape and pieces of card to hide small unsightly features, and a brush and pan to clear up litter.

Use a slow shutter speed (longer than 1/2 sec) to eliminate moving people from the shot.

Use a spirit level to check the camera is level.

Spirit of Ireland

On holiday or on assignment it can be a rewarding exercise to try to capture the spirit of life in a country or region. Ireland is a good example. It is full of character and characters, atmosphere and warmth. Most of Ireland is relaxed and friendly, and many old, photogenic crafts and lifestyles survive. The photographs on this spread were shot for the tourist board, and illustrate something of the appeal of the country.

The actress Julie Walters was one of the personalities chosen to bring out the essence of Ireland. She was lively and responsive, especially when joined by a charming young Irish girl. The exterior of the shop was embellished a little to enhance the scene. *Nikon, 28mm, Ektachrome 100, 1/60 sec, f11*

When two people establish an animated rapport, simply set the scene and then leave them to it while you capture their spontaneity on film. *Nikon, 25-50mm zoom at 25mm, Ektachrome 100, 1/125 sec, f8*

The atmosphere of a country can be suggested in a single expression, object or action. The warm, easy-going nature of the Irish is reflected here in

Julie Walters's countenance and body language. *Nikon, 25-50mm zoom at 35mm, Ektachrome 100, 1/125 sec, f8*

Technique

Assemble the right ingredients, then be ready to photograph the scene once all the elements are working together. Television presenter John Noakes's interaction with the dog, and the presence of the horse and the children all help to evoke a feeling of country charm.
Nikon, 20mm, Ektachrome 100, 1/60 sec, f8

CHECKLIST

Equip yourself with detailed maps, compass, guidebooks and hotel brochures.

Carry a notebook to record the subjects and venues of the photographs.

Use a small tape recorder or video camera to record ideas.

Take Polaroids or colour prints (C41) of potentially good locations and points of interest for future reference.

Use a cool-bag for food, drinks and, in hot weather, camera gear.

In the historic setting of a ruined castle, actress Liza Goddard and her son conjure a mood of carefree relaxation and *joie de vivre*.
Nikon, 20mm, Ektachrome 100, 1/125 sec, f8

Thatching is a rural craft very much alive in Ireland. It typifies the rustic way of life that progress has bypassed.
Nikon, 25-50mm zoom at 30mm, Ektachrome 100, 1/125 sec, f11

A sense of dignity as well as humour is evident when even the graffiti on a derelict building oozes charm.
Nikon, 28mm, Ektachrome 100, 1/125 sec, f8

The
Profession

Cards, Calendars and Posters

Whether photography is your hobby or full-time profession, you can use your photographic skills to promote yourself and/or your business. A controversial or eye-catching poster or print can be one of the most persuasive carrots a photographer can dangle in front of potential clients. Although striking images on a poster or calendar are popular, you can also put your name and image on T-shirts, sweat shirts, address books, bags or anything useful that people will keep. Consider reducing production costs by working with a printer or co-sponsor willing to shoulder the print costs in return for their name appearing on the material.

Invitations provide an opportunity to show what you can do. For an invitation to a Midsummer Night's party, I chose to show my staff in a dramatic scenario. Having arranged all the characters, I took up position on Titania's lap. *Hasselblad, 120mm, Kodak Plus-X (ISO 125), 1/125 sec, f8*

MANFRED & MICKY

The ballroom is a part of my house. The first set-up showed the whole room and the couple dancing. Then, the art director felt it would be more intriguing not to reveal the whole room. I used a Starburst filter to draw attention to the chandeliers. The copy, by a writer at Saatchi & Saatchi, summed up my achievements. The poster was sent to top London ad agencies.
Top: Nikon, 25-50mm zoom at 30mm, Kodachrome 64, 1/15 sec, f8; Above: Hasselblad, 60mm, Ektachrome 200, 1/10 sec, f16

One year I decided to produce a calendar that couldn't be ignored. Rather than dress people in unusual costumes, we asked 'ordinary' people to take off their clothes with the aim of producing an extraordinary picture. Suitable music helped them unwind, and the room was darkened so they didn't feel too self-conscious.

I teamed up with the German paper manufacturer Zanders to produce a poster with several images on one theme – hair. In return for providing free photographs, I received a few thousand posters that were sent to ad agencies in Europe. For the main picture I found an incredible Art Deco barber's shop in the basement of Austin Reed in Regent Street, London, where I used mirrors to emphasize the circular nature of the room. Apart from the young lady in the foreground, who was a professional model, all the characters are either friends or barbers.
Hasselblad, 40mm, Ektachrome 200, 1/15 sec, f11

For the romantic image in the top left I used a Vario prism to produce a heart shape.
Hasselblad, 120mm, Ektachrome 100, 1/60 sec, f22

In the next picture, the lady in the woods posing like a bird about to take off was body-painted and her hair styled with feathers.
Hasselblad, 80mm, Ektachrome 200, 1/60 sec, f8

In the old barber's shop, top right, I again took advantage of the existing mirrors to reflect the customer's face and a tiger's head on the wall.
Hasselblad, 50mm, Ektachrome 200, 1/15 sec, f22

I moved in close to the pop group UFO because the surroundings were rather bland. A Galaxy filter over a wide-angle lens added to the orgiastic feel of the picture.
Hasselblad, 50mm, 1/60 sec, f8

I had the camera perched on my shoulder for the self-portrait wearing a red barber's gown. It was an easy shot as I could see everything clearly in the mirror.
Hasselblad, 40mm, Ektachrome 200, 1/30 sec, f11

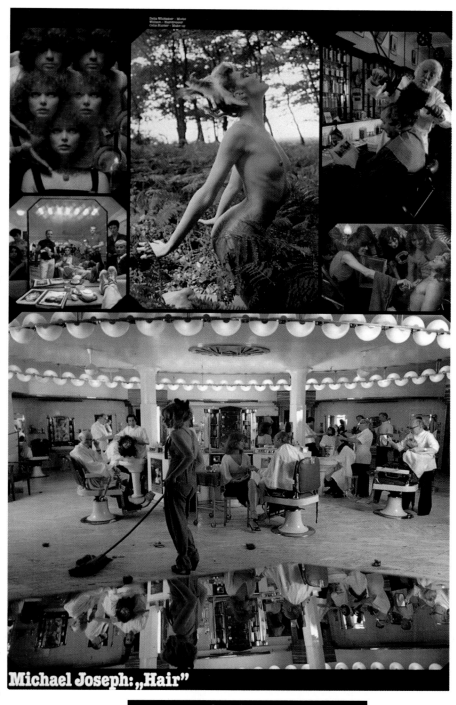

Michael Joseph: „Hair"

CHECKLIST

Use photography to promote yourself and the services you can offer.

Self-promotion ideas can be reproduced on cards, posters, calendars, address books, bags, balloons, T-shirts – almost anything that people will want to keep and, hopefully, display.

Enlist the help of friends and colleagues for their ideas and as models, stylists, copywriters, designers and so on.

Selling Your Pictures

Potential markets for photographs are vast and varied, yet how many of your masterpieces have remained in the dark after an initial airing? Success in having pictures published hinges on presenting the right material to the right client at the right time. Start with what you know: a hobby, a town, an occupation. What types of publication might buy your material? What types of pictures do they use? Highly creative shots might be suitable for greeting cards or record covers, but clear, unambiguous pictures usually illustrate newspaper stories or how-to-do-it articles. Transparencies are generally preferred for reproduction, and can be converted to black and white.

Publishing books, posters or calendars is a precarious business unless you have considerable private funds. Producing personal greeting cards, mailers and visiting cards can be viewed as a cost-effective self-promotion exercise. Be your own severest critic; edit your pictures ruthlessly.

BENSON & HEDGES SPECIAL FILTER, MAYFAIR & HAMLET THEMES BY JACQUES LOUSSIER

Having an agent to help sell your pictures and handle contracts and copyright issues leaves you free to concentrate on photography. A good agent acts as a buffer between business problems and the artistic temperament. He or she cultivates relationships with potential clients, creates an image around the photographer, negotiates fees, remains diplomatic, provides psychological support and, usually, takes 25 per cent commission on jobs.

Pick out key photographs from your collection and group them according to possible uses. Kodachrome and Fujichrome are the most popular. The 35mm format is widely accepted, though some publishers of greeting cards, posters and calendars only accept medium format or larger. Even if they are not used, they may lead to a separate commission (*see* STOCK SHOTS).

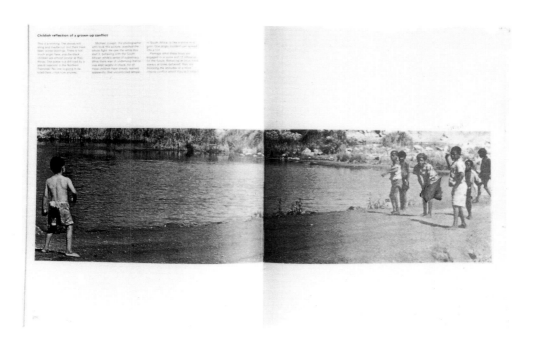

Childish reflection of a grown-up conflict

You can sell individual pictures for use in books through an agent or picture researcher. A strong theme is needed for an entire book of your photographs. Only very well known photographers can hope to sell a random collection of their pictures. Discuss ideas with appropriate publishers to find out if you have something they are prepared to take a risk publishing.

CHECKLIST

Research the market. Many publishers reject more than 95 per cent of unsolicited material.

Submit pictures that are technically excellent and relevant.

Don't send glass-mounted transparencies through the post, as they may crack and damage the film.

Keep a record of photographs dispatched and agreements made.

Don't give up. Glean as much as you can from editors and picture editors, and keep trying.

Good photo libraries issue guidelines to their photographers (see STOCK SHOTS).

Think of potential uses of pictures when shooting. For example, front covers need space for the titles. Avoid dissecting the main subject in a double-page spread.

Photo schools provide handbooks and newsletters detailing a wide range of markets.

Directories, such as the Writers' and Artists' Yearbook (UK) and Photographer's Market (USA), list potential markets, agencies and picture libraries.

Some magazines accept single images, but you will achieve greater sales if you assemble twelve or twenty-four pictures on a definite theme. Illustrate a photographic technique for a camera magazine, for example, or modes of transport in Outer Mongolia for a travel magazine. Pictures for which you own the copyright can be resold for different uses, such as menu and greeting cards (see STOCK SHOTS).

Stock Shots

Stock pictures are photographs that can be used in a number of ways. Photo libraries sell them to advertising agencies and publishers who use them to promote perfumes, sell songs, advertise holidays or provide a background for a product. You don't need to be a professional to make money from stock shots. You can cover the cost of travel abroad by selling the pictures. You can either market your own shots to magazines and travel companies, or let a stock library do it for you. Also called picture or photo libraries, stock libraries generally pay you 50 per cent of the income they receive from the sale of your pictures. They work hard for their commission. They catalogue and file the images (often digitally), duplicate them, circulate them to potential markets, produce a catalogue, chase payments and handle all the paperwork.

Many stock libraries ask for a minimum initial submission of, say, 200 transparencies, with the expectation of regular future contributions. Libraries advise their photographers of their picture requirements. Invariably they require slides not prints, unless you have a world-exclusive shot on print film! Medium format is ideal for many uses, but top quality 35mm transparencies are now widely accepted. Unusual images sell well, especially exceptional views of familiar landmarks. Idyllic family groups, where everyone is attractive, well lit and well dressed, are very popular. Avoid excessive use of filters as special effects can be added later if needed. The library's catalogue gives a good indication of the best sellers. Refer to it for ideas and inspiration. Before a trip, ask the library for a 'Wants' list for the region you plan to visit.

An almost abstract image such as this modern office block in London's Docklands is a good symbolic shot that can be used to depict growth, success, power, and so on. Shoot both portrait and landscape formats to increase the possible uses of your photographs.
Nikon 801, 28-85mm zoom at 45mm, Kodachrome 64, 1/125 sec, f11

Take your own props or make imaginative use of items available on location. Shoot several different set-ups from a variety of angles, using different lenses. Pay particular attention to composition and lighting, keeping the picture simple, clear and graphic. Anticipate how the picture may be used. Travel magazines and brochures concentrate on buildings, scenery, local people artefacts and food that is typical of a particular region.
Hasselblad, 40mm, Ektachrome 100, 1/30, f32

Some people consider the Pearly king and queen to represent the epitome of the London scene. This makes them suitable subjects for postcards, magazine articles and travel brochures. Either hire the costumes and enlist the help of friends, or persuade a real pearly couple to pose in exchange for copies of the photographs.
Nikon FM, 35mm, Kodachrome 64, 1/60 sec, f11

Shot through fern leaves, the romantic feel of this image lends itself to a record or CD cover, or to selling perfume or illustrating a classic story.
Hasselblad, 250mm, Ektachrome 200, 1/250 sec, f5.6

CHECKLIST

Find out the most popular types of images by studying travel magazines, brochures and library catalogues.

To reduce grain use a slow or medium speed film (ISO 25-100) unless the subject demands a faster film.

Take a tripod to help produce shake-free images.

Ask people you photograph to sign a model release form (see PRE-PRODUCTION).

Shoot several different versions of the same set-up, including vertical and horizontal shots, with and without people.

Allow space around the subject for headlines, titles or cropping (see CROPPING).

Expect a slow return on your investment; you are unlikely to receive any payment for six to twelve months.

Pre-Production

An enormous amount of preparation goes into advertising and some editorial photography. As many elements as possible are planned before fees are incurred for models, stylist, location and photographer. Ideally the photographer should be involved in the planning stage so that he or she understands the thinking behind the ad or fashion shoot, and can advise on what is and isn't possible photographically. The freelance photographer is now recogized as the author of his or her own work and the first holder of copyright, even if the work is commissioned or the film supplied by the client. Be clear about who owns the copyright, and avoid signing away all rights unless you are offered a handsome fee. Also work out a re-use fee to compensate you for images that may be sold on.

Art directors in advertising agencies are often willing to see your work if you have an appointment. It is sometimes better to show your portfolio to the art buyer, who keeps art directors informed about suitable photographers. Art directors want to work with photographers who are flexible and co-operative, as well as technically good, especially if they have a different look of unique selling point.
Nikon AW, 35mm, Kodacolor 400, auto-exposure

Casting cards, which show models in various poses and costumes, simplify the process of choosing suitable characters for a shoot. When you photograph someone for commercial gain, ask them to sign a model release form, agreeing to pay them a given sum or percentage of sales – often 25 per cent, shared if there is more than one model.

The photographer contributes to the pre-production process in many ways. A knowledge of striking and appealing locations, such as these surreal moon craters in Lanzarote, increases your value.
Nikon 801, Kodacolor 400, 1/125 sec, f11

Build up a scrapbook of annotated snaps of interesting locations. Always carry a camera and keep your eyes open. Where necessary, seek permission beforehand from owners, residents or the police. Be diplomatic and, where appropriate, offer incentives such as prints of someone's house or car.

CHECKLIST

Wherever possible, become involved in the early stages of pre-production so you can suggest creative ways of improving a picture (see **SPECIAL EFFECTS** and **TRICKY SHOTS**).

You own the copyright on your pictures, unless or until you sign away these rights.

You do not relinquish copyright by giving someone licence to use your photographs.

For detailed information on copyright and re-use fees, contact the Association of Photographers (UK), or the Association of Magazine Photographers (USA) or the Society of Photographers' and Artists' Reps (USA).

If the commissioning agency pays for the film and expects exclusive use of the pictures, shoot back-up photographs using your own film.

Creative Casting

Casting means finding people who can look and play a part. You might see someone in the street, put an ad in the local paper or contact a model agency. Experiment with a light-hearted or lateral look at characterization; it will invariably raise a smile. Casting and photographing a large number of people can be as involved as a movie shoot and requires a model or casting agency.

Within twenty-four hours an ad in the local paper generated 150 replies from would-be John McEnroes (*see* LOOKALIKES). By adding his trademarks – a headband and sultry expression – a team of lookalikes gave the advertising copywriter his cue for the caption: 'You don't have to be McEnroe to wear Nike'. White polystyrene was positioned on the ground to bounce light back up into the shadow areas. This was cropped out of the ad itself.
Sinar 8 x 10, 210mm, Ektachrome 200, 1/30 sec, f22

CHECKLIST

Imaginative casting can produce bizarre images that can be used to promote your company or as a party invitation.

Build up a library of characters by photographing people you meet who might one day by suitable.

Have people watching different sections of the set for anything out of place and to check people's expressions.

Shoot a couple of test rolls before lunch so the results can be examined and adjustments made while the cast is still on set.

In a studio only 18 ft x 28 ft, about thirty people were staged within an area 12 ft x 12 ft, supplemented by a number of polystyrene cut-outs at the back (*see* SPACE MAKERS). Remembering names was a problem because everyone was so made up they were virtually unrecognizable from their pictures (*see* ORCHESTRATING ORGIES).

The model Caroline Cossey (also known as Tula) was first choice for the leading lady as she is so beautiful, statuesque and professional. The picture gives the impression of movement, yet everyone had to be well controlled because of the flames, daggers and swords. If someone moved an inch or two they could hide the person behind or reveal an inappropriate tattoo, as happened in this shot.

In order to be sure of a picture in which everybody looked lively and spontaneous, more than 100 frames were shot. A diffuser over the lens helped play down the differences in skin tones and soften people's outlines. A megaphone or PA system is essential when controlling a crowd scene, and having music playing between takes helps people enjoy the experience.
Hasselblad EL, 60mm, Ektachrome 200

Shooting Stars

Personalities can be impatient and self-conscious, and may not allow you the time you would like to take their photograph. Be ready before they arrive. Prepare the set and take Polaroid shots *in situ*, using a stand-in. When they arrive, show them a couple of Polaroids and discuss ideas for the sitting, perhaps indicating other reference material. Background research on the personality will arm you with topics that can help establish a rapport, and may suggest a theme or stance for the picture.

A powerful portrait of the actress and model Iman was made by using a fog filter and keeping the background dark and moody, with a fish fryer directed towards her.
Hasselblad, 120mm, Ektachrome 200, 1/125 sec, f22

Nicol Williamson was adamant that the character he played in the film *The Human Factor* was dull, so he should not be portrayed as cheerful. Iman and Nicol were illuminated by a fish fryer. A fog filter was used over the lens to evoke the tenderness of their relationship.
Hasselblad, 120mm, Ektachrome 200, 1/125 sec, f22

CHECKLIST

Research the personality before your session.

Understand that their time is probably limited, but that they will usually want to co-operate in order to achieve a good photograph.

Have lighting ready and cameras loaded.

Be polite, encouraging and efficient without being obsequious.

At the end of each roll let them relax, assume a different position and check clothing.

Consider different outfits, expressions and viewpoints.

When on location provide a make-up mirror and check on the facilities and catering.

Employ a stylist or personal assistant to attend to the needs of the star.

While TV presenter Alan Whicker was being photographed in Dominica for an ad, the art director Tim Mellors shot the set-up. The white sheet was positioned to reflect light on to the subject.
Nikon, 35mm, Kodachrome 64, 1/125 sec, f11

During a book signing at Harrods in London, the English actor Terence Stamp was obliged to be amenable, whatever he was presented with!
Nikon 801, 28-85mm zoom at 30mm, Kodacolor 400, 1/60 sec, f4.5

Disc jockey Jimmy Savile was available for just five minutes, time enough for two 8 x 10 shots. An existing painted backdrop was used as it was compatible with his outfit.
Sinar 8 x 10, 300mm, Ektachrome 100, 1/60 sec, f32

Otto Preminger was photographed to publicize the film of Graham Greene's *The Human Factor*. He was unwilling to pose and would not put his hand in front of his double chin. The portrait was sidelit using a fish fryer (*see* STUDIO LIGHTING).
Hasselblad, 120mm, Ektachrome 200, 1/125 sec, f32

Comic Cuts

Photographing natural comedians can be fun, but you must be on your toes. Actors and comics are often particularly animated and vivacious, needing careful handling to ensure you get good shots. Build up a file of press cuttings about personalities you would like to photograph. Research their background to discover areas of common interest or topics for discussion. Provide basic make-up and grooming facilities, although some characters will arrive fully equipped. When on location take a selection of props and accessories, including background paper such as natural canvas supported by two stands (*see* SHOOTING STARS).

This double exposure of the English comic actor Leslie Phillips involved one flash exposure of him with a small aperture in order to keep the subject in focus from the front of the dish to his ears. Then the modelling light was turned off, the focus changed to infinity, the aperture opened up and a long exposure made for the auditorium, with the chandeliers in focus.
Hasselblad, 50mm, Kodak Tri-X (ISO 400), (a) flash at f22, (b) 10 sec, f4 for background

When there is time, go beyond the set poses. By encouraging people to clown around you can achieve amusing or risqué results. 'Is this what you want?' asked *Carry On* star Sid James as he stuck his finger through a hole in his trousers!
Hasselblad, 80mm, Kodak Tri-X (ISO 400), 1/60 sec, f16

The Profession

The actor Gordon Jackson was most co-operative and had a very professional approach to the session, arriving an hour early to help ensure that all went well. Artificial cobwebs gave the room the quintessential wine-cellar atmosphere. The scene was lit from the right by an Elinchrom T-head in a SQ44. Other T-heads concealed behind columns illuminated the casks (*see* STUDIO LIGHTING).
Hasselblad, 60mm, Ektachrome 200, 1/4 sec, f22

Trying to take a serious shot of someone who has built his reputation on being zany may be difficult. Grey background paper and Elinchrom lights were taken to his house, where Kenny Everett could not resist playing up to the camera.
Hasselblad, 120mm, Ektachrome 100, 1/30 sec, f16

CHECKLIST

Ideally, have on hand an assistant to number and reload film and take notes, as well as a stylist to check hair and straighten ties.

Have a spare flash unit with fresh batteries as a backup light source.

Consider placing a mirror next to the camera so that sitters can assess how they look.

Use bizarre or ridiculous diversions such as a squeaky toy or whistle, to amuse the personality and help him or her perform.

Provide drinks to break the ice and relax the person.

Eye For Design

Designers are often flamboyant, extrovert characters and wonderfully photogenic subjects. Their studios may provide the most interesting setting for a portrait, allowing you to make use of unusual architecture, interior designs or wall decorations. Although you should have ideas about how the photograph might be approached, broaden your perspective by listening to how they perceive their image.

Mary Quant's studio was crammed with a busy and colourful array of pictures that made a rich setting for the photograph. A strobe head to the right with a 4-foot umbrella was positioned at shoulder height so that the papers on the desk would not be too bright.
Hasselblad, 50mm, Ektachrome 200, 1/60, f22

The photographer's studio was chosen for this shot, as it was more spacious and away from the distractions of Jasper Conran's busy office. An Elinchrom X-head and two 404 packs illuminated the bride, while a fish fryer lit Jasper Conran from the front. Tungsten light was also used to warm up part of the scene (*see* STUDIO LIGHTING).
Linhof 6 x 12, 65mm, Ektachrome 200 rated at ISO 350, 1 sec, f32

The clothes and theatrical designer David Shilling was full of ideas for poses and set designs. He chose to elevate himself on a ladder and position one of his creations on a pedestal. The strobe lights were covered with pink gel.
Hasselblad, 120mm, Galaxy filter, Fujichrome 100, 1/30 sec, f22

Have an assistant or stylist on hand to help look after the well-being of the person and to check that he or she looks immaculate.

Play suitable background music.

Be prepared with safety pins, clips, double-sided tape and scissors to trim loose threads, adjust garments or hold them in place.

Go armed with suitable props and ideas, but also be willing to take their suggestions.

The Rolling Stones

As the commissioned photographer I didn't have to jostle with other photographers, nor did I have to resort to detective work or subterfuge for the shots. The Stones arrived on the first day of a two-day shoot for a record sleeve with their own ideas about how they wanted to look. I had to manipulate them to do things that would make the shot flow. Controlling a complex scene can be quite demanding when it involves a variety of animals and a number of people who are not used to being ordered around. In this scene we had a goat, a sheep, a cat, a Labrador, and a pug dog (*see* ORCHESTRATING ORGIES).

The Beggar's Banquet 'orgy' is one of my favourites. The room was lit by a swimming pool light comprising four 5000-joule strip lights, which we just managed to squeeze into the bay window. At the end of the first day's session, which was photographed on 8 x 10 sheet film, I quickly shot off, for my own amusement, a roll of black and white on a Hasselblad. I then spent the night printing them on Kodalith paper. When I showed Mick the 16 x 20 inch sepia enlargements he hardly even looked at the 8 x 10 colour transparencies, but chose one of the black and white 'snaps'.
Sinar 8 x 10, 165mm, Ektachrome 100, 1/60 sec, f22

CHECKLIST

Be polite and diplomatic, and don't be intimidated by famous personalities.

Gain people's co-operation by keeping your cool and demonstrating that you are confident, competent and know how many rolls you need to get the shot.

Guide and cajole people into doing what you feel will make a good photograph.

Listen to their suggestions and be accommodating where it does not interfere with the final picture.

Take the opportunity to shoot relaxed, more candid pictures with a backup camera, as well as the set pieces.

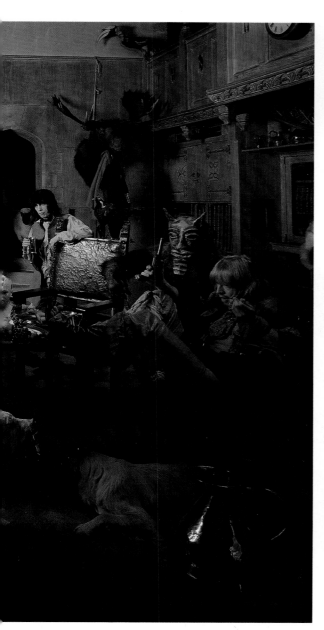

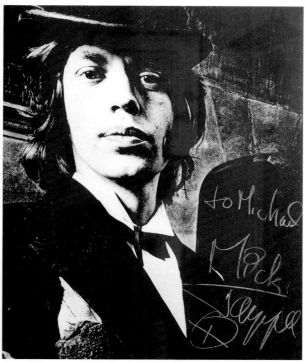

Mick was so delighted with the Kodalith image that he flamboyantly signed the print of himself. A sepia toned black and white image was chosen for the album cover in preference to the colour. *Hasselblad SWC, 38mm, Kodak Tri-X (ISO 400), 1/30 sec, f16*

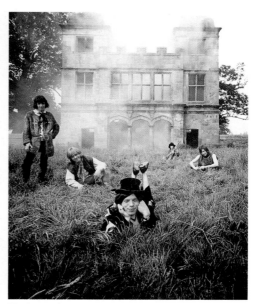

Having seen me in action and having seen the photographs of the banquet, the Stones had more confidence in my abilities, and the second session was more relaxed and easier to handle. *Hasselblad, 40mm, Ektachrome 200, 1/30, f32*

A Day's Work

Idyllic, nostalgic and romantic scenes are seldom as straightforward to photograph as they might appear. Apart from the casting, propping and location finding, a shoot involving lots of equipment is likely to attract attention. On private property, including many parks, you should obtain official permission and may have to pay a prohibitive location fee. On this particular assignment the photographer's fee had to cover the cost of models, animals, vehicles and locations, so it was in my interest to keep expenses down. A few weeks before the shoot I saw this wonderful golden Morgan in London's Regent Street. I gave the driver my card and asked him to send some reference photos of himself and the car.

After a sandwich lunch to save time, this relaxed shot was taken in the warm afternoon light. We thought we were on land belonging to the local polo club and had cleared the shoot with the club's secretary. In fact we were on crown land opposite the club and were moved on by the park's police.
Hasselblad, 60mm, Fujichrome 100, 1/125 sec, f11.5

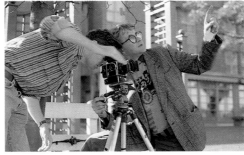

The art director checked the scene through the Hasselblad.
Nikon, 135mm, Ektachrome 100, 1/250 sec, f4

A camera case makes an ideal seat. Other cases alongside the Hasselblad and Linhof 6 x 12 are full of filters, coloured gels, film, clips, tape, gardening wire and scissors.
Nikon, Ektachrome 100, 1/125 sec, f11

Photography is as much about diplomacy as exposures and composition. Patience and imagination are important qualities when trying to persuade people to co-operate.
Nikon, Ektachrome 100

CHECKLIST

On professional shoots where a fee or commission is involved, make sure that the legal side is covered.

Ask all models appearing in the shots to sign model release forms (see PRE-PRODUCTION).

Take extra forms on the shoot in case you see an interesting character who could be included.

Seek permission where necessary. Try to keep location fees low by offering to provide some free photographs for their own publicity.

Keep a record of people to thank, pay or send prints to.

As a precaution, shoot parallel pictures with a backup camera. These could be a different format.

We tried many variations of pose, including movement, as in this shot taken in Windsor Great Park. My colour temperature meter indicated the wintery light was on the warm side, so I shot a few rolls using a 10 Blue CC filter to cool the colours. Although one of these was used, I prefer this warmer image.
Hasselblad, 60mm, Fujichrome 100, 1/60 sec, f8

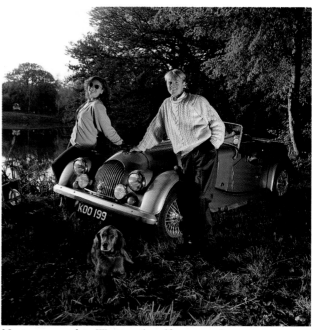

Next we moved to Wentworth golf course, where I set up the camera on a tripod and two portable flash units in one softbox. 'There should be no problem as long as you keep away from the greens', we were told when researching locations. Then the club secretary arrived and presented us with a huge bill! Again we moved on – after quickly exposing a couple of rolls.
Hasselblad, 60mm, Fujichrome 100, 1/15 sec, f11

Cars

Commercial car photography has become a highly developed craft. Lighting is the key element transforming a mere car into an object of desire. Mood is sometimes more important than showing detail, as most people are attracted to the image of a car. On location, the most flattering light occurs around dawn and dusk. In the studio, lighting is more predictable but may take days to perfect. Car studios are normally 65 ft x 45 ft or larger and require a minimum of 40 kW of power. Cars are often photographed in 'infinity coves' to keep all reflections smooth and continuous. Hard-line reflections can be created using a 'floating flat' white reflector over the car.

It was easier and cheaper to join two shots on computer than to fit so many people into a studio in a single line and photograph them without distortion.
Sinar 8 x 10, 360mm, Ektachrome 100, 1/60 sec, f22

The marble-painted set and lighting were arranged, using a stand-in model, before the British athlete Linford Christie arrived, as he had just two hours before flying to the Seoul Olympics.
Sinar 8 x 10, 250mm, Ektachrome 200

The Ford Orion was photographed in the vineyards of St Emilion in France and the shot comped with another landscape image (*see* DIGITAL TECHNOLOGY).
Foreground: Sinar 8 x 10, 210mm, Ektachrome 100, 1/30 sec, f32
Background vines: Hasselblad, 120mm, Ektachrome 100, 1/250 sec, f8

This Ford GT40 was photographed with the parking-meter lady in the late afternoon, just after a downpour had left attractive reflections and droplets.
Nikon, 28mm, Kodachrome 64, 1/125 sec, f8

The lighting was set up on a Saturday and the scene shot on Sunday in the Milan Stock Exchange. A megaphone was needed to communicate with all the local characters and one model. Placing a car in a particular environment gives it added attributes. The setting may be in harmony with the type of car, or may provide a jarring juxtaposition.
Sinar 5 x 4, 90mm, Ektachrome 200, 1/15 sec, f16

CHECKLIST

Shoot around dawn and dusk.

When searching for locations use a Polaroid or C41 process print film. At good locations shoot a series through 360° to show what reflections may appear in the car.

Enhance the personality of a car by placing it in an appropriate location, or add a touch of humour by choosing an incongruous setting.

Test different lenses to assess the amount of distortion produced.

Experiment with filters and effects (see FUN FILTERS and SPECIAL EFFECTS).

A megaphone or radio enables you to communicate the models, or with a distant driver.

Reportage

The adrenalin created by shooting exciting photographs is doubled if they are then published. And the prospect of your pictures appearing in magazines or newspapers can spur you on to try harder. Working for publications gives you the motivation as well as the opportuniy to visit new locations and venues. Start with subjects familiar to you, and approach local papers and hobby magazines with your ideas. Find out how publishing works on modest assignments, so you make fewer mistakes when you move on to more prestigious publications that do not suffer fools gladly. Offer the picture editor a selection of pictures on a single theme. Include graphic images with crisp outlines and dramatic lighting. If you plan to go somewhere interesting, an editor may offer to supply the film. This helps defray costs but gives that publication the rights to the photographs. If you accept film, also shoot other types of film which will then be your own property (*see* SELLING YOUR PICTURES *and* PRE-PRODUCTION).

When covering a story, shoot many different aspects of the overall theme. Ascertain the key subjects and make sure you get the best possible angle on them. For example, this coverage of shark fishing in Ireland for *Town* magazine would be incomplete without the catch itself.
Nikon, 28mm zoom, Kodak Tri-X (ISO 400), 1/125 sec, f11 and f16

CHECKLIST

Study the approach to photographs of Paris Match, National Geographic and other quality magazines that may already have covered the topic you have in mind.

Contact the editor or picture editor with a proposal for the type of material he or she uses.

On location use at least two cameras loaded with two different types of film to cover a variety of situations.

Take a notebook and/or tape recorder to collect information for captions.

The war in Vietnam was full of potent images of power and pain. Faced with personal hardship and danger, war photographers have to find the flashpoints and be capable of recording them in a way that picture editors find arresting. A flare in the sky provided the ambient light that silhouetted the American machine gunner.
Nikon, 28mm, Agfa Record (ISO 3500), 1 sec hand-held, f2.8, printed on Agfa Extra Hard, equivalent to grade 6 paper

This montaged portrait of the Albert Brothers against a curio shop appeared in *Queen* magazine. It incorporates two different portraits, double exposed in the darkroom.
Nikon F2, Tri-X (ISO 400), (a) the window, 35mm, 1/125 sec, f8, (b) close-up, 55mm, 1/125 sec, f2

This reconstruction of the Blitz in London was costly to arrange. It required realistic props and professional styling, which was handled by the *Observer* magazine. Besides the warm glow from the bonfire, everyone was illuminated by a single flash powered by a small Honda generator.
Hasselblad, 50mm, Ektachrome 200, 1 sec, f11

Theatre of War

War presents many opportunities for graphic pictures of high drama and tension. The hazards associated with obtaining these pictures increases the adrenalin, which in turn can stimulate greater creativity. In addition, a certain prestige is attached to photographs that are difficult to shoot. War photography is a specialist field that demands a lot more than technical knowledge of cameras. You need a basic understanding of the politics of the country or countries involved. You may be talking to opposing factions and must be able to handle situations sensitively. You need an enquiring mind when trying to find out, and reach, the points of greatest activity. You need to be able to negotiate your way through bureaucracy, on to appropriate transport and back again to base. You need to cope with personal discomfort and keep taking pictures.

The background graffiti adds to the story by providing a setting for this portrait of a soldier on duty.
Nikon, 85-250mm zoom at 150mm, Ektachrome 100, 1/250 sec, f8

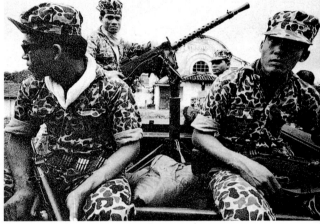

A semi-posed picture is a good scene-setter, an establishing shot that shows these are real people with a job to do. This also features some of the equipment used in the Vietnam War, and shows the bleak environment.
Nikon, 28mm, Ektachrome 100, 1/125 sec, f11

One way to illustrate frenzied activity is to use a slow shutter speed to show movement.
Nikon, 28mm, Ektachrome 100, 1/60, f11

South Vietnamese leader, General Ky, was pro-British and extended this co-operation to British photographers.
Nikon, 85mm, Ektachrome 100, 1/60 sec, f2.8

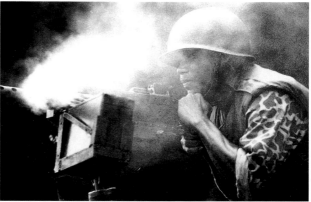

The machine-gun fire produced by this Cambodian mercenary was so deafening that an accompanying journalist stuck his fingers in the photographer's ears as ear plugs.
Nikon F2, 85mm, Agfa 3500, 1/250 sec, f8

This young Vietnamese girl was shot in the spine by Viet Cong machine-gun fire. The date on the cast – six months later – is when it was due to be removed. The pathos of the picture is more acute than scenes of limbless soldiers.
Nikon, 35mm, Agfa Record (ISO 3500), 1/60 sec, f2.8

A wide-angle shot through the open door of a helicopter hovering over the Mekong near Saigon (Ho Chi Minh City) is very involving and gives a sense of being there.
Nikon, 28mm, Kodak Tri-X (ISO 400), 1/60 sec, f11

CHECKLIST

Make sure you have as much accreditation as possible before entering a war zone.

Take backup equipment as cameras also suffer fatalities under harsh conditions.

Protect film and carry drinks in a cool bag.

Use a mini tripod for long exposures at night or in dark buildings.

Take Multi-Flash and extra flash and slave units, as well as spare batteries.

Find out the best way to dispatch film. This could be through a local press agency.

Take a map, compass and notebook.

Besides the drama of the battle and its casualties, war brings many touching examples of sadness and futility, especially among the civilian population. Here a Vietnamese child takes advantage of a free shower.
Nikon, 28-250mm zoom at 200mm, Ektachrome 100, 1/250, f5.6

Film Stills

Photographers are sometimes asked to shoot stills of a movie for publicity, or a stills version of a television commercial for the print ad. If you shoot on the same day you won't need to arrange the casting, set, props and costumes, but you will usually have to work around the schedule of the movie shoot. A dress rehearsal is often a good time for stills photography. Some photographers even cross over into directing TV commercials, but the transition is not necessarily a logical one. The skills of a lighting cameraman are more akin to those of a photographer. Instead of telling a story in 1/60 second, a director of commercials has thirty or sixty seconds to build a narrative using the language of the moving image together with sound. You also lose autonomy and have to consider about thirty other 'experts'.

With the consent of the director and actors, the stills version of a TV commercial can be covered during the lunch break. Here the Hasselblad waits for a forty-five minute break in the shooting of a French socks commercial. The simple, two-wall set is lit by a 2 K light on the left and two 3 K Softlites on the right.

These convincing lookalikes were given videos of Laurel and Hardy movies, then mimicked their gestures while putting on the socks (*see* LOOKALIKES *and* CREATIVE CASTING). A considerable saving in the budget was achieved by shooting the stills ad on the same day, which meant that studio, costumes, props, make-up and model fees were not duplicated. Because it has the facility for a Polaroid back, a Hasselblad was used, allowing the results to be assessed instantly. *Hasselblad, 40mm, Ektachrome 200, 1/15 sec, f22*

CHECKLIST

Doubling-up on stills and movie helps make savings in the budget.

Be prepared to work quickly, as you may only be allowed a short time in which to shoot.

Find suitable slots within the shooting schedule for the stills pictures.

Make sure you have the director's consent and the actors' co-operation.

Being on the set of a movie offers opportunities to photograph actors in a variety of situations: performing, relaxing or preparing for their role. Here Diana Dors is given a few extra inches around the waist by a 'dresser'.
Nikon FE, 90mm, Kodak Tri-X (ISO 400), 1/125 sec, f11

In David Puttnam's first foreign production, Donovan played the Pied Piper in a big-set movie also starring John Hurt and Diana Dors. The stills photographer has to choose his moments carefully; he is often there under sufferance, and the demands of the movie invariably take priority. His task is to capture the essential elements of the story without disrupting the flow of filming.
Hasselblad, 40mm, Kodak Tri-X (ISO 400), 1/60 sec, f22

Although some of the rats were rubber, many of them were real and trained to co-operate! An extra rat was double-printed in the foreground to add impact to the shot (*see* CROPPING AND CHANGING).
Nikon, 28mm, Kodak Tri-X (ISO 400), 1/60 sec, f22

Orchestrating Orgies

When you are handling more than a dozen people and arranging lighting, props and animals, the logistics of the occasion can be quite mind-boggling. You need to be something of a lion tamer, using your voice as the whip to keep everyone's minds on the job. It may take a week to organize the models, props, costumes, food, stylists, assistants, transport and venue for an 'orgy' (*see* HANDLING ANIMALS, ROOM SETS *and* COSTUME DRAMA).

On the day of the shoot I position all the characters on the set, then draw a name plan, using annotated Polaroid snaps pinned to a large piece of card. I refer to this when asking someone to move, change expression or simply to pay attention. Most people are self-conscious and respond quickly to having their name called out over the megaphone. They feel more involved and put on a better show. It also makes everyone else perk up and be more disciplined. Those in the background are warned how important they are, as the viewer's eye is invariably drawn towards the back of the picture.

It is difficult to keep my eye on everyone in the frame, so I use observers to watch different sections of the crowd. Using a beeper just before each shot alerts the crowd to react simultaneously (*see* CREATIVE CASTING).

This mini-orgy was a foretaste of the main banquet tableau. The intimate hue provided by the candlelight enhanced the orgiastic nature of the scene. A one-second exposure was necessary for the candles to glow sufficiently. Individually controlled electronic flash units provided illumination for each of the couples, with gold gels on four lighting heads so as not to kill the atmosphere. Three of the lights were in soft boxes, which give a more diffused light; whilst the fourth was harder, to suggest firelight.
Hasselblad, 50mm, Ektachrome 100, 1 sec, f16

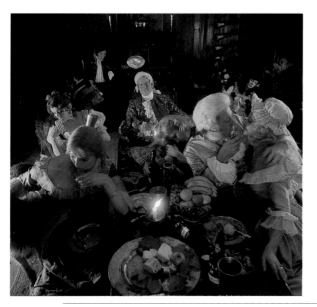

CHECKLIST

Allow the previous day to organize the lighting, arrange props and check all batteries, including those in your megaphone!

Shoot tests for colour, lens sharpness and depth of field.

Use a megaphone or PA system, which can be hired for the day.

Make a sketch of the scene and write each person's name in the correct position. By sticking annotated Polaroids on to card, you can reposition them quickly if you need to rearrange people on the set.

Stress the need for co-operation and total dedication from start to finish.

Shoot plenty of film; it is much cheaper than reassembling the cast. Shoot Polaroids at the end of each roll to check that the lens and lighting are still functioning correctly.

Make provision for the basic needs of the cast such as food and drink, including extra snacks to allow for working late.

Enlist helpers to watch different sections of the scene to check costumes, props and animals for anything that may spoil the photograph.

Appoint one assistant to check that all flash units are 'synching'.

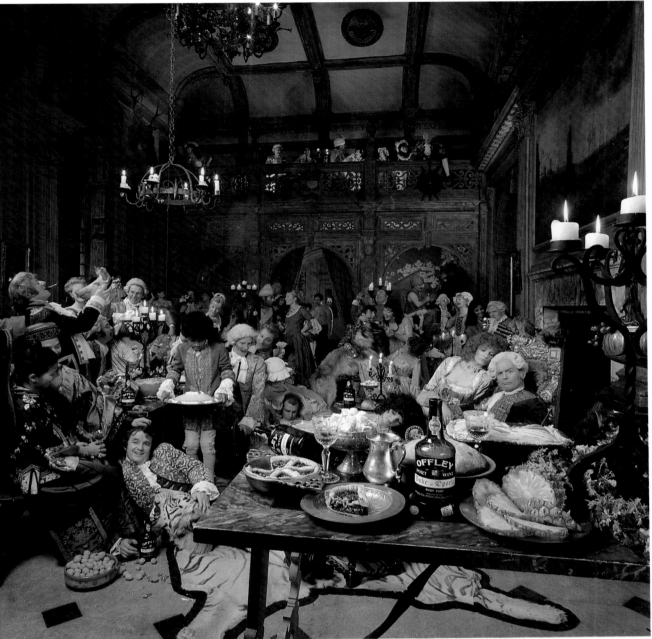

One of the most adventurous pictures I have ever done involved eighty extras and friends, and even my casting lady had to join in to try to keep expenses to a minimum. We dressed everyone in my studio and, together with three stylists, wined and dined them on the bus to Knebworth House in Hertfordshire, England. The props and equipment filled three vans. The cast, together with monkeys and Irish wolfhounds, was on set by 3 o'clock. I started shooting on a 8 x 10 Sinar, and after only two hours changed to a Hasselblad.

With this format and a recharging time of two seconds, I was able to capture the evolving action between the characters. I shot 100 exposures with shutter speeds varying between half a second and two seconds so as to emphasize the candlelight and give sufficient depth of focus – from 2 to 50 feet. Four striplights in a 'swimming pool' on the left gave the feeling of a candelabra, while striplights were concealed behind pillars and above, in the minstrels' gallery (*see* STUDIO LIGHTING).
Hasselblad, 40mm, Ektachrome 200, 1 sec, f32

Tricky Shots

People are drawn to mysteries and surreal images. They are fascinated by how certain shots are achieved. You can shoot intriguing illusions by using a little trickery. Objects suspended on thin wire appear to be floating. A hidden trampoline gives people unexplained bounce. An unusual viewpoint will command more attention (*see* SPECIAL EFFECTS). If carefully planned, double exposures may not need retouching.

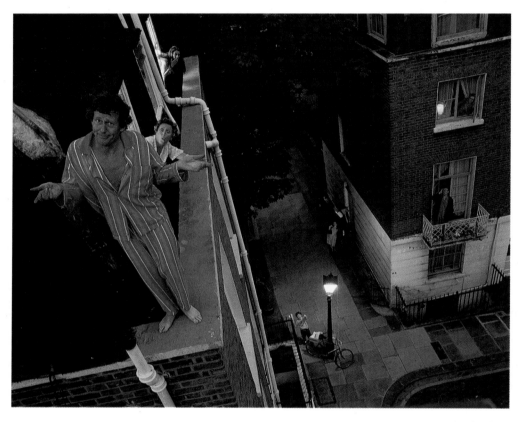

The sleepwalker was photographed from a cherry-picker (mobile crane) about 70 feet high. Attached to the cherry-picker were two 5-foot electronic flash strips covered with light blue gel to enhance the evening feeling. A small flash was placed inside the street lamp with a concealed cable running to the front door. As this was a test shot, a letter and number are in the bottom right of the picture to identify the roll of film. *Hasselblad, 50mm, Ektachrome 200, 1/8 sec, f16*

This man leaping through the air could have been suspended on wires, although he would probably have looked awkward. Instead, a trampoline was concealed behind the Cossacks and the trampolinist was frozen mid-jump by electronic flash. After the session a plastic cup was noticed on the ledge to the left, demonstrating the need to watch every detail. *Hasselblad, 50mm, Ektachrome 200, 1/60 sec, f16*

The characters were jumping on two large trampolines cropped for the ad. The logo for Jean Machine was cut out of tracing paper and spread 70 feet over the hillside. Two thousand plastic tulips were planted through the paper, which was then torn away. A small make-up mirror on the skyline reflected the morning sun. *(Main shot) Hasselblad, 50mm, Ektachrome 100, 1/500 sec, f11; (set-up shot) Nikon FM, Kodachrome 64, 1/250 sec, f8*

CHECKLIST

Make sure you have appropriate insurance when performing a dangerous activity.

Rehearse tricky shots carefully.

Check that any tricks are safe and, where necessary, have someone in charge of them.

Ensure your equipment is working and that all lights and props are ready before the action starts.

Consider using wind or smoke machines to add to the drama (see SPECIAL EFFECTS).

Use a megaphone or walkie-talkie for noisy scenes or when people are a long way from the camera (see ORCHESTRATING ORGIES).

Appoint someone to check the scene for out-of-place items, including discarded cups!

Elaborate Lighting

This scene for a Finnish beer involved a cast of twenty-five characters. In it, a medieval hunting party has returned to camp and the evening's revelry is about to commence. A company called Tyme Bandits organized the casting, costumes, styling and props.

Creating the right mood while also highlighting the product demanded careful positioning of people, props and lights. Put the light sources on to 'wink' mode, so that when they have recharged, the model bulb flickers. Here, lights ranged from small tungsten torpedo bulbs concealed behind the glasses, to a fish fryer on the left to illuminate the background.

By lunch time the exact positioning had been established. I used a name plan to help identify people quickly, and a megaphone to hold their attention (*see* ORCHESTRATING ORGIES).

I shot a few 8 x 10 test sheets to establish the exposure, degree of distortion and depth of field. Here I am holding a Minolta spot meter with flash meter incorporated and an incident light meter. *Sinar 8 x 10, 165mm, Ektachrome 200, 1 sec, f16*

Chalk at the end of the straw helps create better froth, which remains intact for several hours if gelatine is added. Each glass was lit from behind by a separate tungsten torpedo bulb concealed from the camera and attached to a wire that went up the character's sleeve and down his trouser leg.

CHECKLIST

Test the lighting the day before the shoot to allow time to replace lights and ascertain the ideal exposure and colour balance, making sure that different electronic light sources are compatible.

If tungsten is used, test with different gels, for example gold, straw and salmon.

Test lenses for depth of field and sharpness.

Check the flash duration of different heads if you plan to show movement. 1/60 sec to 1/1000 sec are available.

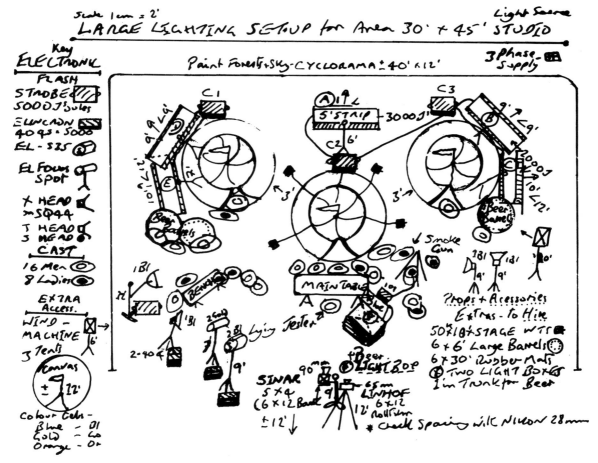

When planning a large lighting set-up, a diagram is essential because it can be very complicated. Number the different packs with coloured tape and have corresponding coloured tape on the different heads and leads going to the packs. If a fault occurs, it can be traced very quickly.

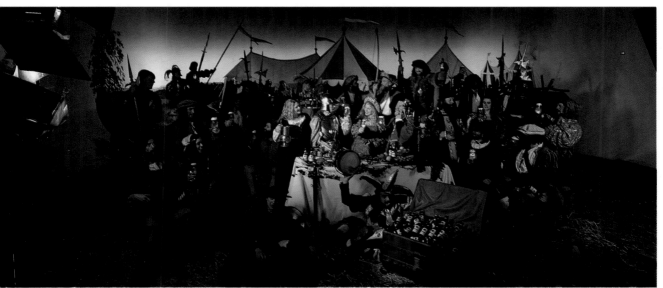

An Elinchrom X-head with two 404 packs was positioned on the left illuminating the foreground. The cool blue light was created by putting one stop blue gel and a layer of diffuser on an SQ44 reflector on the right. The chest of beer and central characters were given a warm glow with a couple of Elinchrom spotlights.
Linhof 6 x 12, 65mm, Ektachrome 200, 1 sec, f16

Jewellery

For this assignment, the auction house Christie's wanted a very regal look for their jewellery. As we were pressed for time we had to find one model who could convey just the right level of sophistication and arrogance, and then photograph her in a suitably grand setting – the Richmond Hotel in Geneva. The Royal Suite normally costs an arm and a leg but we used it free of charge having persuaded the management that the publicity they would receive would be worth more than the hire of the room.

In initial casting sessions in Geneva I saw seventy models, then another fifty in London, but I still wasn't happy. Then, the day before we left for the shoot, I received a model composite of an American model. She had the look of a duchess. I decided on painted backdrops, since the hotel's panelling was modern, and not in keeping with the aristocratic image we needed. Props were chosen to complement the jewellery. A stylist from *Elle* magazine chose hats and gloves, whilst Christian Dior in Paris sent a trunkful of outfits. A local antique shop lent chairs, and the hotel next door let us borrow an elegant chaise longue. I had to work fairly fast since the jewellery was being auctioned almost as I was shooting it, and clients were coming in to inspect it.

Posing for jewellery photography requires patience as the lighting is more critical than most fashion or beauty shoots. If the model feels awkward or uncomfortable, reassure her that you appreciate the problems, and try to make her more comfortable, for example by providing a cushion for her back.

Inspired by Bill Brandt's photographs of Scottish landscapes, I had three scenes painted on canvas, each 9 ft x 9 ft. The canvas was rolled up and driven to Geneva on the roof-rack of my Range Rover.
Nikon 801, Kodacolor 200

I was given the assignment thanks to a test shot I did on my stairs at home. By shining a small scoop on an Elinchrom flash head through the railings, dramatic shadows were created on and around the model (*see* STUDIO LIGHTING).
Hasselblad, 120mm, 1/60 sec, f22

To highlight the necklace, I used an Elinchrom (S35) electronic flash – similar to a 2000-watt light – with a Fresnel lens shining through a diffusing screen. At the same time I created a natural light on the model herself by lighting her and the couch from the right-hand side with a soft Elinchrom (SQ44), diffused with two layers of diffuser. A mini spotlight provided the light on the back of her neck and arm. As the aperture was stopped down to f64, tungsten light alone, which needs an exposure of about ten seconds would not have been powerful enough. On the vertical shot, the shaft of light on the painted canvas behind came from a focus spot to the top left of the picture. The diamond earring was lit by a 2000 watt spotlight shining over the model's shoulder to create highlights on the jewellery, gloves and back of the chair. Some of the light was refracted through the diamond, creating fragments of light on her cheek. Using an 8 x 10 Polaroid, I checked that sufficient emphasis was being given to the jewellery. As it reflected the light source so effectively, I was able to make the skin tones a little darker without losing the sparkle. *Sinar, 8 x 10, f64*

CHECKLIST

Choose the model and props to enhance the jewellery.

When casting, shoot colour negative (C41) film to check complexion and hands.

Illuminate the model with a soft light, then concentrate on making the jewellery sparkle, using a spotlight and/or matt-silver reflector or small mirrors.

Using Polaroid or colour negative (print) film, check that the jewellery shines out clearly. The print film can be processed in one hour.

Children in Advertising

Children look appealing in photographs if they are quite at ease with the photographer or oblivious of his or her presence. How you relate to them will largely determine how successful the results are. Models understand the aims and requirements of advertising photography; babies and young children don't. They therefore have to be bribed or coaxed into giving the performance you need. It is easier to capture a child's natural gesture or expression if you have created the right atmosphere, and have suitable props and enticements. Have the mother on the set; she can best reassure the child, who is likely to respond to her voice. Children are interested in anything new – for a while. This interest will soon wane and they will need further stimuli to prevent them from becoming bored or tetchy. If you are not ready when the child is performing well, you may have blown your only chance. As a child's expression and interest change rapidly, be prepared to shoot a lot of film. You will have greater flexibility if you use general lighting, a simple background and a hand-held camera, even in a studio. A 50-250mm zoom lens is ideal for letting you to keep your distance and re-compose quickly. Events may unfold so quickly that you have to respond instinctively in order to capture the highlights (*see* WORLD OF CHILDREN *and* IMPROMPTU PORTRAITS).

A visual pun – 'Stamp out inflation' – formed the essence of this political advertisement. Most photographers accustomed to the whims and inconsistencies of young children would opt for a photocomposition, combining the best elements of several different pictures. During the test shots, however, the favourite children performed perfectly on the very first exposure and could not be coaxed to repeat their performance.
Hasselblad, 120mm, Ektachrome 100, 1/60 sec, f16

Older children respond more readily to instructions and/or suggestions. When two of them get together they often inspire each other to put on a livelier show, enhanced here by elaborate clothes and whacky specs. This fruit-juice ad was lit by a 1-foot square reflector to create interesting reflections in the specs. *Hasselblad, 150mm, Ektachrome 200, 1/250 sec, f22*

Advertising photographs do not need to show the product if clothing and props can be chosen to suggest a lifestyle or mood. The two boys in sailor outfits send a message to the viewer about the quality and status of the product, in this case carpets. The addition of a model aeroplane creates a visible tension between the disgruntled boy on the left and the proud possessor of the plane. *Hasselblad, 60mm, Kodak Plus-X (ISO 125), 1/60 sec, f22, printed on Kodalith paper*

During the casting session, Michael Joseph's daughter, Justine, was encouraged to display a range of expressions. Even with your own children you have to create and maintain some form of interest; in this case, the prospect of tucking into a huge slice of cake did the trick. This set was lit by a fish fryer, slightly diffused with one layer of tracing paper, positioned over the photographer's right shoulder. *Hasselblad, 150mm, Ektachrome 200, 1/125 sec, f16*

CHECKLIST

Create an atmosphere in which the child will be happy. Playing children's cassette tapes can help them relax.

Have a variety of toys and props available to absorb the child's interest, as well as rewards for after the session.

Act quickly when the child is performing; you may not get a second chance.

Be prepared for dribbles down the one and only outfit.

A backup child may help encourage the one on set to put on a more enthusiastic show.

Always cover advertising sessions in a variety of ways; art directors and clients have a habit of changing their minds.

Studio Beauty

Keep the studio lighting quite subdued so that people don't feel intimidated. It is advisable to shoot tests early in the session. While the film is being processed, try different accessories and backgrounds, experiment with lighting and finalize the hairstyle and make-up. Shoot and label Polaroids as a guide to help with the preparations. Try diffusers over the lens, for example silk stockings or muslin, for a soft image. Black netting does not fog the picture, whereas white creates a light, foggy effect.

If the focus is critical, provide a support behind the model's head so that she knows exactly where her head should be. If she is sitting, position her quite high. Besides making her feel elevated – on a pedestal – it is then easier for the make-up artist to reach her and for you to shoot while standing, without having to keep bobbing up and down (*see* PRETTY WOMAN).

The pose is intimate and sensual, without being overtly sexy; it implies the use of the skin cream that is being advertised. The main soft light is from electronic flash shining through the curtain on the left. A separate fill-in light was bounced back from a 4 ft x 8 ft sheet of polystyrene on the right. *Hasselblad, 140-280mm zoom at 140 mm, Kodak Tri-X (ISO 400), 1/125 sec, f22*

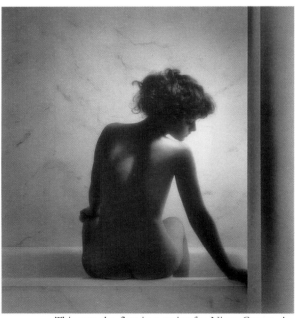

This was the first in a series for Nivea Cream. A Diffuser One and black net was used on the lens, softening the face, especially the eyes. She was lit by a fish fryer just above and behind the camera, and to avoid heavy shadows she held a white reflector at chest height to bounce light back up to her face. The black and white print was blue-toned. *Simar 5 x 4, 150mm, Kodak Plus X (ISO) 125, 1/60 sec, f32*

CHECKLIST

Use subdued lighting to minimize feelings of self-consciousness.

Choose appropriate music to create or enhance an atmosphere.

Shoot tests early to check film colour, establish lighting and camera angles and the best use of accessories.

Try a range of diffusers over the lens for varying degrees of softness.

Use Polaroids to guide you in making decisions about lighting, props and the model's body language.

Focusing can be critical; make sure the model knows exactly where to be.

The aim was to create a flowing honey swirl of hair by using a slow flash to allow the hair to blur slightly, while keeping the face acceptably sharp. To the right, an Elinchrom Square 44 (SQ44) light source was covered with three layers of diffuser and was positioned quite close, in order to accentuate the contours of the face. It was a little higher than eye level to look natural, but not so high as to create too much shadow. Before the model flicked her head, she looked very static. Polaroids then showed that the swirl worked well (*see* STUDIO LIGHTING *and* MOVEMENT). *Sinar 8 x 10, DB shutter, 360mm, Ekta Professional ISO 100, flash speed 1/250 sec*

Pretty Woman

A successful beauty shot is often simple, with a plain background and soft lighting. However, if you want a modern and aggressive look, a hard light can be used. Table lamps can be useful props and give exciting shapes (*see* STUDIO BEAUTY). Take advantage of special occasions, such as anniversary meals, weddings or theatre visits, by photographing a lady after she has spent time making herself look (and feel) good. Where possible, prepare lighting and props beforehand so that the photography session flows easily and quickly. For indoor beauty photography, have the room/studio warm, with appropriate music playing.

Try different poses and expressions: a soft smile or a serious look. Flip through quality fashion magazines for ideas on lighting and poses. Discuss examples with your subject.

Back and sidelighting through a Diffuser One gives a very flattering look. The pert expression and movement in the cards give xtra life to the picture.
Hasselblad, 140-280mm zoom at 250mm, Ektachrome 200, 1/60 sec, f22

The dog adds to the interest of this scene without dominating it. The eye is naturally drawn to the human face, especially if it is well lit. The lady's confident, almost haughty, expression is echoed by the dog, and is in keeping with the style of the picture.
Hasselblad, 80mm, Ektachrome 100, 1/60 sec, f16

This stark image was lit mainly by a soft fish fryer over the woman's shoulder, giving the photograph an almost painterly quality. A white reflector provided fill-in light on her front, retaining her facial features. Side-lighting creates shadows on the subject, giving it texture. If the light had come only from the direction of the camera, her body would have appeared flat.
Hasselblad, 120mm, Ektachrome 200, 1/60 sec, f16

CHECKLIST

Special events give people an excuse to dress up. Be ready to photograph the finery.

Keep it simple.

Use a medium telephoto lens (85-250mm on a 35mm camera) when photographing one or two models, and a 150-250mm lens for close-ups.

Use a soft, diffused light, as hard light emphasizes any imperfections in the complexion.

Experiment with home-made diffusers in front of the lens, using stockings or chiffon scarves stretched over a frame of stiff card.

For variety try different filters on the lens, including coloured grads and fun filters.

Watery Woman

Photographing people around water provides unlimited opportunities for unusual shots. People are generally relaxed and the water itself creates exciting effects. Shooting a shower scene can be expensive if you are paying nude rates for the model. Photograph a friend or shoot a test roll on three or four models, paying a half-hour fee or giving them prints for their portfolios instead. Use a background that is suitable for the model's temperament and skin colour. An appealing effect can be created by oiling the body, so that water droplets remain on the shiny skin. The shape of the breasts is usually more attractive if the model's hands are above her head or her shoulders are slightly back. Once wet, hair goes darker and may appear inappropriately straggly. Unless you want a sleek, wet look, make sure the model knows she should keep her hair dry. In a shower this can be done by positioning the spray to land on the shoulders.

Photography is not locked into a single viewpoint (see ODD ANGLES). Shots from above can capture very graphic designs. As the models may not be proficient swimmers, it is useful to be able to shoot fast, especially when two swimmers are co-ordinating their movements. Here, three exposures were made on each run, thanks to boosters on strobe lights.
Nikon, 25-50mm zoom, Kodak Plus X (ISO 125), 1/250 sec, f5.6

CHECKLIST

Discuss the purpose of the shoot with the model, including the type of expression and speed of action required.

Agree basic hand signals to use when she is in the water.

If you plan to sell or publish the photographs, ask her to sign a model release form before the session and agree a percentage of any payment you receive (see PRE-PRODUCTION)

Try spraying water droplets on skin that has been oiled.

A nude figure usually looks more attractive with hands above the head.

Steam can add greatly to the drama of a picture. It is created naturally when cold air comes in contact with warm water or warm moist air, or even a boiling kettle in front of the lens.

When near water, provide appropriate safety measures for people and equipment. Secure lights, stands and tripods.

Experiment with special-effects filters (see FUN FILTERS)

Looking down over a 150-foot cliff near Cannes in the South of France, the photographer communicated with the model via a walkie-talkie wrapped in a towel behind the model's head. For each shot, the assistant had to duck down underwater, while also trying to control the angle of the air bed.
Hasselblad, 500mm, Ektachrome 100, 1/500 sec, f11

Photographed indoors in winter, the aim was to create a South American look (see ROOM SETS). Being cold outside, steam formed naturally when the doors were opened. The scene was lit by a round 9-inch reflector with Diffuser One suspended from a boom arm over the pool. It is easier to produce a convincing intimate scene if the couple already has a close relationship.
Hasselblad, 120mm, Ektachrome 200, 1/125 sec, f16

Cosmetics

A diffuser creates a softer, more romantic image. If the model's complexion is not quite perfect, a Diffuser One on the lens will disguise minor blemishes. A faster film (ISO 200 or 400) has more grain, which also has the effect of softening the picture (*see* FILM SPEED). When shooting abroad you are much more vulnerable than you would be at home. The surroundings are unfamiliar, there may be language and culture barriers, and you are far from your usual film supplier, camera repairer and processing lab. To avoid disappointments, you need to make careful preparations and take backup equipment and extra film. Seek out a local lab where you can have colour negative (C41) film processed quickly. Shooting a test roll on colour negative film will enable you to check the focus at different focal lengths and apertures, and also to ascertain the best poses, lighting and amount of diffusion.

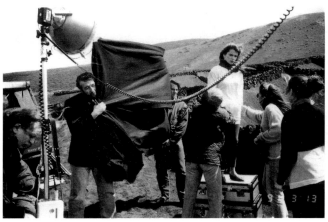

The black drape over a wooden frame was used to reduce Lanzarote's strong winds and to mask the light. An improvised reflector bowl was attached to a portable Norman flash and covered in one layer of diffuser. The model was raised on camera cases to fit into the volcanic background.
Nikon AW, 35mm Kodacolor 400, auto-exposure

A series of test shots indicated which pose, film and degree of diffusion worked best. The shot, on Fujichrome 100, was diffused with a Diffuser Two over the lens as well as a 81C filter to warm up the skin tones.
Hasselblad, 120mm, Fujichrome 100, 1/125 sec, f11

CHECKLIST

When travelling abroad take backup equipment and plenty of film – slow, fast and tungsten.

Use Diffusers One or Two and/or fast film to soften a less-than-perfect complexion.

Cover yourself by shooting both with and without diffuser, but remember that the photograph can be diffused later, at the printing stage.

Avoid colour filters that alter the colour of the cosmetics.

Shoot a test roll to check the focus is accurate (focus on the eyes); to ascertain ideal exposure; and to determine the most appropriate poses.

Use short film (12, 20 or 24 exposure) for the test roll.

The first shot was diffused by a 4 ft x 4 ft frame covered in muslin or tracing paper positioned 1 foot in front of the light. On the second shot a layer of gold gel was placed over a portable Norman flash with a 24-inch round reflector bowl to warm up the image.
Above left and right: Hasselblad, 120mm, Ektachrome 100, 1/125 sec, f11

Slight changes in position and expression can alter the mood of the shot. This image is enticing and might work well on a brochure. The shot is flipped because the lean to the right seems more natural (*see* FLIPPING).

Home Sweet Home

Think of your home as a studio or potential location for picture-taking. A host of props are on hand, such as wineglasses, jewellery and flowers from the garden, but you are free from the pressures of working in someone else's premises. By careful selection of lens, camera angle and lighting, the rooms can appear more spacious, and they can also be converted into convincing sets by adding 'flats' that change their shape (*see* SPACE MAKERS *and* ROOM SETS).

This shot was taken in a studio converted with props from around the house. A small aperture gave sufficient depth of field. The wall lights were dimmed so they retained their detail and did not 'burn out'. In the hallway, electronic flash with a warm orange (85C) filter was used to 'freeze' the two children sneaking down the stairs.
Linhof, 65mm, Ektachrome 200, 1 sec, f22

A spotlight shining from the alcove on the left gives a feeling of greater space. The main light source was an umbrella to the right of the camera, positioned between the two French windows to avoid reflections. A Square 44 (SQ44) medium light source 15 feet from the models gave an even light, while a focus spot on the conductor's face helped make him stand out (*see* STUDIO LIGHTING).
Hasselblad, 40mm, Ektachrome 100, 1/15 sec, f16

CHECKLIST

Think of each room in your home as a potential studio.

A wide-angle lens will increase the apparent size of a room, especially if you shoot through open doors or French windows.

Illuminate alcoves and hallways for a more spacious feel. Conceal flashguns behind furniture or in lamps (see SPACE MAKERS).

Before-and-after pictures show what can be done in your own home. An attic room is transformed into a child's dream bedroom full of colour and exciting toys. The cartoon picture on the screen is a drawing. Electronic flash overpowers normal TV images. A powerful light source (two 404 packs) outside the window gave the impression of summer evening light (*see* STUDIO LIGHTING).
Hasselblad, 50mm, Ektachrome 200, 1/250 sec, f11

With a little vision you can clear out the everyday paraphernalia in a room and add a few elegant props and furnishings to create a sensuous setting that is almost unrecognizable.
Linhof, 65mm, Ektachrome 200, 1/30 sec, f16

Room Sets

Finding a suitable location for a particular shot may be costly, difficult or impossible. It can be easier and quicker to create your own room sets. A few well-chosen props and an imaginative use of lighting can soon transform an ordinary attic or living room (*see* HOME SWEET HOME *and* SPACE MAKERS). In addition to accessoires from junk shops, look in rubbish skips for useful building materials. Don't worry if things look threadbare as this will add to the realism of the picture. When looking for props, shoot video or colour negative pictures of potentially interesting items. These can be filed for future use.

A panelled study whose owner would be willing to have holes made in the walls would have been impossible to find, so a set was built. The floor was raised 2 feet to allow the blonde model to perch under it. Fibreglass panelling was painted with a matt mahogany spray. Rather than cut a hole in a good carpet, felt flooring was put down.
Hasselblad, 50mm, Ektachrome 200, 1/30sec, f22

In your own premises you have more control over props, lighting and the length of time you can spend on a picture. Three images illustrating the stages of a loft conversion were used to promote a loan scheme. The cobwebs were sprayed from a can (*see* SPECIAL EFFECTS) and the props hired or found around the studio. There was enough space around the set to accommodate four striplights at the back and two striplights in the front, bounced off polystyrene to soften the scene. The boy and cat were kept reasonably 'hard' by shining a directional strobe fish fryer from the bottom left-hand corner (*see* STUDIO LIGHTING).
Hasselblad, 120mm, Ektachrome 200, 1/60 sec, f16

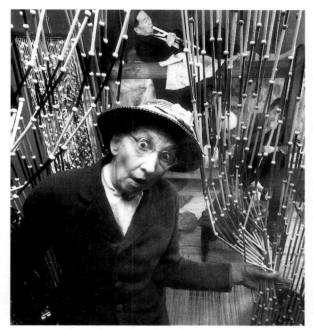

A genuine opium den, if you could find one, would probably be very different from what most people imagine, and even assuming the proprietor allowed you access, the clientele would certainly be embarrassed, probably much worse! However, a set was easy to put together with two plywood walls ('flats'), a bead curtain and smoke from a Bee gun, which helped distinguish the lady from the background.
Hasselblad, 50mm, Ektachrome 200, 1/125 sec, f22

After a fruitless week location-hunting for a suitable alpine chalet, a replica set was built in the studio, based on some location shots.
The hillside was a 12 ft x 18 ft colour print supplied by the Austrian Tourist Board. To make the picture realistic, a sheet of glass was positioned so that the chandelier was reflected. The walls were given an interesting texture by using stucco plaster and the pine beams were decorated with a stencil pattern to make them look authentic. Instead of having less than an hour to shoot, as you might on location, the whole day was spent experimenting with different positions and clothing. And the sunset, which normally lasts ten to fifteen minutes, was permanently available.
Hasselblad, 50mm, Ektachrome 200, 1/15 sec, f22

Mirrors can provide interesting reflections and can make a room appear at least twice its size. Set-builders prefer mirror foil stretched over hardboard as an inexpensive and safe alternative to the real thing.

In this set the camera is concealed behind a matt-black shelf that appears to be on the opposite side of the room. It is eye level with the standing model. Top strips are shining through a diffused panel to look like a top light.
Hasselblad, 40mm, Ektachrome 200, 1/60 sec, f22

CHECKLIST

Building your own room set frees you from the time and cost restrictions of a location shoot.

Keep a photographic record of potentially useful props and furnishings.

Use lighting and selective focus to hide any inaccuracies in the set.

Have fun with mirrors!

Space Makers

By the careful selection of viewpoint, lighting and lenses, even a small room can appear spacious on film. Shoot through an open doorway with a wide-angle lens to maximize the coverage. Light-coloured walls and high-key lighting give the impression of greater space, and interior designers often use mirrors to create the illusion of space (*see* HOME SWEET HOME *and* ROOM SETS). Just as forty people can be squeezed into a saloon car, so it is possible to accommodate a large cast of characters within a relatively modest studio (*see* CREATIVE CASTING).

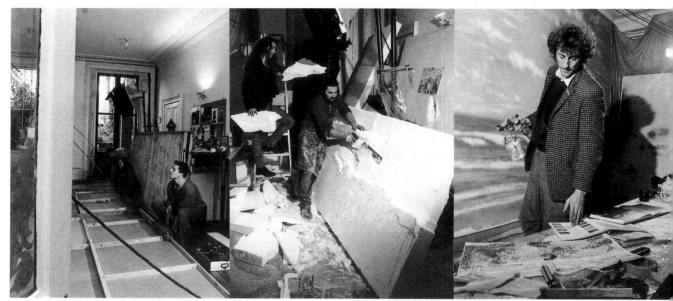

Here the studio is being prepared for the scene opposite (top). Two model-makers cut cliffs out of polystyrene, while the backdrop painter consults reference material of sea and sky.

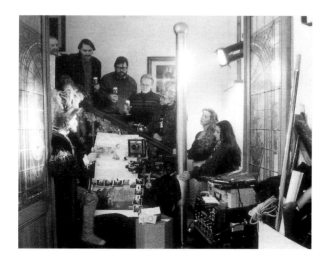

By shooting through the open doorway maximum use was made of the studio space. Here the knight is checking the Polaroids.

An appropriate choice of film can reinforce the illusion. Tests on ISO 100 film indicated that the little cut-out soldiers appeared too sharp, and the grainier ISO 400 was more realistic.
Sinar 5 x 4, Fujichrome 400

A Strobe spotlight lit the scene from the left. Two layers of gold gel helped neutralize the blue light from the swimming pool.

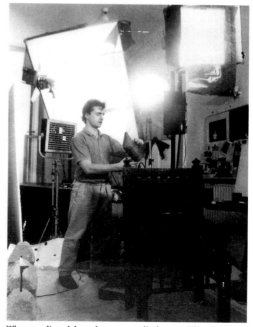

A small corner of a studio can be made to appear comfortably roomy. Stained-glass partition doors create a feeling of space.
Hasselblad, 120mm, Ektachrome 200, 1/60 sec, f16

The medieval beach set was lit by an Elinchrom S35 with two orange gels, plus a swimming pool and fish fryer, both of which had one blue gel. A wind machine and Bee gun added further to the atmosphere (*see* SPECIAL EFFECTS).

Painted Backdrops

Painted backdrops can greatly enhance a sense of period, place or time of day. Sometimes just a hint of colour or rough outline is all that is required. The background can be out of focus, giving the scene depth and disguising any imperfections in the painting. Use four 5-foot striplights on backgrounds that are bigger than 9 ft tall x 12 ft wide.

Using front-projected images to create the backdrop is more complex and involves restricting lighting, especially with large-format cameras (*see* SPECIAL EFFECTS LENSES). Painted backdrops can be much bigger, but a 9 ft x 9 ft backdrop is a good starting point, and needs only two striplights.

Using reference pictures of New York, matt paint was applied to a 5 ft x 10 ft sheet of transparent Perspex. Once dry, small pencil lines of paint were scratched off to create the illusion of fluorescent lights. The illumination was provided by bouncing two striplights into a sheet of polystyrene behind the backdrop. A Diffuser One and Black Net Two over the lens gave soft edges to the lines of light. One fish fryer lit the front of the painting from the far right to ensure overall even light. This elaborate backdrop was designed to be comped together with a new car (*see* DIGITAL TECHNOLOGY). *Sinar 8 x 10, 350mm, Ektachrome 100, 1/60 sec, f16*

This cleverly painted room set enhances the illusion that the famously small English comedian Charlie Drake is nearly as tall as the ceiling. The exaggerated perspective created by the steep angle of the ceiling gives the impression that he is standing in a large scene. The set was created for an ad whose headline ran: 'A Harris Roller makes a man ten feet tall'.
Sinar 8 x 10, 300mm, Ektachrome 100, 1/60 sec, f45

A painted backdrop, makeshift railing and stuffed seagull on a nylon line were more reliable for shooting this scene for an Italian fashion company than venturing out on location. Soft smoke from a Bee gun gave depth and helped make the painted backdrop more realistic (see SPECIAL EFFECTS).
Hasselblad, 60mm, Diffuser One, Ektachrome 100, 1/60 sec, f16

CHECKLIST

Use painted backdrops to create the illusion of exotic locations, different historical periods or surreal, cartoon-like scenes.

Use matt paint on light cotton stretched over a wooden frame.

Put the background out of focus to give the picture depth without detracting from the foreground subject.

Add mid-ground objects, such as plants, to achieve greater realism.

As the aim was to produce a theatrical rather than a realistic scene, the American liner was painted to resemble a *New Yorker* magazine cover. The 'glitzy', staged look was enhanced by the use of luminescent plastic on the sea and the palm tree, creating a spectrum effect.
Hasselblad, 120mm, Ektachrome 100, 1/60 sec, f22

Lavish Locations

Castles, museums, stately homes and parks can provide exciting and unusual settings for your photography. If you carry an inconspicuous amount of equipment you generally do not need prior permission, nor will you be charged a location fee. More elaborate set-ups usually require official authority and a facility fee. Find out what additional props can be borrowed at the venue, from table settings and vases to plants and statues. Offer to supply free photographs in exchange for people's co-operation or a smaller fee (*see* COSTUME DRAMA).

Knebworth House in Hertfordshire, England was a fitting backdrop for the launch of a hot-air balloon in the soft, early-morning light.
Nikon, 35mm, Kodachrome 64, 1/60 sec, f8

The 'butler' at Beaulieu House in Hampshire was lit with a fish fryer (*see* STUDIO LIGHTING), producing striking reflections in the glasses. Because a long exposure was required for the candle flames, the picture was shot when it was dull outside. A similar effect could have been achieved with two layers of neutral density filter (equivalent to one stop) over the windows. A small aperture gave a depth of focus from 3 to 50 feet.
Hasselblad EL, 50mm, Ektachrome 200, 1/10 sec, f22

CHECKLIST

In your travels keep a record of possible locations. Collect hotel and travel brochures showing exciting and eccentric settings.

Take a compass on the recce to determine the direction from which the sun may be shining at the time of the shoot.

Obtain permission where necessary, even if you are only considering using a farmer's field.

Ask what additional props are available.

Consider the physical comfort of those in the picture: provide food and drink, warmth and changing facilities.

A sumptuous room with an antique fireplace
provides the opulent location for the two
dedicated backgammon players. The mirrors give
the room depth and interesting reflections. The
camera had to be concealed by placing a large
sculpture on the mantelpiece.
Hasselblad, 50mm, Ektachrome 200, 1/30 sec, f16

Fashion on Location

Spend time considering props for a fashion shoot, as they can provide a short cut to producing more relaxed and more natural pictures. The props and setting often lead you into suitable poses, perhaps holding a bottle, glass or telephone, or leaning on a table or over a fence. As a session progresses, new ideas invariably present themselves. For example, the physical elements may guide the way the model behaves, causing her to raise a hand to brush aside her wind-blown hair, or shield her eyes from the sun.

Eye contact with the camera produces a very direct image that can be appropriate in fashion photography as viewers are more likely to associate themselves with the good-looking model. Don't be afraid to add a touch of humour; make the viewer smile and you have made an impact! As a rule of thumb, keep the camera at chest height. Any higher and the model's neck will appear too short, any lower and the waist is over-emphasized. Although a soft light is more flattering to skin tones, a hard light is often necessary in order to pick up the texture of the fabric.

Shot in Provence in the South of France, this ad for Christian Dior had to show the natural colour of the garment. Quite a hard light was needed to bring out the texture. The colourful local character was half-hidden behind the wine press so that he did not detract from the 'hero'.
Hasselblad, 120mm, Ektachrome 200, 1/60 sec, f11

In addition to the warm, mottled light streaming through a skylight, electronic flash was diffused through a roll of tracing paper placed over the French windows. The props were dimly lit so they did not take over the picture.
Hasselblad, 80mm, Ektachrome 200, 1/30 sec, f8

Before the session, have films open and ready to load.

Prepare and number labels to stick on the cassettes once the film has been exposed.

Choose props that will enhance the 'story' and give the models something to do.

Use a hard light source to bring out the texture of the garment.

Shoot the model in a variety of poses, in different locations and with different lenses.

Study fashion magazines, especially Italian Vogue, and the work of master and modern painters; learn from their treatment of light, props and locations.

Shoot each outfit in different settings. Here, the position of the pigs' heads leads the eye towards the main focus of attention. The stick provided the model with something to occupy her hands and also improved the composition.
Hasselblad, 140-280mm zoom at 280mm, Ektachrome 200, 1/125 sec, f8.5

Giant beech trees provide a powerful setting. The tufts of grass growing in the tree work beautifully with the colour of the woman's hair, garments and boots. Responding to a breeze, she spontaneously brought her hand up to hold her hair away from her face. No artificial light or filters were used.
Hasselblad, 140-280mm zoom at 140mm, Ektachrome 100, 1/60 sec, f11

The Profession

Out and About

Do you take pictures or make them? If you are an opportunist photographer you are always on the lookout for photo opportunities to present themselves. You anticipate what will happen next and are prepared to snap the shot when all the elements come together naturally. On the other hand, if you have preconcieved ideas about what pictures should be, you prefer to *make* them happen by arranging all the ingredients. A lot of photography is a combination of these two approaches (*see* HAPPY SNAPS *and* ORCHESTRATING ORGIES).

By keeping eyes and ears open you come across people, props and locations that could lend great character or atmosphere to a picture, yet on their own seem incomplete. A little coaxing and stage managing can bring together the elements in a visually satisfying way. These two individuals were seen in a pub and later tracked down on their stud farm and persuaded to come and stand in front of a nostaligic old sign, and the bicycle brought in from down the road completed the picture (*see* POSING PEOPLE, SPIRIT OF IRELAND *and* PRE-PRODUCTION)
Sinar 5 x 4, 150mm, Ektachrome 100, 1/15 sec, f11

CHECKLIST

For exciting and intriguing locations, examine travel brochures, travel books, National Geographic and other magazines.

Stock library catalogues are good sources of inspiration (see STOCK SHOTS).

Carry a range of filters, including a graduated filter, which helps to hold the picture together when the sky is bright.

Shoot polaroids of local characters.

Give a picture added life by inventing a narrative and choosing appropriate props, characters and locations.

Experiment with slow shutter speeds and special effects

If you plan to sell the photographs, make sure that everyone in the picture signs a model release form.

Be aware of how the photograph might be published. For example, leave space at the top of a cover shot for the magazine title, or avoid placing the main subject of a picture in the centre in case it is printed across a double page.

Most advertising images are minutely pre-planned, leaving little to chance. Everything but the ideal weather was introduced to this selected location. A light breeze blew the special effects smoke across the background of this staged duel, revealing theatrical shafts of sunlight through the trees, which lent depth and drama to the picture. Without the wind, someone would have had to run through the scene with a smoke bomb or Bee gun (*see* SPECIAL EFFECTS). A slow shutter speed was used to help the picture appear more animated.
Hasselblad, 50mm, Ektachrome 200, 1/15 sec, f22

By noting the position of the sun and sail, and appreciating the effect of putting the two together, you can create a dramatic picture that reflects the excitement of the sport. With the exposure on automatic, and holding the camera so that the sail's shadow falls across the lens, a spectacular starburst effect is produced, without the use of filters. Shoot several frames to achieve just the right burst of light, especially when photographing a swaying subject from a moving platform (*see* SPORTING CHANCES *and* INTO THE SUN).
Nikon 301, 20mm, Fujichrome 100, 1/250 sec, f11

Model-Making

Using dolls, toys or model cars in an imaginative way can produce bizarre or humorous images. 'Models' also enable you to exert more control over a shot. In advertising, cigarette packets are often made at least twice normal size for easier lighting and to produce sufficient depth of field. Plastic fruit can be photographed out of season, model ice-cream doesn't melt, and stuffed animals are well behaved!

It was cheaper to make an 18-inch model of the 'E'-type Jaguar, and a 24-inch model bed, than to photograph a real car in a studio and comp or sandwich it with a separate shot of a bed (*see* DIGITAL TECHNOLOGY).
Sinar 8 × 10, 300mm, Ektachrome 100, 1/250 sec, f45

Pictures of computers and calculators need an eye-catching gimmick in order to be noticed. In this case, a model of Einstein provided the solution.
Hasselblad, 120mm, Ektachrome 200, 1/15 sec, f11

The maze in the grounds of Brocket Hall, Hertfordshire, England, was only 2 feet high and 8 feet square. It was made of sections of real box hedge arranged into the shape of the advertiser's logo. The far end of the model was raised by 2 feet to increase the sense of perspective.
Hasselblad, 40mm, Ektachrome 200 rated at ISO 400, 1/15 sec, f16

CHECKLIST

Look at magazines for ideas. Tear out favourite ads and locations for reference.

Models can be made from a host of materials – clay, fabrics, wood, and so on.

Use a nylon line and tent pegs to prevent tall models blowing over, or for suspending objects.

A bottle-and-glass shot with a difference! The box hedging had to be photographed the day it was assembled, before it wilted. A tobacco grad made the sky blend in with the lady's outfit (*see* GRADS AND POLARIZERS).
Sinar 5 x 4, 90mm, Ektachrome 200, 1/15 sec, f16

A real snake would have been unpredictable and probably too alarming! The humour of this over-the-top scenario relies on an excess of related models and props (*see* COSTUME DRAMA).
Hasselblad, 60mm, Ektachrome 200, 1/15 sec, f16

Costume Drama

Convincing reconstructions can be achieved in theme parks, museums, or in association with local dramatic societies or school productions. If you obtain the blessing of the organizer you will have the co-operation of the director and actors, and you will be able to use lights, tripods, etc. Where appropriate, offer your pictures for their promotional uses. Alternatively, set up your own costume drama by hiring or borrowing outfits and props. If you are going to a fancy dress party or ball, take the opportunity to produce a cogent record of the event (see LOOKALIKES, HOME SWEET HOME, ROOM SETS and LAVISH LOCATIONS).

Hard lighting in a studio adds drama to this interchange between Napoleon and Josephine.
Hasselblad, 40mm, Ektachrome 200, 1 sec, f22

A few drapes and props set the scene for the Rudolph Valentino character. An exposure reading for the lamp was taken using an ambient light meter held a foot from the lamp (see EXPOSURE METERS).
Hasselblad, 80mm, Ektachrome 200, 1/15 sec, f22

The art deco props, costumes and styling all contribute to the 1930s set. Electronic flash was positioned inside the lampshade. A light layer of Vaseline on a piece of glass over the lens added to the romantic, nostalgic atmosphere.
Hasseleblad, 120mm, Ektachrome 200, 1/60 sec, f16

The opulence of the days of the Raj in India is recaptured at this grand ball. One layer of blue gel covered each of the windows to subdue the daylight. The long exposure necessary to record the candles was combined with electronic flash. As a result the flames shone through the face of the lady who danced in front of the candles on the right. A 4-point cross-star filter added to the lively atmosphere (see FUN FILTERS).
Hasselblad EL, 50mm, Ektachrome 200, 1 sec, f11

CHECKLIST

Take advantage of special occasions when family and friends dress up in period or character costumes.

Find suitable public places, such as old disused bridges, barns or railway stations.

Avoid anachronistic details such as watches, zips, specs, TV aerials and aeroplanes, by strategic positioning of plastic ivy, period lamps etc.

Use Vaseline sparingly on glass for a fogging effect.

Study the work of photographers such as Jacques-Henri Lartigue, Cecil Beaton and Angus McBean.

The garden of Syon House near Heathrow Airport, London, provided the ideal location except for the aeroplanes that kept flying across the background! One large umbrella was shone through a 2000-joule head to help illuminate the foreground.
Hasselblad, 40mm, Ektachrome 200, 1/30 sec, f22

The Creative Darkroom

Your Darkroom

As long as it can be made light-tight, almost any room can be converted into a darkroom, whether an attic, a bathroom or a storeroom. Having running water is ideal but not essential, since buckets of water can be brought in, and the thorough washing of prints can be done later. Choose somewhere that is not too hot in summer and which has heating in winter and ventilation to clear the chemical fumes. When constructing a temporary darkroom, install hinged surfaces that can be lifted out of the way. Processing and printing information can be taped on the folded down flaps. Keep the wet and dry areas separate to avoid splashing chemicals on the enlarger, photographic paper or negatives.

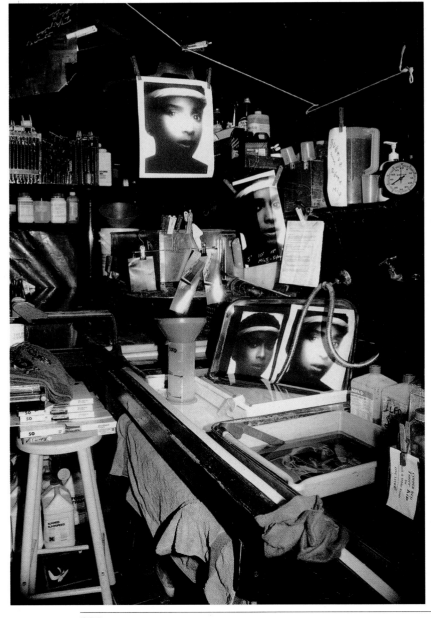

This typical darkroom has the enlarger on the left, a clock with luminous hands above the developing trays, boxes of paper and a print trimmer, towels and sponges. A set of wedges or blocks are used for tilting the enlarging easel or masking board. Under the enlarger, shelves of different papers are within easy reach. Lightweight plywood shelving and drawers store negative bags, prints, test strips, notes and accessories. Cupboards containing chemicals should have doors. Minimize the danger of fogging prints by painting the area around the enlarger black. The pull switch for the light should be within easy reach of the enlarger. An orange safe light is suitable for most papers, although a red filter is advised for Kodagraph and other sensitive papers. A tent-shaped 'cover' over the safe light with a mask down one side prevents light hitting the enlarger. A flap with a magnetic catch can be held up when more light is needed on the enlarger area. A drip tray can be incorporated underneath to catch drips from test strips clipped to the flap.

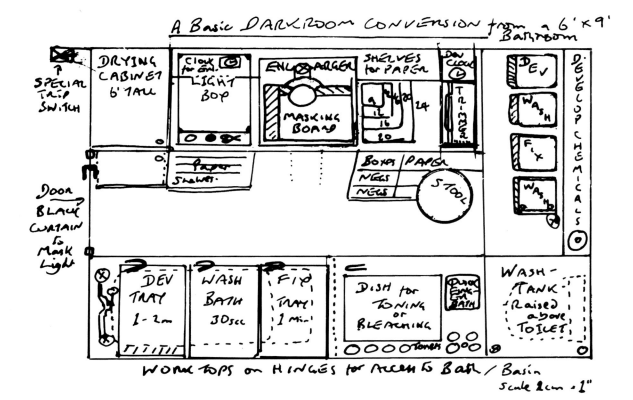

A Basic DARKROOM CONVERSION from a 6'x9' Bathroom

This plan of a converted bathroom shows where the trays and tanks could be positioned in relation to the bath, toilet and basin. In addition to hinged work surfaces, create a sliding shelf that comes out near to the enlarger to hold tape, scissors, indelible marker pens, and so on.

It is useful for future reference to note on test strips the different exposures and filters used, as well as any ideas for printing.

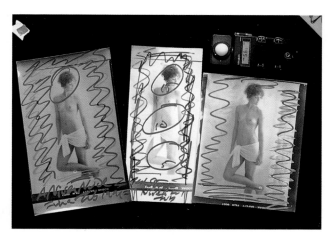

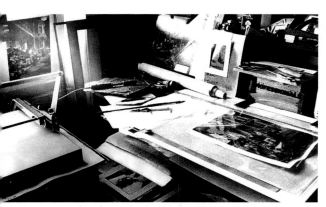

To dry-mount a print, tack mounting tissue to the back of the print using a tacking iron, then trim off the excess tissue. Position the print on a piece of card, and heat the layers together, using either a mounting press or domestic iron.

CHECKLIST

Consider buying second-hand equipment, especially when starting out. Consult camera magazines.

Use clips or pegs to hold a selection of pencils and shaders, tongs and thermometer.

Screw two battery clips together to hang up notes.

Have handy a little torch to help find things in the dark.

Make a little dark box with a matt black interior where half loaded film or exposed paper can be placed if you are interrupted.

Use different plastic tongs for the developer and fixer to avoid contaminating the chemicals.

Processing Black and White

Behind every good print is a well processed negative. By following a clear-cut process of develop, stop, fix, wash and dry, predictable results can be achieved. Load the film on to a spiral, insert in a developing tank and add the developer. Agitate for the first thirty seconds, then for ten seconds every minute thereafter. Set the clock alarm to sound every sixty seconds. Development time is usually seven minutes for slow film, ten minutes for fast film. Empty the developer and pour in stop bath to halt the development process. Next insert fixer for two to three minutes, agitating for the first thirty seconds. Fix the film for twice the time it takes for the film to clear.

Process a test strip in sections, giving different development times in order to pull and push the film by +/− two stops. Reduce the recommended development time by ninety seconds for each downrated stop. Increase it by ninety seconds for each additional stop.

Practise loading rolls of reject film in the light with plastic or metal spirals. Use a can/cap opener or screwdriver to prize open the 35mm cassettes, then use scissors to cut off the end of the film before loading in complete darkness.

To avoid drying marks, add a few drops of Fotoflo solution or washing-up liquid to a 2-litre container of water. Run the film through this solution with a see-saw action. Then rub off excess water with your fingers, or use squeegee

Negatives will turn out fogged if the undeveloped film is exposed to light. They can also easily be scratched if, for example, the squeegee tongs used to clear off excess fluid are not pre-rinsed.

Wear cotton gloves when marking negatives of transparencies, as fingermarks can damage the emulsion. Use an indelible fine marker, such as Rotring. When dry, store negatives in transparency sleeves, and leave them in the sleeves when contact printing.

CHECKLIST

Large plastic bottles with big openings are useful for storing developer, whilst Perrier bottles are good for toners and dyes; the green glass helps preserve the chemicals.

The stop bath can be water, but an indicator stop bath is more useful as it shows it needs replenishing by changing colour when it becomes contaminated.

To clean dust and drying marks, put a few drops of CleanArt either side of the negatives. Then gently wipe off any dust or dirt.

Cut up negatives as soon as they are dry, then store in transparent sleeves to keep off the dust.

Devise a simple filing system so that you can locate negatives quickly.

The Creative Darkroom

A black and white interneg can be made from a colour transparency by positioning the transparency over a same size piece of film with the emulsion side up. Cover with a piece of glass to hold them flat. This test strip shows the results of twenty-two, forty-four and sixty-six-second exposures. The film can be developed in normal paper developer, here Ilfospeed, for two or three minutes.
Original transparency: Sinar 8 x 10, 165mm, Ektachrome 100, 1/30 sec, f22

Printing Black and White

Seeing an image materializing on paper is one of the most exciting aspects of photography. First a negative or transparency is inserted into an enlarger and projected on to light-sensitive paper. The image becomes visible only when the paper is developed. To avoid causing streaks, the developer tray should be rocked, especially during the first thirty seconds. After about two minutes' development, wash for thirty seconds, ideally in running water, and fix for the recommended time. Give it a quick wash, then examine the print in the light. If it is too contrasty, reprint using a lower number grade of paper. Finally, wash the print thoroughly in running water.

A focusing magnifier is used to check the grain structure of a negative and to ensure accurate focusing of the enlarger. Before positioning the photographic paper, pre-focus on a sheet of white paper, using the magnifier for finer adjustments.

Contact prints of all your negatives provide a quick reference. With the glossy side up, place the negative strips on the baseboard and position over them a 12 x 16 x $^1/_4$ inch piece of plate glass with bevelled edges. Stick plastic tape along the sides of the glass to facilitate handling and to protect the glass. Contacting is quicker and less precarious when negatives are kept in transparent sleeves.

CHECKLIST

Avoid chemical splashes on your clothes by clipping a towel around your waist.

Use a wooden or Perspex rod to hold prints down in developer or fixer.

Make sure there is no fixer on your hands before handling the paper again, as this leaves white marks on the print.

Record exposures, type of paper and developer on the back of test strips and contacts. This saves time and money when reprinting.

Resin coated paper dries quickly. Fibre-based paper such as Multigrade matt is good for toning and retouching.

Spotting can be done using a fine paintbrush and black waterproof paint. Practise on test strips.

Shading or dodging is done to keep certain areas lighter. Multigrade filters can be used to shade parts of the image or to increase contrast. If scratched, move the filter during the exposure to avoid leaving an impression on the print. Hands, fingers or a range of card or plastic shaders can be used for shading prints. Do not allow the negative sprockets to shine on to the paper for more than ten seconds, as it may cause fogging, even through a red filter.

When the print is wet you can burn in (darken) specific areas by using concentrated developer on a cotton swab or the tip of your finger. You can go back and forth between the wash and developer until you achieve the desired result. Have a funnel to catch the drips and direct them into a beaker as you hold the print up for examination.

Print a test strip using Multigrade paper and different filters. Start the test strip with a grade zero filter, then half, one and a half, two and a half and five. Filters allow you to use a longer exposure and develop the print more evenly, with time for burning and shading. Certain areas may be exposed up to ten times as long as the rest of the print. The second print is overshaded. The final print is shaded and selenium toned to produce an unusual and powerful effect.

Colour Processing and Printing

Whereas the sophisticated machines of professional labs produce reliable results quickly, processing and printing colour film at home is more costly and less predictable than with black and white film. Whether processing colour negative or transparency film, careful attention must be paid to the timings and temperatures given in the instructions provided with the processing kit. The C41 processing kit, which can be used for most colour negative film, includes six (sometimes only four) chemical stages: developer, bleach, rinse, fixer, rinse and stabilizer. The E6 process, used for many colour transparency (reversal) films, involves nine stages: developer, rinse, reversal bath, colour developer, conditioner, bleach, fixer, rinse and stabilizer.

If you pull (downrate or cut) or push (uprate) Kodachrome film more than one stop a magenta cast appears. Here Kodachrome 200 was cut one stop (–1) making it ISO 100; normal – ISO 200; and push one stop (+1) making it ISO 400.

The new fast films such as Ektachrome 1600 can be pushed up to three stops. As they may not be DX coded, set the film speed manually when loading the film in the camera.

Modern E6 processing labs can monitor the exact position of film during processing, enabling them to push or pull film with greater accuracy.

Kodak's C41 Create-A-Print machine processes and prints a colour negative film in minutes. It is useful for test prints which help you decide composition and shading. A small part of the image can be enlarged to produce quick, high-quality prints.

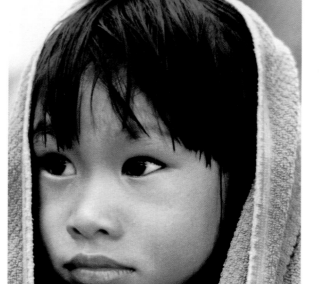

There is no visible grain in an 11 x 14 inch enlargement of this fast film, which gives realistic colours even in overcast conditions.
Nikon 801, 28-85mm zoom at 85mm, Kodacolor 400, 1/250 sec, f8

CHECKLIST

Kodachrome and Fujichrome film should be processed by Kodak and Fuji respectively.

Store colour negatives in transparency sleeves.

Colour negatives printed in black and white can look more dramatic; you may start 'seeing' more exciting images.

Experiment with extremes of filtration to produce toned effects. Colour toned prints can be produced from black and white negatives

Prints can be made from slides using reversal papers, or dye destruction papers (Cibachrome).

Cropping and Changing

View each photograph as a starting point rather than a *fait accompli*. You can salvage disasters or add new life to your pictures in a host of ways. Consider cropping into a small part of the image to change the message, or produce a moody, grainy enlargement. With Kodagraph paper and Kodalith developer you can vary the high-contrast results by changing the exposure and development. Unusual results can be obtained by bleaching away the image on a print that appears too dark, then developing it again in another developer. Even accidentally double exposed film may produce interesting juxtapositions, parts of which may be worth printing.

This effect was achieved by printing on Kodagraph paper in Kodalith developer. The subject was heavily shaded using two shaders, and the background was burnt in, exposing for an extra two or three minutes. Shadowy streaks were created by flashing a torch across the print. Shapes cut out of card and placed over the paper protected the areas that were not to be subjected to this treatment.

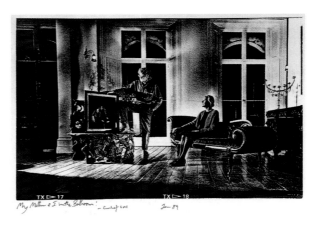

Towards the end of the development time, the room light was switched on for one second. Further development then created this solarized effect.

CHECKLIST

Make a print more interesting by throwing a tablespoon of salt across the image before exposing under the enlarger.

Experiment with rolls of outdated film.

Wear gloves and use tongs if you have sensitive skin.

Wear an overall or towel clipped around your waist to protect clothing.

A torch is handy for darkening certain areas on a print during exposure, thereby producing dramatic effects.

A wide range of formulae for toners and dyes is available from photographic shops.

One advantage of doing your own printing is the fun of being able to montage different images, often with humorous results. Careful shading helps blend the pictures together. You can also copy prints by shooting through glass with Vaseline around the edges or through a black oval with serrated edges to give the picture a dark frame.

Two images can be sandwiched together by placing two overlapping negatives in the negative carrier. A double exposure can be made by drawing the outline of the master image on backing paper. Then put the second negative in the enlarger and decide where to position it. Expose two or three sheets of paper, shading out selected areas, then expose the first negative on one of the sheets. Develop it and assess the result. Print another, making changes as appropriate.

A New Look at Old Pictures

Take a fresh look at your photographs. Images that seem tired and lifeless can be revitalized by cropping, flipping, reprinting, montaging or toning. Simply by displaying the pictures in an imaginative way, they can take on a new life. Think about producing posters or postcards of your most striking images to promote yourself or your business. Consider assembling photographs on a single theme and submitting them for possible publication in an appropriate magazine or newspaper. You can protect prints from fading, loss or damage by making duplicates on transparency film. And restore old or damaged prints by retouching, spotting or copying.

The second image was achieved by half exposing the image in the enlarger, then inserting a piece of wrinkled muslin for the second half of the exposure. A sharper, less confused image is produced by not leaving the muslin there for the entire exposure.

CHECKLIST

Consider putting together a collage of similar or contrasting images of varying sizes, perhaps with one main picture fringed by many variations.

Create a photo mobile by mounting prints on card or plastic.

Make a flip book of photographs telling a narrative.

Toners are supplied with good instructions, but it is advisable to do test strips as some papers work more effectively than others.

Try printing colour pictures in black and white.

Selenium toner is a good way of protecting and preserving an image, making it less easily damaged by ultraviolet light.

Hand-colouring is an effective way of pepping up a plain print. Use watercolour paints on matt prints, or coloured dyes on any surface including lustre or gloss. It gives you the artistic licence to create bizarre images.

Even if you like a particular effect, you can change the mood and achieve equally appealing alternatives with different treatment. A stark black and white print on matt paper gives great impact to the ladies in white, whereas by bleaching out a similar print, and losing a lot of the dark areas, the second image portrays a different atmosphere with its sepia appearance and decreased contrast.
Above left: Sinar 8 x 10, 360mm, Kodak Tri-X (ISO 400), 1/15 sec, f32
Above right: Sinar 8 x 10, 360mm, Kodak Tri-X (ISO 400), 1/30 sec, f32

By blue-toning this scene in France a very different atmosphere is created.
Nikon 801, 85mm, Kodak Ektapress 1600, 1/60 sec, f32

The left shot of a Diana Ross lookalike was flipped so the two images worked better together (*see* FLIPPING). It was printed through a wicker–cane effect, which can be bought by the roll. The lattice was positioned over the paper, making sure the eyes were showing. After printing it was bleached and green-toned to produce an exotic feel. The second print was exposed through a wire mesh, then copper-toned. Experiment with different materials.

Glossary

Agitation The movement of the processing solution to keep it in contact with the surface of the emulsion during processing.

Ambient light meter see **Reflected light meter**.

Angle of view The maximum angle 'seen' by a lens. The longer the focal length of the lens, the narrower the angle of view.

Aperture The opening in the lens that determines the amount of light reaching the film. It is usually adjustable and is measured in f numbers.

Aperture-priority The exposure system in which the photographer selects the aperture manually and the camera automatically sets the appropriate shutter speed.

Art director Advertising agency person responsible for the visual appearance of an ad. An art director works with a photographer towards achieving the desired photograph for an ad.

ASA Speed rating indicating the film's sensitivity to light, devised by the American Standards Association, now replaced by ISO. Higher numbers denote higher speed (faster) films.

Auto exposure A camera system that automatically sets the correct exposure.

Auto focus A system of automatically measuring and setting the focus.

'B' setting The shutter speed setting on some cameras that causes the shutter to open for as long as the shutter release is depressed. It originally referred to Bulb exposure.

Backdrop Background material, often paper, fabric or canvas, on which images can be painted.

Barn doors Adjustable flaps that fit around a studio light to control the light reaching the subject.

Barrel distortion A lens aberration distorting the shape of the image, most evident in ultrawide and fish-eye lenses. A rectangular subject appears to bulge outwards like a barrel.

Bayonet mount A type of fitting enabling lenses to be mounted on the camera body quickly and easily.

Bee gun A hand-held smoke gun used to produce special effects smoke by burning charcoal and incense.

Bellows unit A concertina-like black sleeve between the camera body or back and the lens, used to focus on close subjects.

Bounce flash Light from an electronic flash bounding off a reflective surface, such as a wall, ceiling or white umbrella, producing a softer, more diffused illumination.

Bracketing Making a series of different exposures above and below the estimated setting in order to achieve a good result with non-average subjects, such as snow scenes, sunsets, very dark or very light subjects.

Bromide paper Photographic printing paper commonly used when producing black and white prints.

Bulk film Long rolls of 35mm film which can be reloaded into cassettes to save money.

Burning in see **Printing in**.

Camera obscura The original concept which had a pinhole, and created an image in a darkened room on the opposite wall from the pinhole.

Caption Descriptive information about a picture.

Casting The selection of suitable characters for a scene.

Changing bag A light-tight bag with

sleeves to allow safe handling of light-sensitive photographic materials.

Character light Light that defines the shape of a subject.

Clip test A short strip from an exposed film, processed to assess adjustment needed when processing the rest of the film. Clipping is the act of cutting a piece of film.

Close-up attachment An accessory, such as a close-up lens, bellows or extension tube, that enables the camera to focus closer than normal.

Collage One picture made up of several different images assembled together.

Colour cast A bias towards one colour, evident in photographs processed or printed abnormally and in film exposed in non-compatible light, such as tungsten film exposed in daylight. A colour cast may also be evident in pushed or outdated film.

Colour correction (CC) filter A filter designed to restore the correct colour balance.

Colour temperature meter A meter that measures the 'colour' of light in degrees Kelvin, and indicates the filtration required for correct colour balance.

Compact camera A small 35mm camera with a direct viewfinder.

Comping see **Photo-composition.**

Contacts, contact prints A same-size print of a negative or strip of negatives made by placing the negative in direct contact with the paper, and held flat by a piece of glass.

Contre jour Against (into) the light.

Contrast The variation in brightness and density between shadow and highlight areas. A 5-stop variance is the average range for transparency film.

Cropping The removal of unwanted sections of an image.

Cutting see **Downrating.**

Daylight film Colour film designed for use in daylight or with flash. It can be used in tungsten or fluorescent light with suitable correction filters.

Dedicated flash, integrated flash A flash unit that is integrated with the camera's automatic exposure system.

Depth of field, depth of focus The closest and furthest planes that are acceptably sharp.

Development The chemical process by which an invisible latent image is converted into a visible one.

Differential, selective, focus A technique used to isolate a subject by using a large aperture to produce a small depth of field so that areas not in the subject plane are unsharp.

Diffuser Translucent material capable of scattering transmitted light, producing softer illumination.

Digital A method of recording, storing and processing information using computer technology.

DIN Deutsche Industrie Norm (German standards organisation) is the German system for rating film speed, now replaced by ISO. An increase of 3 DIN units indicates a doubling of film speed.

Disposable camera An inexpensive plastic and/or cardboard camera that is sent together with its film for processing.

Diffraction The scattering of light as it passes close to an opaque surface such as a lens diaphragm. At very small apertures loss of image quality can occur.

Distortion The change in shape of an image.

Dodging *see* **Shading**.

Downrating, cutting, pulling The technique of decreasing the film speed, then underdeveloping the film during processing.

Dry mounting The method of affixing a print to card, wood etc by heating mounting tissue between the two surfaces.

Dust-off An aerosol can of compressed air used to blow dust and other particles off transparencies, lenses etc.

DX coding A system of marking the film canister with the film speed. Many cameras can 'read' this code and set the film speed automatically.

Easel, masking frame A flat board used to hold and frame photographic paper during printing.

Electronic flash *see* **Flash**.

Emulsion Light sensitive chemicals, such as silver halides, suspended in gelatin, that provide the coating to film and photographic paper.

Exposure The result of allowing light to reach photosensitive material. The amount of exposure is controlled by the shutter speed and aperture, governing the duration and intensity of light.

Exposure latitude The amount by which photosensitive material can be over- or under-exposed and still produce acceptable results.

Exposure value (EV) An indication of the aperture/shutter speed combination for a given level of light. For example, 1/30 sec at f16 has the same EV as 1/250 sec at f5.6.

F numbers A series of numbers marked on the lens indicating the relative size of the aperture with the smallest number denoting a wide open aperture. Each f-stop increase represents a halving of the amount of light that can pass through: f1, 1.4, 2, 2.8, 4, 5.6, 8, 11, 16, 32, 64 and 90.

Fast film Film that is sensitive to light, with a film speed of ISO 400 or over.

Fibre optic A system of transmitting light along flexible highly reflective Perspex tubes.

Fill-in flash A supplementary light source used to increase the exposure in certain (usually shadow) areas, without altering the overall character of the lighting.

Film speed A measurement of a film's sensitivity to light, usually on an ISO scale.

Filter Transparent material that modifies the light reaching the film. It is placed in front of a light source or between the film and subject.

Fish-eye lens An extremely wide-angle lens exhibiting barrel distortion and a very large depth of field.

Fish fryer A large light source measuring about 2ft x 3ft, usually used in a studio supported on an adjustable stand.

Fixer A chemical solution that 'fixes' the photographic image on negatives or photographic paper making it permanent.

Flare Stray light that reaches the film, reducing image contrast and shadow detail. Multi-coated lenses cut down flare. It can be further reduced by using a lens hood or shade.

Flash A unit that produces short bursts of intense light lasting between 1/60 sec and 1/40,000 sec. It is recharged from the mains or battery.

Flats Temporary walls used by set-builders, made of plywood on a pine frame.

Flipping Turning over a negative or transparency so the image appears back to front to increase the drama or flow of the image.

Focal length The distance between the film and the optical centre of the lens (not necessarily within the lens) when the lens is focused on infinity.

Focusing Adjusting the distance between the lens and film (or printing paper) to achieve sharp focus.

Focus spot A spotlight with a narrow angle of view, generally 1°.

Format The size and shape of a negative or transparency.

Fresnel lens A 'flat' condenser lens used with spotlights or with focusing screens.

Front projection A system of projecting an image onto a background screen. A medium format camera can shoot through a two-way mirror to combine two separate scenes.

Gelatin filters, gels Coloured filters made from dyed gelatin, used over the lens or light source.

Gobos Cut-out shapes or masks placed in front of a light source to cast shadows over the scene.

Grade Scale indicating the contrast of printing paper from soft to hard (0-5).

Graduated filters, grads A toned filter that gradually reduces in density towards the centre of the filter.

Grain Pattern of tiny particles within the photographic emulsion.

Graininess The subjective assessment of granularity. Graininess increases with fast film

Hand colouring 'Painting' a photographic image by hand, usually with a brush and coloured dyes.

Hard light An intense light that creates distinctive shadows.

High key An image comprising light or pale tones only.

Highlights The brightest part of the scene.

Hot Bright or too bright, when referring to light or exposure.

Incident light meter A meter that reads the amount of light falling onto the subject. It is held in front of the subject, facing the light source.

Infinity cove A 3-foot radius coving used in a studio to produce an horizonless background or smooth, continuous reflection in cars.

Infra-red film Film designed to record to infra-red light, not visible to the human eye.

Integrated flash see **Dedicated flash.**

ISO International Standard Organization is the universally accepted system for measuring a film's sensitivity to light – the film speed. The numbers used are the same as the old ASA rating. A doubling in the film speed rating denotes that the film is twice as sensitive to light, therefore ISO 100 film requires half the exposure of an ISO 200 film, under the same lighting conditions.

Joule A unit of energy used to measure the power output of electronic flash. An average flash unit has a rating of about 60 joules.

Key light The light providing the main illumination, usually supplemented by other light sources and/or reflectors.

Large format cameras Camera using sheet film measuring 5in x 4in or larger.

Lens Shaped glass or plastic that refracts light.

Lens hood A non-reflective shade that attaches to the front of a lens to reduce flare.

Light A form of energy that makes up the visible part of the electromagnetic spectrum.

Lightbox A box containing fluorescent tubes balanced for white light, covered by a diffuser, and used for viewing transparencies and negatives.

Light source Term used for any source of light – the sun, flash, tungsten or fluorescent.

Light tent Translucent material surrounding the subject and diffusing the light reaching it.

Lith film A high contrast film emulsion

that can produce striking photographic images.

Lookalike A person with visible characteristics that resemble another (usually well-known) person.

Low key An image comprising mostly dark tones.

Macro Close-up photography where the subject appears at least life-size on the film. The correct term is photomacrography.

Masking frame, easel A flat board used to hold and frame photographic paper during printing.

Medium format cameras Cameras using 120 and 220 roll film, producing negatives of varying formats, notably 6 x 6cm, 6 x 7cm, 6 x 12cm and 6 x 17cm.

Modelling light A continuous low-wattage light source built in to electronic flash heads to show the effect that flash will produce. The term is also used to describe sidelighting that accentuates the three-dimensional nature of a subject.

Model release form A legal document that a model signs to show his or her agreement to photographs being published, usually for a fee or percentage of sales.

Monochrome A term used for a picture with only one colour, usually referring to black and white.

Montage A picture made up of parts of several other pictures.

Motor drive A motorized film advance device attached to or built-in to the camera, enabling single or continuous frame advance, measured in frames per second (fps).

Multiflash Repeated flashes to produce a sequence of images of a moving subject, or to increase illumination of a static subject.

Multiple exposure Recording more that one image on the same piece of film.

Negative A photographic image in which the original tones are reversed.

Neutral density Colourless tone.

Neutral density filter A filter that reduces the amount of light without affecting the colour balance.

Overexposure Exposure that is more than normally considered 'correct', causing loss of highlight detail.

Panning Rotating the camera to follow a moving subject and releasing the shutter in the process.

Panoramic, wide, camera A camera with a very wide view and a minimum of optical distortion.

Paper grade Scale indicating the contrast of printing paper from soft to hard (0-5).

Parallax The difference between the image viewed through the viewfinder and the image viewed by the lens. This occurs because the two are viewed from slightly different positions and has no noticeable effect on distant objects.

Perspective The illusion of three-dimensional depth within a two-dimensional picture.

Perspective correction, shift, lens A lens used mainly in architectural photography to correct converging verticals. With the camera horizontal, the lens can be shifted in any direction.

Photo CD Images stored digitally on a compact disc, similar in appearance to an audio CD.

Photo cell, slave unit A light-sensitive cell that triggers a flash unit in response to the camera-activated flash.

Photo-composition, comping The joining of photographs to form one picture. This can be done manually or using a computer.

Photographer's agent A person who represents the work of a photographer by showing it to art directors etc with a view to obtaining sales or commissions. He or she prepares quotations and helps organize shoots.

Polarizing filter A filter that absorbs polarized light, to varying degrees depending on its orientation. It is used to reduce reflections in water, glass etc, and to increase colour saturation in skies.

Portfolio A selection of photographs that demonstrates the ability of a photographer.

Pre-production Planning and preparation for a shoot, including casting, location finding, obtaining permission, propping, set-building, determining the lighting etc.

Printing in, burning in Increasing the exposure during printing of selected areas to dramatize the image or change the emphasis.

Programmed exposure A system of determining exposure in which the camera sets an appropriate aperture/shutter speed combination according to a pre-programmed selection.

Pulling see **Downrating**.

Pushing see **Uprating**.

Rear curtain flash A method of triggering the flash at the end of the exposure, creating more realistic images.

Reciprocity failure Very short and long exposures cause a loss of film emulsion sensitivity. In colour film this results in a colour cast. Added exposure may be necessary for shutter speeds exceeding one second.

Red-eye Eyes can appear red when looking at the camera for a shot taken with flash on the camera. The effect is the result of light reflecting off the back of the retina. It can be avoided by using a pre-flash that contracts the pupil, or by positioning the flash away from the camera, or by bouncing the flash.

Red head A 750-watt tungsten halogen light providing extra light to help in focusing, when stopping down to f32 or more.

Reflected, or ambient, light meter A meter, such as a through-the-lens meter, that measures light bouncing off the subject.

Reflector A surface that reflects light. This could be a white board, sheet or umbrella.

Reportage photography Photography that tells a story, generally used in magazines and newspapers.

Resin coated A water-repellent base to photographic paper enabling them to be processed and washed faster, and dry more quickly than fibre-based papers.

Retouching The treatment of negatives, prints or transparencies by hand to alter tonal values or remove marks.

Reversal film, transparency, slide Colour or black and white film that produces a positive image on exposure, without a separate negative.

Ring flash A circular electronic flash unit positioned in front of and around the camera lens, producing shadowless lighting ideal for close-up medical and scientific work.

Roll film Film loaded on a metal spool and protected by opaque backing paper. The most common format is 120.

Safe light Darkroom light of a colour and intensity that will not affect specific light-sensitive material. Film and paper manufacturers indicate the type of safe light required.

Sandwiching Combining two or more negatives within one frame when printing, or transparencies when projecting.

Saturated colour The pure colour, undiluted by black and white.

Selective focus see **Differential focus**.

Self-timer A device that delays the shutter release. The delay time can be varied on some cameras.

Shading, dodging The covering or masking of selected areas of the paper while printing in order to hold back development.

Sheet film Large format film, such as

5 x 4in, 8 x 10in, available in flat sheets and loaded into film holders.

Shift lens see **Perspective correction lens**.

Shootlist, wants list A colloquial term referring to the list of picture requirements issued by photo/stock libraries.

Shutter The mechanism that controls the duration of exposure.

Shutter-priority The exposure system in which the photographer selects the shutter speed manually and the camera automatically sets the appropriate aperture.

Shutter-release cable A cable enabling the photographer to trigger the shutter remotely, without causing camera shake.

Single-lens reflex (SLR) A camera that uses a hinged mirror system to allow the subject to be previewed through the lens.

Skylight filter A filter that absorbs ultra-violet light, reducing haze and blueness. Exposure remains the same. It is advisable to keep a skylight filter on each lens for protection.

Slave unit see **Photo cell**.

Slide film see **Reversal film**.

Slow film Film that reacts slowly to light, with a film speed of ISO 50 or less.

Snoot A cone-shaped collar fitted over a lamp to channel the light into a circular area.

Soft box A light source that bounces a light in a white reflective box, enclosed by a diffuser.

Soft focus A diffused image with a slight loss in sharpness, used to smooth over blemishes in portraiture.

Soft light A diffused light that creates soft or indistinct shadows.

Solarization The reversal or part reversal of tones caused by extreme overexposure. A similar effect can be created by exposing a print to light during development.

Speedflash A rapidly recharging flash unit, with an output of up to 16 frames per second.

Spotlight A lamp whose beam can be focused in a controlled way.

Spot meter A reflected light meter with 1° angle of acceptance, used when precision readings are taken from a distance.

Spotting The retouching of small black or white marks on prints or negatives, using watercolour paint, dye or pencil.

Spreading filter A filter used in 6 x 12 and 6 x 17 panoramic cameras to spread the light evenly over the entire image.

Square 44 (SQ44) A reflector with white sides, each 44cm wide.

S35 An electronic flash with a fresnel lens similar to a 2kW spotlight as used in the movie business.

Squeegee A roller or flat rubber implement used to squeeze water out of wet prints.

Starburst filter A filter that turns points of light into 'stars' with 2, 4, 6, or 8 points.

Still life A static subject arranged into an aesthetically pleasing picture.

Stills video An electronic camera that records still images on a floppy disc.

Stock library, photo library A company that markets photographers' pictures to publishers and advertising agencies.

Stock shots Existing photographs with several possible applications or potential markets.

Stop bath A bath or tank of chemicals that halt development of photographic negatives or prints by neutralizing the action of the developer.

Stopping down Reducing the lens aperture and the amount of light reaching the film, often done to increase the depth of field.

Stops see **F numbers**.

Strip lights Flash tubes varying in length up to 5 feet.

Strobe A colloquial term for electronic flash, more correctly an abbreviation for 'stroboscopic light'.

Swimming pool A 4ft x 6ft light source used in a studio to provide even illumination over a wide area.

Synchronization The precise timing of the flash with the camera shutter.

Tacking iron A heated implement used to melt part of the dry mounting tissue so that it sticks to the print and the mounting board.

Teleconverter A lens attachment placed between the lens and camera body to increase the magnification of the image. A x2 converter effectively doubles the focal length of the lens.

Telephoto A long focal-length lens designed so that the length of the lens is less than the focal length.

Test strip A strip of photographic paper which has been exposed for different lengths of time in the enlarger in order to determine the ideal exposure.

T-head A flash head with the power pack incorporated into the head, with an output of 250 joules.

Through-the-lens (TTL) meter A reflected light exposure meter built into the camera.

Tilting The angling of the lens and film plane about a horizontal axis to increase focus, which is normal practice on plate cameras.

Toning A system of bleaching and dyeing to add an overall colour to black and white prints. Many colours can be achieved including green, blue, purple, magenta and gold.

Transparency see **Reversal film**.

Tungsten light film Colour film balanced for use with tungsten light. Most domestic and some studio lights are tungsten.

Underexposure Exposure that is less than normally considered 'correct', causing loss of shadow detail, reduced contrast and density.

Uprating, pushing The technique of increasing the film speed, then overdeveloping the film during processing.

Viewfinder An optical device indicating the edges of the images to be formed on the film.

Wide-angle lens A short focal-length lens that records a wide angle of view.

Wide camera see **Panoramic camera**.

X-head Two flash tubes combined in one head, powered by two 404 packs, producing light brighter than sunlight – 5000 joules.

Zoom lens A lens with a continuous range of focal lengths within given limits, such as 35-70mm, 28-85mm and 50-300mm.

Index

Picture Credits

All photographs by Michael Joseph except those by Dave Saunders: 17 bottom left, 19 top, 37 top and bottom, 46 bottom left and bottom right, 80 right 92 top left, 95 top, 113 bottom, 116 right, 118 right, 120 left, top right and bottom right, 121 top and bottom left, 149 bottom right, 157 top, 162 top left, 165 top right, 167 bottom, 168 top, 179 centre left, 188 top right, 192 bottom right and 257 bottom; Etienne Bol: 9 and 181 top; Julie Joseph: 10; Fran Saunders 11 and 152 left; Ginette Dureau: 15 top; Manfred Vogelsanger: 34 top left; Kay Widermann: 34 bottom left; Malcolm Venville: 35 top; Jessica Strang: 121 bottom right; Oliver Scott bike on jacket and 133; Michael Portelly: water baby on back jacket, 188 left; 189 top and bottom; Tim Mellors: 209 top right.

Captions for section opening spreads

Page 12-13
This shot involved 600 sheep and three shepherds wielding mobile fences. A stylist with a walkie talkie swooped in every time the girl's hair looked wind-blown. The flocks were on a 60-degree hillside and were photographed from across the valley. Only one negative caught the instant when the black-faced sheep looked straight at the girl.
Pentax, 1000mm, Tri-X (ISO 400 rated at 320), 1/250 sec, f8.5

Page 86-87
In the dimly lit streets of Saigon (Ho Chi Minh City) a young girl suddenly appeared running along guiding a hoop. Quick reactions, a slow shutter speed and accurate panning captured the fleeting moment. The negative had only a ghost of an image, which materialized when printed on very hard grade Kodalith paper using lith developer.
Nikon, 28mm Agfa Record 3500, 1 sec, f2.8

Page 196-197
Careful propping, positioning and lighting encourage you to 'read' the scene beginning with the prominent lady on the left wearing a red bikini. The eye follows the line of the umbrella to the maid in black and white. From there, the reclining lady in a white bikini and the dog lead the eye down to the lady in the water, enticed by her gesture and the lightness of the pool. The eye is then led up to the ladies at the back where Japanese fans echo the umbrella. The scene was lit by twelve different electronic flash sources (*see* STUDIO LIGHTING AND READING PICTURES).
Hasselblad, 60mm, Ektachrome 200, 1/15 sec, f16

Page 262-263
The sandwiching of three negatives into this triptych was inspired by the architecture of a new supermarket wing. The negative sprockets mirror the design of the gates, which in turn, seem to mimic the punk hairstyles (*see* CROPPING AND CHANGING).
Nikon AW, Kodacolor 100, auto exposure, blue toned